The Collaborative Director

The Collaborative Director: A Department-by-Department Guide to Filmmaking explores the directorial process in a way that allows the director to gather the best ideas from the departments that make up a film crew, while making sure that it is the director's vision being shown on screen. It goes beyond the core concepts of vision, aesthetic taste, and storytelling to teach how to effectively collaborate with each team and fully tap into their creative potential.

The structure of the book follows a budget top sheet, with each chapter describing the workflow and responsibilities of a different department and giving insights into the methods and techniques a director can use to understand the roles and dynamics. Each chapter is divided into four sections. Section one provides an overview of the department, section two focuses on directors who have used that department in notably effective ways, section three looks at collaboration from the reverse perspective with interviews from department members, and section four concludes each chapter with a set of tasks directors can use to prepare.

Ideal for beginner and intermediate filmmaking students, as well as aspiring filmmakers and early career professionals, this book provides invaluable insight into the different departments, and how a director can utilize the skills and experience of a crew to lead with knowledge and confidence.

Greg Takoudes is a Director, Producer, Writer, and Adjunct Professor of Film Studies at The New School, New York. His feature film *Up With Me*, distributed by IFC Films, premiered at South by Southwest, where it won the Special Jury Award, and has played at film festivals in America and Europe. His debut novel *When We Wuz Famous* was published in 2013, and he previously worked for Ron Howard and Brian Grazer as a member of the creative team at Imagine Entertainment. For more information, visit www.takoudes.com.

The Collaborative Director

A Department-by-Department Guide to
Filmmaking

Greg Takoudes

Routledge
Taylor & Francis Group

LONDON AND NEW YORK

First published 2019
by Routledge
2 Park Square, Milton Park, Abingdon, Oxon OX14 4RN

and by Routledge
52 Vanderbilt Avenue, New York, NY 10017

Routledge is an imprint of the Taylor & Francis Group, an informa business

© 2019 Greg Takoudes

The right of Greg Takoudes to be identified as author of this work has been asserted by him in accordance with sections 77 and 78 of the Copyright, Designs and Patents Act 1988.

British Library Cataloguing-in-Publication Data
A catalogue record for this book is available from the British Library

Library of Congress Cataloging-in-Publication Data
Names: Takoudes, Greg, author.
Title: The collaborative director : a department-by-department guide to filmmaking / Greg Takoudes.
Description: London ; New York : Routledge, 2019.
Identifiers: LCCN 2018058666| ISBN 9781138618046 (hardback : alk. paper) | ISBN 9781138618053 (paperback : alk. paper) | ISBN 9780429461392 (e-book : alk. paper)
Subjects: LCSH: Motion pictures–Production and direction.
Classification: LCC PN1995.9.P7 T26 2019 | DDC 791.4302/32–dc23
LC record available at https://lccn.loc.gov/2018058666

ISBN: 978-1-138-61804-6 (hbk)
ISBN: 978-1-138-61805-3 (pbk)
ISBN: 978-0-429-46139-2 (ebk)

Typeset in Bembo
by Swales & Willis, Exeter, Devon, UK

To Mom and Dad.

For the journey and the bravery that you gave to us.

Contents

Acknowledgments

This book could only have happened with the help of the wonderful people lending themselves to me at key moments in my life.

Thank you to my siblings. Christina, who during one summer of my middle school years, introduced me to the work of Alfred Hitchcock. These films, and the *Hitchcock/Truffaut* book that she shared to aid our discussions, set me on a lifelong love of cinema. That same summer, Tom sat me down to watch an assortment of his favorite movies and George indulged me in conversations about architecture. It was a summer that defined my tastes and passions.

Thank you to The New School, for the support and faith that you have shown to me. In particular, my deep appreciation to Melissa Friedling, Lana Lin, and Gustav Peebles.

Thank you to Sheni Kruger for initiating the conversation that would lead to this book. Your enthusiasm, professionalism, and kindness have helped my writing tremendously.

Thank you to the people who gave their time to be interviewed for this book: Miyako Bellizzi, Becky Glupczynski, Rebecca Gushin, Andrew Hafitz, Samson Jacobson, Tim Perell, Ryan Price, Margaret Ruder, Daniel Sauli, Theodore Schaefer, Bragi F. Schut, Patrick Southern, and Andrew Wonder.

Finally, thank you to Emily, Max, and Sadie. Your love and many excellent movie tips have meant everything.

1 Introduction

The role of a film director

The focus of *The Collaborative Director* is to explore an important skill underutilized by many directors on film sets, and infrequently addressed in filmmaking books: collaboration with one's cast and crew. Books and articles about directing tend to focus on other areas of filmmaking, such as the vision of the director and technological innovations in filmmaking equipment. These are certainly worthy topics and covered extensively. But movies are not made by ideas and cameras; they are made by people.

Directorial vision, no matter how creative and compelling, is of little use unless it is clearly communicated and successfully disseminated across the departments of a film crew. Technological innovations are essential but have created an erroneous assumption among many filmmakers that making a good movie—as opposed to merely getting a movie made—is somehow an easier endeavor now with the digital revolution. Digital movie cameras have decreased the costs of production and increased the ease of achieving professional-level cinematography. Due to improved camera sensors that can produce high-quality images even in challenging lighting conditions, gyroscopes that balance and steady camera movements, and the general automation of cinematography, directors have access to powerful storytelling tools. Post-production software gives filmmakers ever-increasing ability for manipulating image and sound elements in their films. Non-linear editing systems have, for many years, given filmmakers an edge in assembling their films with speed, and those editing systems are continually improving and becoming more intuitive and powerful.

Moreover, the expense of these new technologies drops every year, and with the success of low-budget yet commercially-viable films such as *Tangerine* (2015), which was filmed solely with a smartphone (and the addition of inexpensive lenses and software), the cost-of-entry for directors to make films is lower than ever in the history of cinema. Combine this phenomenon with the increasing number of distribution platforms that are being filled by new and diverse cinematic voices; this is a great time to be a filmmaker.

However, the most foundational tasks of the director remain unchanged by technological advancements. Creating a team of people to tell a worthy story

with compelling performances is as challenging now as it was in the early days of cinema. No advancement in camera technology can help a director figure out how to work with the writer to tighten a story arc that is dragging. Improvements in editing software cannot improve an actor's performance, fix a location that was improperly chosen for production, or correct a prop that does not fit the tone of a story. New technologies have helped to bring a broader and more diverse range of directors to make movies, but technology cannot help them make a good film.

A director must be able to employ and inspire the best work and most creative ideas from the people working on the film. This activity is the very nature of collaboration. But collaboration does not always come naturally to a director, and is usually a skill that needs to be learned. Here is the point of this book: to instruct and explore ways that directors can best collaborate with their crew and cast to make the best film possible.

This book is less technical than it is emotion- and process-based. There is an array of other books that competently cover the technical aspects of filmmaking, and while some of that information is here, *The Collaborative Director* has a different focus. The heart of filmmaking is working with people to tell a story, so this is a book about telling stories and working with people. The people who surround the director are a source of creative ideas, a source of resiliency during stressful production days, and a foundation for a director's ability to lead the cast and crew. It is clear, therefore, that to make a great film, a director must first become a great collaborator.

Vision and leadership

Some directors see risks in collaboration. She or he might be concerned that to collaborate is to lose the originality—or singularity—of their vision. Directors may also worry that collaboration shows a lack of ideas on the part of the director, or that collaboration puts the director in the position of ceding control to other people both on and offset. These are, at face value, valid concerns. Directors should avoid falling into the trap of "directing by committee." Mike Nichols, the director of *The Graduate* (1967) and *Angels in America* (2003), said that the director is the only person with the entire movie in their head. John Cassavetes, the "godfather" of American independent cinema, used to talk about how all directors have a creative spark inside of them—a vision that is unique only to them—and this spark is inherently fragile and therefore must be protected against the outside forces that may seek to change, or diminish, the spark. Indeed, that spark is a thing of immense power.

However, collaboration does not diminish or make any less original the director's vision. Collaboration does not mean allowing everyone else to have a say in how the movie is directed, and it does not make a filmmaker any less of an *auteur* of the film. When appropriately used, collaboration is a technique for getting the most out of the creativity, energy, and enthusiasm of a

cast and crew; to allow them to use their fullest intelligence, experience, and talents towards the fulfillment of the director's singular vision. It is the confident director who can seek inspiration from others—who can ask questions, is open to new ideas, and is receptive to the intelligence and creativity of others to improve the film.

Likewise, collaboration does not diminish a director's ability to lead. It increases leadership because it builds loyalty and trust. It strengthens the "spark" because it allows the cast and crew to align themselves with the director's intentions. Collaboration inspires every crew member to feel invested in the broader vision of the film. Making movies is hard. There is never enough time or money, regardless of the size of the budget, or the length of the shooting schedule. When the production is particularly challenging—the hours are long and the obstacles mounting—sometimes loyalty and collaboration are what help to get through those times. Collaboration is the essence of team building, and the whole team is required. But more than that, collaboration gets the best ideas out of the teams.

Leadership also comes in many different styles. Federico Fellini, director of *8 ½* (1963) and *La Dolce Vita* (1960), led his film sets by sheer force of will and an out-sized personality. In behind-the-scenes footage, he cut a powerful figure, loud and brash and full of charisma, unafraid to make himself heard to the vast crews and crowds of extras that he had to manage. However, not all directors are like this. There is footage of Gus van Sant on the set of *Gerry* (2002) where he cuts a more modest figure, an immensely approachable and intelligent director, who does lots of listening and speaks one-on-one with crew members in a relaxed style. He, too, is a tremendously effective leader of his sets, able to work with his crew and cast to create films of singular vision and power.

Leading does not mean having a loud voice and berating people. But it is up to each director to figure out their own style of leading and collaborating. This book is intended to give the director tools by which they can work with a team in an open and creatively transparent way, while also maintaining control of the project, and protecting their singular vision for the film.

Structure of this book

The Collaborative Director is designed to impart upon the director, both new and experienced, a deep enough well of information so the director can communicate the vision of the film, and work together with the cast and crew to fulfill that vision. It is not enough for a director to have a great film in her or his head; no matter how powerful or original that vision is, it is of little use if that vision cannot be communicated. This task is more complicated—and important—than one might initially think. Therefore, each chapter in this book has four sections, and each section looks at collaboration from a different angle.

The first section provides an overview of what that department does, the key players in that department, and the language and terminology by which that department operates. There will also be a discussion of how that department functions on low-budget films versus high-budget films. For instance, the camera department on a more expensive shoot might employ a dozen people, but this same department, on a much smaller budget, could hire just one or two people. The general responsibilities of the department would largely remain the same, but its operations—and a director's expectations of the department—would be entirely different based on the budget.

The second section of each chapter focuses on one or more directors who have used that department in notably effective ways. For instance, Chapter 10 examines director Kelly Reichardt's moving use of the wardrobe department, and Chapter 8 explores how director Xavier Dolan uses his art department to maximum storytelling effect. These case studies delve into the thought process of prominent directors' successful collaborations with the respective departments.

The third section looks at collaboration from the reverse perspective—that of the department itself. This section will be in the form of an interview with department members, or the department head, about their experiences of working with directors. The interviewees share their experiences of working with directors who are particularly effective collaborators, as well as examples of when collaborations did not work well, and why. It is important that directors hear from the department's side of things about what a director can do, or say, to inspire the best work from a department. The interviews in these sections have been edited and condensed for clarity.

The fourth section concludes each chapter with a set of tasks that directors can use to prepare for their collaboration with each department. The idea is to take the information from each chapter and boil it down to specific actions that will aid the collaborative process.

Stepping back and looking at the bigger picture of collaboration, this book aspires to help directors across a range of directorial styles, genres, and budgets. No two directors, or films, are alike. But there is one thing that all movies share, whether a $100 million superhero movie or a $100 student film: a budget. The budget, it is sometimes said, is the script written in numbers; it is also the document that shows the general organizational structure of the cast and crew. The top sheet of a budget is a one-page summary showing how all the production money will be spent. To look at a top sheet is to see the teams that comprise a film because each line is devoted to a particular department.

For instance, the camera department is written on one line of a budget top sheet, the location department is written on another line, the art department is still another line on a budget, and so forth. The chapters of this book follow a budget top sheet, so that each chapter describes the workflow and responsibilities of a particular department, and explores methods and techniques for how a director can collaborate with that department.

For instance, Chapter 2 of this book begins with one of the first lines of most top sheets: the screenplay. Then, each subsequent chapter will move through another department in the process, from pre-production, to production, to post-production. Techniques and insights, as well as examples and anecdotes, are shown from through each step of making a film, giving the reader the tools to work like a collaborative director.

A director must understand the roles and dynamics of those departments, each of which has its own language—or common terms of usage—and its unique protocols and challenges. Each department has the potential to add another layer of expression to the director's vision. How can the wardrobe or art department, for instance, help to tell the story, or develop a character's backstory? There are a tremendous variety of ideas that departments can offer to the director, to help make a better film, but it is up to the director to find a way to tap into these deep wells of potential and expertise. Collaboration not only makes the best use of the people hired onto the film, but also requires the director to think more deeply about the entire range of their "toolbox"—locations, props, wardrobe, etc.—that will allow them to tell their story well. Even if the crew is made up of a few non-professional crew members helping out the director as a favor, it is still up to the director to understand what everyone's roles are, and how best to work with them to fulfill their particular responsibilities.

2 The director and story department

1. Story department overview

The story department—one of the first lines of a budget top sheet—refers to all things relating to the script: the writer's fee and the cost of the story rights, which includes the script itself and any source materials upon which the script is based. But the story department is different from most film departments because a sole member usually occupies it: the screenwriter (or screenwriters, if there is more than one). Of all the departments, the story department is often the smallest and largely amounts to the director's relationship to the screenwriter.

The majority of the story department's work happens during pre-production—the phase when the script is revised. The writer (the "department head") is in charge of the script, but the director oversees the development of the script—that is, working with the writer to improve the script through a series of rewrites. This process can take months or longer. It is an involved and time-consuming process, and should only begin if the director feels committed to the work. Indeed, after the first read of a script, it is important for the director to ask her or himself, is this story worth being told? The director should feel, deep down, that this story *has* to be told. This feeling is a matter of passion and is often a gut reaction to the material. Does the director love it, despite what work is needed to fix the script? When reading the script, does the heart (and mind) fill with ideas about how to shoot it, how to cast it, what colors and essential themes come to mind? Making movies is hard and requires a significant devotion of time and resources. Naturally, making movies is also a profound thrill and a great privilege, but a director can only maintain her or his excitement if there is a deep love for the material. Truly, no one can answer this "worthiness" question except for the director, and that answer comes from a very pure, raw place in the director's inner creative self.

If the director commits to a script, then the first phase of development is to figure out what changes need to be made to improve the script. The director's initial gut reaction to the material—while essential to gauge the general strength of the script—will not be enough to guide the development process,

because to improve a script, the director will need to identify the problems. Clarity from the director is essential if she or he is to work well with a writer in guiding rewrites. The better the director understands the mechanics of the writer's craft, then the more capable the director will be in talking about the script. But before we get into those mechanics, let us dig a bit deeper into the importance of development.

The unforgiving arithmetic

If it is not on the page, it will not be on the screen. This is a well-worn adage of filmmaking. Few scripts are flawless in their early drafts. It is the job of the director to make sure that the script is as fully developed as possible before filming begins.

Flawed scripts lead to flawed movies, and script problems cannot be fixed in production or post-production. Rushing into production before the script is ready, or ineffectively guiding a screenwriter through the development process, puts the director on the short end of an unforgiving arithmetic: poor direction will make a bad film out of a great script, but great direction can never make a good film out of a bad script. In short, a movie is only as good as the script.

This basic lesson can be forgotten. There is also sometimes a belief that clever casting can fix character problems, or that a vibrant visual style can somehow distract from the deficiencies of the script. None of this is true. Even more at risk are those directors who hope that story pacing and structural issues can be "fixed in post." This is almost never true.

Writing cannot be hurried. It happens at its own pace, which is frequently slower than anyone wants or expects. As the director, try not to rush development. Production is heavily dependent upon tight schedules and even tighter budgets—but not so for script development. The costs of writing amount to little more than coffee to help power through late-night writing sessions. But that does not mean the process should go on too long. There are development horror stories in Hollywood about script rewrites that have gone on for years—long after the relevancy of the story has passed. Other movies have been stuck in development for so long that they even change genres across dozens of drafts. This is also a bad sign. If the director does not have a vision for how to fix a script, then it is time to move on to a different one.

As long as consistent progress is being made on the rewrites, and problems are getting solved, stick with it. Remember the unforgiving arithmetic: the ceiling for how good a movie can be is set by the strength of the script.

The director must know enough about the mechanics of screenwriting to guide the development process; to find cinematic solutions to those problems; to push the script deeper into the territory of plot instead of just story; and finally, to turn the script into a work that the cast, crew, and audience will also agree with the director's initial feeling that this movie *had* to get made.

Basic rules of screenwriting

The director does not need to know every nuance of screenwriting rules, but a director does need to be at least comfortable with the norms of the writing process. The director must be able to speak the writer's language, so the writer knows what the director wants out of the rewrite. Vague notes on a script, and miscommunication over the terminology of writing for the screen, can backfire if the screenwriter is not sure what changes the director wants to make.

First, a disclaimer: there are notable and famous expectations for every rule of writing. It is easy to read the rules and gleefully come up with lists of films that break them. Here are a couple of things to consider: these rules have been working since the beginning of the dramatic form, and if they made sense to Aristotle, who codified the basics of dramatic structure, then, given a chance, they will likely make sense to you, too. Yes, some great films break the rules of screenwriting, but when the rules are broken, they are often broken with an understanding that the thing broken is replaced with another screenwriting tool to make up for it—to apply in the broken spot. Screenwriting rules are not broken willy-nilly; they are broken knowing that now they need to be fixed by a new type of tool.

As has been said many times, you need to know the rules before you can break them. It would be unrealistic to expect the director to learn all of them in a short amount of time; they take years, and even a career, to fully master. The director has many other concerns to deal with (other departments to assemble and manage), so the point in this chapter is to give the director a select, but meaningful, set of concepts and terms that are fundamental to the screenwriter's craft. Remember, the director needs only be conversational in the language of each department, not fluent.

The many rules and norms of screenwriting craft can be boiled down to three main topics: character, dialogue, and structure. If the director can always keep these three things in mind, then she or he should be able to address many of the most significant problems that occur in scripts. At the very least, they will be a starting point for a productive conversation with a screenwriter, to get the screenwriter going in the correct direction. They will also give the director a language to put her or his gut feelings about the script into accurate and meaningful words. These concepts will become the basis for effective collaboration.

Let us look closely at how these concepts work.

Character

A character is only as interesting as her or his problems. If the director is going to look for one thing in assessing the protagonist in a script, it is this. One of the many reasons why the Coen Brothers' films are so effective is that their characters simply have better problems than most movie characters. A folk singer loses someone's cat in New York City and must find the pet

before the owner notices (*Inside Llewyn Davis*, 2013). A hunter who, in the aftermath of a shootout, grabs a satchel of cash is wracked with guilt about a dying man's request for water (*No Country for Old Men*, 2007). A car salesman gets in too deep with a pair of killers after attempting to stage his wife's kidnapping (*Fargo*, 1996).

If your characters (especially your protagonist) have interesting problems, then—quite naturally—they will have to fix those problems., pushing the plot forward. A weak or slow plot can often be fixed by addressing what the character is dealing with in the story. Is their problem specific enough? Interesting enough? Hard enough to solve? Usually, when a character tries to fix her or his problem, the attempt does not go well (or, at least, it should not), because this failed attempt will lead to other problems, which then *also* need to be fixed. The repetition of these sequences—with the stakes increasing at each attempt—will tighten your plot and help the pace.

In the Coen Brothers' movies, the problem-attempt-failure sequence plays out like this: the singer does not find the cat, but finds a different cat and tries to pass it off as the original to its owners; the hunter gets water to the dying man, but then is located by the men whose money he took; and finally, the salesman's father-in-law is killed by the kidnappers.

A protagonist who is trying to fix a problem is usually a more interesting character than one who is passive, or merely reacting to the events of the plot, or observing them. When a character drives the plot forward by trying to solve a problem, this is called a proactive protagonist. This is a term common in screenwriting discussions, and a frequent topic of conversation to have with screenwriters. Most filmmakers know that a protagonist should be proactive, but they do not always know how to achieve that. The simple answer is to give the character a problem to fix.

The specificity of these problems matters. The more literal and actionable the problems, then the more story there is for the writer to use. For instance, in Roman Polanski's *Chinatown* (1974), protagonist Jake Gittes faces many problems, one of which is the existential nature of evil. However, existential evil does not, by itself, make for a plot. And *Chinatown* does not start with this matter. The movie begins with a problem that is more actionable: Jake has been lied to by a woman asking him to investigate her husband's supposed affair, and he needs to figure out who set him up. It is through the course of him attempting to solve this one problem that more problems ensue, and pretty soon this series of problems is what raises the larger issue of the nature of evil.

Another term helpful in this discussion is the sympathetic protagonist. The idea here is that for an audience to root for a character, the audience must like her or him. It is a useful idea, but too often filmmakers take this to mean that a protagonist must be good or moral. Scripts can suffer from efforts to water down the rough edges of a protagonist in an attempt to make them a "good guy." If a character is too "good," and lacks ambiguity or unappealing qualities, then they risk becoming flat and predictable.

A better way to create sympathy for a protagonist is to look, once again, at the problems they are given by the screenwriter. Sympathetic does not mean we have to like the protagonist—we only need to be able to feel for them. A character's problems should be specific to move the plot forward, but there should be a universal quality to the problems as well. If a filmmaker can make an audience feel a character's pain or embarrassment, and if the audience can be led to identify with those emotions, then the protagonist is sympathetic. As a character struggles and suffers to fix the problem, the audience can see itself in the character's struggle. Even if the problem is not the exact thing an audience has experienced, the broader emotions of panic, heartbreak, or worry that a character feels are certainly emotions everyone has felt at some time. Everyone knows what it feels like to do another person wrong (losing the cat), to want to help another person (the dying man), and to worry about money (the salesman). We may not agree with the tactics a character uses to solve that problem, but that discrepancy is what is so interesting: we sympathize with their root motivation (the problem), but find their actions scary, ridiculous, funny, strange, etc. And this dynamic is more entertaining and sympathetic than the character being blandly or generically "good."

Problems, therefore, are one of the essential keys to writing compelling characters. Look at Superman. He can do just about anything: move faster than a speeding bullet and leap tall buildings in a single bound. He is generally invincible. But scripts should not play to a character's strengths. Watching a character who is invincible is interesting for only a brief time. Superman is interesting, as a character, because of the things that make him weak: kryptonite, the loneliness of not being human, the pain of not being able to save everyone he would like to save. It is his problems that make him intriguing. Fixing those problems drives his stories.

Here is an exercise: watch a romantic comedy with a stopwatch in your hand. Add up the amount of the time that the couple spends happy and together versus the amount of time they spend unhappy or searching for love or broken up, and the latter will usually often far outweigh the former. When things go wrong in a script, there is drama and comedy to be mined; when things go right for the characters, then the plot had better go south pretty quickly.

It is important that the problems are not so easily solved. Perhaps the character earns a momentary victory, but solving that problem costs the protagonist a larger price than they expected; or solving the problem creates a new, bigger problem; or the problem cannot be solved with one method so another method must be tried. Scripts work best when characters are moving in and out of states of failure and yet still trying to succeed.

Let us look at this topic in one last perspective: strong problems can also help improve lackluster scenes. If a scene is not working, consider whether the protagonist has a purpose for even being in that scene. If not, consider cutting the scene, or rewriting it in a way that focuses on the protagonist

walking into a scene to fix a problem. A character should usually enter a scene because they want something (for example, to buy flowers for an angry wife), and in the course of them trying to achieve this goal (buying flowers), something happens so that their efforts do not go as expected (perhaps they fall in love with the person selling the flowers). It is through this basic pattern—a character begins a scene with a specific goal, and either fails at that goal or is dissuaded from that goal, and then must begin the next scene with a new problem (telling the angry wife that she has even more reason to be angry now)—that the scenes become more dramatic and motivated.

If a script can do this most of the time (because some scenes are merely texture or tone, or a break from a storyline), then the script has a good chance of being paced well. Pace, proactive and sympathetic characters, story drive, and motivated scenes all stem from, and can mostly be addressed by, this idea of making sure your characters have interesting problems. The director who understands these issues, and can recognize them in a script, will be in a strong position to guide the development process with the story department.

Dialogue

Writing effective dialogue is a challenge for many screenwriters. There is a good reason for this. In movies, dialogue is tasked with two often contradictory goals: to sound natural, and to deliver plot and character information to the audience. In real life, a casual conversation between two friends usually does not include them also summarizing the broader circumstances and backstory of the topic they are discussing. But these are things that a movie audience might need to know about those two friends. So, how can writers deliver both information *and* make the dialogue sound real? There are several general strategies, but before getting into it let us first talk about the purpose of dialogue. As the director, it is important to understand the mechanics and uses of dialogue to be able to spot bad dialogue, and to understand possible solutions to fix it.

At its most fundamental level, dialogue can explain what is going on in the story—who the characters are, how they are related to each other, and what they are trying to do. Dialogue can also convey the internal feelings and fears of characters, or suggest the subtext and themes of the movie. Dialogue can make the audience laugh or cry or be shocked, or it can add texture and flow to a scene. But mostly, dialogue, just like in actual conversations, helps to create emotional connections—person-to-person in real life, or, in the case of a movie, audience-to-character.

That is a lot to achieve. One of the more common dialogue mistakes occurs when writers rely too heavily on dialogue to explain what is happening in the movie. This mistake is called expositional dialogue and is most noticeable when characters slip into a pattern of explaining the plot to each

other—just for the sake of the audience understanding. There are plenty of examples of expositional dialogue in film and television, and this type of writing tends to pull the audience out of the story. When the scene becomes about merely relaying information to the audience, then the scene will cease to be dramatic, or funny, or whatever the screenwriter's intentions were.

The question for the screenwriter (and for the director reading the script and having to make note of bad or expositional dialogue) is how to convey information about the movie while also making the dialogue feel natural. There are many ways to do this.

One solution is to remember that movies are, essentially, a visual medium, and the camera has a great deal of storytelling power. If there is ever a line of dialogue that can be replaced by a shot or a bit of physical action in the scene that will convey the same information, then remove the dialogue and let the visual explain what is happening. For instance, instead of a character saying they are sad, it is usually better to perhaps see them trying to hide their tears from another character. Allowing an actor to express an emotion with their eyes, or their physical actions—as opposed to their words—makes for a more cinematic and nuanced scene.

A common screenwriting exercise is for a writer to run a scene through their head over and over without any dialogue. The point is to focus on what the characters are doing in the scene—how they enter it, how they leave, the mood and pace of the scene—and only once the physical shape of the scene takes shape will the writer attempt to put words in a character's mouth.

Of course, the eyes of an actor can only convey so much. Eventually, information will have to be spoken. If the screenwriter needs to explain that a character was out of town for a long time, the dialogue could be helpful. But the way this information is expressed will make or break the scene.

For instance, in the powerful, quiet Kenneth Lonergan drama *You Can Count on Me* (2000), a brother and sister reunite in a café after having been estranged. As the sister asks questions about her brother's whereabouts over the last months, every answer he gives raises additional questions that do not get answered. We learn that he was in Florida, but the brief mention of a stint in jail raises a number of questions (barely answered in the scene) about his months in Florida. Then, when he asks her for money, the scene only coyly suggests what he needs the money for, leaving the audience wondering, guessing, and generally feeling intrigued about this mysterious, troubled young man. The scene concludes with the audience understanding the basics of his backstory, but for every answer he gives, he raises several more questions that do not get answered. We leave the scene feeling more curious about this character than at the start.

From this example, we can surmise that often the job of dialogue is not to tell the audience what is going on, but rather to make the audience wonder what will happen next. This is drama at work. Dialogue is at its best when setting up for future scenes while leaving the audience in a position of being

surprised or intrigued. It is useful for the director to review the dialogue with these elements in mind, and to talk with the writer about looking at the dialogue through this lens as well.

Another solution to tell information without seeming obvious occurs in a scene from Quentin Tarantino's *Pulp Fiction* (1994). In the famous "Royale with Cheese" scene, two henchmen are driving to retrieve a stolen suitcase. The important information that needs to be conveyed to the audience is that the henchmen, Vincent and Jules, are old friends, and Vincent was out of the country for a long time before returning to California. The way that screenwriter/director Quentin Tarantino delivers this information is through a seemingly digressive conversation about fast-food options in Amsterdam. As Vincent talks about the difference between McDonald's and Burger King menus in America versus Europe, we get the information we need: Vincent has been traveling abroad for a long time. The way he regales his story to Jules so casually suggests that they are old friends. No one needs to say anything heavy-handed such as, "You were gone for a long time, huh?" or, "You're finally back in town." The dialogue in *Pulp Fiction* is clever and hardly feels like information. The audience learns what it needs to know while laughing the whole time.

Additionally, just as important as what the characters say is how they say it. The sound and rhythm of the dialogue can give scenes shape and texture. By limiting how much is said in a scene, a screenwriter can create a tone of intrigue or danger, or romance and intimacy. Go the other way, and have characters talking over one another, and a scene can feel intense or over the top. By paying attention to how a character sounds, we can learn a lot about that character. Is the character shy and awkward and speaking little, or attempting (as is the case in the scene from *You Can Count on Me*) to speak in an overly formal way to sound smarter than they are. In real life, people can hide their intentions by carefully choosing their words—but it is how they talk that is more revealing about what is going on in their heads.

To this point, another way to make dialogue sound more interesting is to play with the truth. When characters speak with honesty to one another and explain their feelings with sober accuracy, the dialogue can tend to feel on the nose or expositional. By finding ways that a character can lie, or be less honest (with themselves or with another character), or be confused or unsure about an event in the story, a scene can start to come to life. A common screenwriting technique is to have characters not answer questions when asked—to offer a different response than the first character expects. However, if it is important that a character be honest in a scene, to perhaps make a big, sincere speech to move the audience, then it is best to couch such honesty in a moment of stress or an argument. An argument is a great time to allow a character to dig down and speak honestly. It just feels better on the page and sounds better coming from the mouths of actors.

Making dialogue work well takes a lot of practice. The director should read as many scripts as possible (just as important as seeing many movies) to

get a feel for when dialogue is working and when it is not. Does the dialogue feel forced or expository? Are the characters in the scene listening to each other, or just talking for the sake of information? If they are only talking, then take the scene one line of dialogue at a time: if a character says something, then put yourself in the mindset (and emotional state) of the other character, and try to think of what they would actually say as a response. Do not worry about the information in the scene, or what the writer wants the scene to be. Do not try to force the scene to be funny or dramatic. Listen to the characters. Let them respond honestly to what the other characters are saying and doing. Refrain from ambitious dialogue, or poetic dialogue, or dialogue that sounds like characters from other movies. Keep the dialogue honest and true, and it will start sounding much better.

Before leaving the topic, let us address a common question about dialogue: how to deal with improvisation in a script. Many directors like the technique of improvisation (allowing the actors to go off script while filming a scene) because it can be a great way to inspire raw or unexpected performances for a scene that might otherwise feel stiff or predictable. Often directors will wonder if a scene needs to have the dialogue written if they plan on the actors improvising a scene.

The quick answer is yes, dialogue should still be written. It can be risky not to have any dialogue on the page, and it is often irresponsible to hope that when everyone arrives on set, the dialogue will suddenly, magically start to flow. Sometimes the dialogue does not flow. If inspiration does not hit at that moment, or on that day of shooting, then the director will not get the scene. If a director goes into the shoot with the dialogue written, then the actors have a starting point for the improvisation to begin. After shooting the scene with the written dialogue, the director will at least have the scene finished. Then, if a director and the actors want to open the scene up to improvisation, they can feel free to take dramatic risks because everyone knows that the scene is complete. The improvisation will only improve what has already been done. Shooting the dialogue can sometimes serve as a good warm-up, and once everyone has spent a bit of time easing into the circumstances of the scene, they can feel a bit looser and more comfortable to dig in and try something new.

Structure

A script without structure can feel aimless and confusing—regardless of how strong the characters are or how tight the dialogue is. Structure is the framework upon which a plot is built. Structure allows for the script's many narrative bits and pieces to be organized and told in a way that is comprehensible, suspenseful, or dramatic. Some writers mistake structure for formula, but these are two different concepts. Formula, which is to be avoided, suggests writing that follows a pattern of clichéd and predictable plot turns. Structure, on the other hand, does not inherently make stories predictable—it allows writers to be more creative in

their storytelling choices because they have a tried-and-true way to assemble the plot. If the structure is taken care of, then surprises can be written into the details of the script.

There are many different structural models available to a screenwriter, but from college film classes to Hollywood development meetings, the three-act structure—and its component parts—is the most widely used. Not everyone is a fan of this model (more on this later), but it is essential for directors to have a grasp of it because discussing the three acts can be a helpful way to work with the screenwriter.

Generally speaking, in the three-act structure, act one takes up the first quarter of the script, act two takes up the middle half of the script, and act three takes up the final quarter of the script.

Act one is where the central elements of the story get introduced: we meet the protagonist, glimpse the world that they live in, are introduced to a problem in their life, and learn what the goal is to fix that problem. Act one can best be compared to a zip file that gets downloaded onto a computer, because this is a lot of information packed into just 20 or 25 pages. Quite often, the protagonist will not want to complete the goal—it may be hard, or unpleasant, or the problem is something that the protagonist would rather avoid than fix. This is called a reluctant protagonist. The end of act one is concluded by what is commonly referred to as the turning point—some event happens that forces the protagonist into taking action. Circumstances have grown dire, and the problem that they are supposed to fix will now have to be dealt with head-on.

Act two is, broadly speaking, what happens when the zip file gets unpacked: all the little pieces of act one are given breathing room and allowed to be expanded and fleshed out. Act two is defined by the protagonist facing the obstacle, or obstacles, that prevent her or him from attaining their goal. Act two is often broken down into two sections—part A and part B—with each section defined by a run-in with the obstacle. The part A obstacle is often a mere taste of the challenges that the protagonist will face in trying to achieve their goal. The Part B obstacle is often a far more intense run-in that will leave the protagonist battered, bruised, embarrassed, or otherwise at the brink of failure. In fact, the end of act two is marked by a structural component called the big gloom, where the protagonist appears to have been defeated, or the original goal has been rendered moot. A new idea about how to attain the goal, or a reorientation of the goal, is needed to bring the story into act three.

Act three is marked by the protagonist once again asserting themselves. They will confront the obstacle a final time, but now with a new knowledge bequeathed to them, before either succeeding or losing (but most often succeeding) in achieving their goal. Along the way, the protagonist's act one goal may have shifted from something slightly self-centered to a new goal that is more giving and altruistic.

This is, in a nutshell, the three-act structure. This model is a key tool for directors to gauge the structure of the writer's story. For instance, if the script

does not explain the goal of the character until midway through the movie, the three-act structure makes clear that this central goal should be established in the first act. Or, if the protagonist has things too easy in the latter part of the script, without enough drama, looking at the big gloom is a good way to challenge and break the protagonist, before building them back up in act three.

Some writers like to align their stories close to the three-act structure. Other writers will perhaps use this model as a reference point, but generally stay away from it, because they find the three-act concept to be creatively stifling. As the director, it is important to know how the writer likes to work and to respect their creative process. Writers and directors looking to explore other structural tools can find many different options: four-act structures, five-act structures, and others.

Another option is a tool that I developed called GoFaSt. This acronym stands for goals, failures, stakes. My idea here is that a screenplay does not always need to be organized by the three acts; sometimes scripts can be organized into smaller cycles of narrative. The size of these cycles varies, but often clocks in at around 20 or 25 pages for a feature-length script. Each of these narrative cycles begins with a protagonist's goal and leads to a failure to attain that goal (or, as we discussed previously, success at achieving it, but the victory comes at a higher price than expected). The failure subsequently shifts stakes for the protagonist; the stakes become more significant, personal, or somehow more acute for the protagonist. In some circumstances, the protagonist does not fail in their goal, but their success comes at a higher price than was originally expected, and that high price will lead to even bigger problems. GoFaSt is a useful way to break the script into smaller pieces and focus more on the immediate dramatic needs of a sequence of scenes.

The 1973 crime movie *Badlands*, written and directed by Terrence Malick, provides an example for how GoFaSt works. *Badlands* tells the story of Kit (Martin Sheen), a 25-year-old drifter who falls in love with Holly (Sissy Spacek), a teenager living a dull and insular life with her father. Kit hopes to become a criminal, if only for the excitement, and he takes Holly along with him on a killing spree across the Dakotas and Montana.

It is up for debate as to whether Holly or Kit is the protagonist. Both are featured in nearly every scene of the movie. Holly's voice-over makes the audience connect closer with her character, which may shift the protagonist role toward her. However, Kit likely fits the description of protagonist slightly better because it is his choices that ultimately steer the plot.

According to the GoFaSt model, there are four cycles in *Badlands*. The first cycle begins with Kit's goal to win over Holly. Even though he does successfully woo her, he pays a high price for this success: Kit must murder her father in order to be with her. As a consequence, the stakes build: they are in love, but now wanted for murder.

Kit's goal in the second cycle is to take Holly far away from her hometown and find a place for them to live in isolation from the world. Together

they set up a rustic home in the woods. But he fails in maintaining this isolation after being spotted by a local man, and when three armed men enter the encampment, Kit is forced to kill them all. Now the stakes heading into the third cycle are higher. After Kit killed Holly's father, she offered to tell the police a story that might exonerate Kit. He also stated in a confession that he murdered her father only after being provoked. The crime put Kit and Holly in jeopardy, but it was a jeopardy that they might be able to talk their way out of. However, after he kills three more men (another man soon after, and then possibly an additional couple), it is clear that Kit has no chance of exoneration. Now the whole Midwest is on high alert and the National Guard is after him.

In the third narrative cycle, Kit's new goal is to find supplies for them to survive while they are on the run. He finds those supplies as well as a Cadillac, but he fails to provide for Holly beyond what these limited provisions provide. They wind up living, as Holly states, like animals—barely scraping by. Now the stakes shift and become more personal: along with the legal trouble that Kit is in, Holly has now become disillusioned with him. Day-to-day living without a bed and consistent meals is hard on her, and she falls out of love with him, declaring that she no longer wants to be with a man as troublesome as he.

The fourth cycle provides the last goal for Kit: he wants to get to the mountains of Saskatchewan in Canada. Leaving America is his only hope to escape law enforcement. But he fails at this goal when—short of the Canadian border—he stops to get gasoline and spots a police helicopter flying toward him. He knows this is the end of the road for his escape. Holly declares that she is splitting up from Kit, and he runs away alone, only to be caught by the police. The movie ends by explaining that he is eventually executed for his crimes.

Naturally, different screenwriting models can be used to break down *Badlands*, or any script, but GoFaSt is a useful tool for articulating the sequence of micro-goals that drive the larger narrative. Keep in mind that no model fits all scripts perfectly. The goal of a successful model is to keep the script on the right track, while giving room for each film to have its own nuances that will deviate, to a degree, from what the models describe. Whether a writer is using, for instance, the three-act structure or GoFaSt, script models are mere signposts along the path of writing, allowing for flexibility while also pointing the story in the correct direction.

Budgetary differences

Depending on the budget of a film, the development process with the story department will be different. The most significant difference is that with larger-budgeted movies, there will be additional voices involved in the development process. It will not just be the director reading drafts of the script and giving notes, but also executives on the film and an

assortment of producers. The essential work of the director guiding the direction of new drafts remains unchanged, and the story fundamentals of character, dialogue, and structure are the same—after all, the foundations of good storytelling are unchanged regardless of how much money is being spent. But the writer may be getting more sets of notes than just from the director.

Also, development schedules on bigger-budgeted movies tend to be tighter because screenwriters will often have other writing jobs lined up, and marketing and distribution executives may have plans to release the film at a certain time of year. However, remember to, as much as possible, let the development process happen naturally. It is hard to rush good writing. It is also quite common for certain problems to take more than one draft to fix. Writing is hard, and the more the director respects the writer's process, the more confident and capable the writer can feel to do their best work. Each draft may only partially fix a problem, requiring another draft to dig deeper into the solution. Sometimes fixing a problem will uncover—or create—another problem in a different part of the script. For instance, if the director would like to see more development of a character, and the writer adds lines or entire scenes to achieve it, this may slow down the pace of the story. Finding the correct balance between all the elements of the script takes time to improve, but draft after draft after draft, pulling back on one element, or pushing harder on another element, until everything seems to be working, is a common scenario for how the director will work with the writer. The process requires patience and fortitude.

2. Director case study

Everyone reads a script differently. A producer will read a script with the budget in mind. How many locations are in the script? Are special effects needed? Are there expensive stunts or action sequences? A set designer will read a script with an eye toward how the movie will look. Is the mood dreary and dark or bright and happy? What colors could be used for the location?

But how does the director read a script? What is the director's role in regard to the story department? It is up to the director to work with the writer to ensure that the script has strong mechanics (as previously discussed in this chapter), but the director must also find solutions to take the scenes on the page and find ways to make them feel more visual.

Let us examine this process by using a case study of director Alejandro Iñárritu. In 2006, Iñárritu directed *Babel*, written by Guillermo Arriaga (based on an idea by both Arriaga and Iñárritu). The film stars Brad Pitt, Cate Blanchett, Adriana Barraza, and Koji Yakusho, and tells the story of how a single rifle profoundly affects the lives of characters from Los Angeles to Morocco to Tokyo. The script is audacious in scope, searingly well-paced, and gut-punch dramatic. It is also a beautifully visual film. Iñárritu has a wonderful

approach to the script, and his guiding hand in the development process is evident when comparing the evolution of an early draft of the script to the finished film.

Let us look at two examples.

As described in the first scenes of Arriaga's script of *Babel* (the April 9, 2005 draft), a middle-aged man named Hassan, carrying a bundle wrapped in cloth, arrives at an adobe house in Morocco. He is let in by Abdullah, the father of the household. Arriaga describes the home life of this family in an evocative way: we read that Abdullah's wife is roasting goat with her daughters, while two sons look at the contents of the bundle: a rifle. The two men sit down and trade for the rifle.

Arriaga writes a strong scene. It is full of good "business"—that is, action that the characters can be doing in a scene, and it conveys a glimpse into the world of this family living in poverty in a very desolate area.

So, what does the director do with a scene such as this? The director must be sure that the character, dialogue, and structural mechanics in the script are all sound. But part of the development process is to also make the script as visual and cinematic as possible. How does Iñárritu do this with such a simple scene? Iñárritu deletes the "businesses" (roasting of the goat, the boys looking at the rifle), and essentializes the action to this: Hassan and Abdullah sit in the center of the house while the family members watch from the edges of the room. The business, while interesting, was perhaps not telling enough of who this family is. To stage the scene with the dad in the center and everyone watching from the edges, Iñárritu makes clear that in this family, the father runs the family. No words need to be spoken to convey this power dynamic—Iñárritu has created a visual representation of it. But why? Is showing the father being in charge a better version of this scene than showing the mother roasting a goat? Later in the movie, the boys will defy their father by acting irresponsibly with the rifle—and setting off a long chain of events that will define the plot of the movie. The boys' action is made more dramatic for their defiance, which Iñárritu sets up in this early scene in the house.

Furthermore, by removing the "business," Iñárritu allows Hassan to hold center stage on camera as he dramatically unwraps the rifle. This change is more visually dynamic than having the bundle already unwrapped off screen.

But what of Arriaga's other descriptions to show the poverty of the household? We get that in Iñárritu's direction when Hassan knocks on the corrugated metal door of the house, and we get this by the simple room where they live. The poverty is evident, as is the desolation, with Hassan's long walk through the mountains to reach the house—also an addition that Iñárritu made to the script.

In this example, the director's approach to the story department is at work. The writer delivers a strong draft (the development of which the director has overseen), and then the director continues to work on the scenes to make them more visual and cinematic.

Let us look at another example. Just a few scenes later, the script cuts to a well-to-do house in Los Angeles. We meet two children, Debbie and Mike, whose parents are currently on a trip to Morocco. It is there in Morocco where a bullet from Hassan's rifle will change everyone's lives, including that of the children's loving nanny, Amelia.

Arriaga writes a strong scene that allows us to get to know the characters, while also introducing some important plot elements. The scene opens with Debbie and Mike playing Monopoly with Amelia. The phone rings and it is the children's father, who is hiding how upset he is by an accident that has just occurred in Morocco.

Once again, Iñárritu brings a directorial perspective to develop the scene into something more visual. Iñárritu replaces Monopoly with a game of hide-and-seek. We see the kids tucked behind furniture, then dashing across a living room to avoid being spotted. Why this change from a board game to hide-and-seek? One answer is that it is more visual. We still get Arriaga's scene of playfulness, in which he showcases Amelia's loving role in entertaining the kids. But Iñárritu brings in the idea of a more visual version of this scene. Instead of relegating himself to shooting three characters sitting around a board game (which is not bad), he opens up an opportunity for interesting camera angles and plenty of movement in the frame.

There is another change that Iñárritu brings to the scene. In Arriaga's script, we do not hear Mike's father's voice on the phone call. We only see, and hear, Mike talking on the phone. At one point in the conversation, Mike asks his father if he is okay. The importance of this line is to show that the father is hiding tragic information from his son. But Iñárritu introduces a new element to the scene: he lets us hear the father's voice on the other end of the call. The audience can directly hear the father's strain and feel his pain. This lets the audience know that the father is working to cover the bad news for the sake of his son. The scene becomes more emotional.

None of these changes from the earlier draft by Arriaga, to Iñárritu's work in developing the scenes, are monumental. These are subtle changes, but they have an impact. According to director Clint Eastwood, it is paramount for a director to trust the screenwriter. He is right. Unless the script is way off base, and has significant problems, the director's role in developing the script is to improve what is on the page, and to find ways to take the writer's work and turn those words on the page into compelling images on screen.

3. Interview with screenwriter Bragi F. Schut

Bragi F. Schut has been a successful writer in Hollywood, for both film and television, for over a decade. His screenwriting credits include *Season of the Witch* (2011, starring Nicholas Cage and Ron Perlman), the upcoming thriller *Inversion* (starring Samuel L. Jackson), and ABC network television series *Threshold* (2005).

In this interview, Bragi discusses his working relationships with directors.

TAKOUDES: I want to talk about directors working with writers, and what that relationship looks like when the director is doing a good job of communicating with the writer.

SCHUT: I feel like the good relationships between a writer and director are when the director continues to use the writer as a resource, and continues to try to understand what the writer's intent was. On *Escape Room* (2019), [director] Adam Robitel was wonderful and he was very cool and he would call me occasionally and say, "What were you thinking about such-and-such a plot beat?" Or he'd ask, "Tell me who this character is." And then we would talk about it.

TAKOUDES: What's a director looking to tap into with a conversation like that?

SCHUT: Well, there's a lot of work that the writer has done before the director ever comes on. And in the case of original material, I would say that the writer is doubly important to the director because the genesis of the idea, the very core of the story, was created by the writer. So, what better source is there than that original wellspring?

TAKOUDES: Does this conversation ever change your own vision for your original material?

SCHUT: Definitely. The director is a fresh set of eyes on the material. When I wrote the first draft of *Escape Room*, I thought I had written the most thrilling obstacles for my characters. But when Adam sat down with the cinematographer and really started to think about, you know, how do we make these set pieces even scarier and even more thrilling, well … they have a lot of experience. Adam's directed three or four very successful horror films. Marc Spicer, the cinematographer, has shot some of the biggest movies out there. He's done several *Fast and Furious* movies. So, they know how to really blow people away with these wonderful visuals. They come up with all these ideas that change the script for the better. I always try to take a good note from wherever it comes. And in terms of working with a writer, I think a good director is the same.

TAKOUDES: I've found that different departments read scripts differently. They all view the material through the particular lens of their craft. For instance, actors often give great notes on making characters richer and deeper, because that's where an actor's head usually is—character. How do directors read your scripts, and what do they bring to the material that's unique?

SCHUT: I think a good director has to be a bit of a Renaissance man. They have to be a jack of all trades. A good director has to be very visual, but a good director has to be a little bit of an editor, and realize what pieces of film they need to cut this film together. A good director has to be a bit of an actor. In the case of Adam, because he was trained as an actor before he segued into directing, he knows how to get a good performance. He knows how to speak to actors. He knows that language. Dominic Sena [*Gone in Sixty Seconds*] was a music video and commercial director for years, and so he knows where to put a camera, and how to create a world, and how to make it look incredible. David Goyer [*Man of Steel*] is a director, but he's first and foremost a screenwriter, so he knows story. He

knows how to surprise people. One of the rules that I stole from David was that he said in every script, he tries to imagine three or four things that an audience doesn't think you could possibly do. Places that you cannot possibly go with the story. So, for example, in *Batman Begins*, that's how they came up with the idea of burning down Wayne Manor.

TAKOUDES: That's very clever.

SCHUT: Listen, every director brings a bag of tricks. And I think a director has to have three or four bags in different fields. They have to have the actor bag. And they have to have the cinematographer bag. They have to have the ability to visualize it. And if they can synergize all of that, then I think you have a really strong director.

TAKOUDES: It's interesting that you learn from a director about your own craft. Your own department.

SCHUT: I remember reading about how Steven Spielberg spent the first 10 years of his career going from department to department and learning everything he could about every single aspect of the crew. He worked as a lighting tech in the theater at his school. He was literally the guy in the rafters controlling the lights. And he learned about lenses and fresnels and how to light things, and then he switched to the sound department. He learned how to operate the sound mixer.

TAKOUDES: He made himself into a jack of all trades.

SCHUT: Yes. Now the director doesn't have to be the best at any of them, but he has to know about all of them. I remember working in the model shop on *Titanic*, and James Cameron is walking down the line looking at all of us hacking away at these little styrofoam chunks—we were trying to sculpt miniature icebergs. And Cameron actually stops at my iceberg, and he looks at me and he says, "No, no, no. It's got to look like this." And he takes the tool out of my hand, and he starts hacking at it, and I was shocked to see that it looked great. And I remember thinking, how can that be possible? How can he also be a sculptor? I did a little digging and learned that for many years, he worked in a model shop for [cult director] Roger Corman.

TAKOUDES: So, the collaboration goes both ways. The director learning from the departments, and the departments learning from the director.

SCHUT: I think there's a misconception that directors are this sort of dictatorial job, that they're these generals who tell everyone what to do. My experiences have been the opposite. The best directors are the ones who listen and take ideas, and they're filters. They take the best ideas. They have their own ideas, too. But they're not the dictators. Their word is final on set. But they look at the departments as resources. And for the script, the writer can be one of the director's best resources. If the director is open to that process and they involve the writer, then what better ally could there be? If the director is collaborative like that, I think it'll turn out most times better than if the relationship isn't so collaborative.

TAKOUDES: The editor and sound designer Walter Murch has talked about the director as being the immune system of the film set. That the director's

main responsibility is to hear all the ideas from the departments, sweep away the bad ideas, and implement the good ones.

SCHUT: That's so great. What I would add to that, though, is that the director also generates a lot of ideas themselves. And possibly more than anyone else. But it can't come all from the director. There's no way. It takes a lot of people. And so, to silence any one of those voices is unfortunate. The director needs as many ideas as they can get. And if, for instance, the writer's voice has been marginalized or silenced, then the director is just limiting their choices about what the movie can be. They're removing someone who should be one of the creators of the process.

TAKOUDES: Getting back to the writing process, what do you feel are the best types of notes that a director can give a writer?

SCHUT: I've found that when there's a note, if the director tells me how to fix it, then all I am is a typist. And as the writer, you're blindly trusting that the director knows the best way to fix the script problem. And maybe they do. Maybe the solution is great. So, I'm not opposed to the director suggesting a specific fix. But I think that the best notes are open-ended. The director's notes come from a place that's completely valid. They're bumping against something in the script. But I don't necessarily think that a director dictating the fix is the best way, because then the director is limiting potential solutions. They're cutting out all possible solutions except for the one that's been dictated. And that's okay if that's the best solution, but who knows? The writer could have come up with something that's better.

TAKOUDES: I was recently in a color-correct session for a film, and we wanted a bit more color in the actors' faces. But the most obvious fix to me— bringing up the magenta—wasn't necessarily the correct fix. The solution might be to bring down the other colors, or to adjust the contrast, but regardless it's best for the director to say something isn't working, and to be specific, but to not shut the door on the department using their own creativity.

SCHUT: That's right.

TAKOUDES: What if you don't like the director's notes?

SCHUT: Well, if you think you might be a prickly writer, and you just want to create your own thing, and not get notes and not be told to rewrite it, then you probably should be a novelist and not a screenwriter. You're going to go insane. Notes are going to come your way. And it's nice that, where I am in my career now, there's more trust in me than when I started. But I still get notes, and I know that the note has to be addressed. But I have to come up with my own solution for it.

TAKOUDES: Many people see directors as a type of godhead, where they don't need anyone's help.

SCHUT: Yeah. And there might be a select few directors who don't need it. It's possible. Maybe like the Stanley Kubricks or James Camerons of the world. But for 99 percent of the directors out there, you want the product

to be as good as it can be. If the director is collaborative, I think it'll turn out most times better than if the director isn't so collaborative.

4. Tasks for the director

Directors have an enormous amount of responsibilities when making a movie, so whenever possible, it is a good idea to keep notes. For the director who is involved in the development process, here is a checklist of tasks and questions to keep in mind when working with the story department.

The next chapter in the book concerns the camera department. Given the adage that "form follows function," it is important to have the script in proper shape prior to the next stage of collaboration, so that the visual strategy of the film builds upon the narrative as it is written on the page.

1. Print out the script. Development meetings can happen over the phone, via email, or on video calls, but whenever possible a meeting in real life is the best option. To have a printed script, where notes and ideas can be written in the margins, and pages can be dog-eared for reference, is a helpful tool.
2. The director should read the script without stopping to get a sense of the pace and flow of the entire story. Make notes in the margins whenever bumping up against something that does not work for character, dialogue, or structure. If the director has a solution, write it down on a separate piece of paper. Also, write in the margins all the times when the script is working well. Writers need encouragement, and it can be intimidating for a writer to hear only the problems in the script.
3. The director and writer should sit down to discuss the notes. The director will not necessarily want to lead the conversation with her or his solutions, but instead see what the writer comes up with first, and then offer ideas if there are no better ideas on the table.
4. For each scene, the director should write down one or two visual shots that will help convey the information, or feeling, of the scene in a cinematic way. Not every scene will necessarily inspire an idea, but if no good ideas are coming to mind, perhaps the script needs to be written more visually. The director should sit down with the writer and discuss this specific question: how to make the scenes more visually dynamic.
5. Continue this process for additional drafts. Developing a script often takes many rewrites, and requires patience.

3 The director and camera department

1. Camera department overview

The cinematographer, who is sometimes referred to as the director of photography, or DP, is the head of the camera department and responsible for the enormous task of creating the look of the film. Does a film feel dark and moody, or bright and colorful? Is it gritty and unnerving, or elegant and warm? The director decides what this look should be, but it is the cinematographer who figures out—both technically and creatively—how to get that look on camera. Through the use of lighting, lenses, camera choices, and other equipment, the cinematographer will find a way to visually bring to life the movie that the director sees in her or his head.

Let us look at budgetary matters as they relate to camera department, to give the director a better understanding of the cinematographer's work, and then delve into creative and process-oriented topics.

Budgetary differences

The size and makeup of the camera department can vary significantly based on the budget of a movie. At the lowest budget, the entire camera department might be solely comprised of the cinematographer—she or he alone will usually operate the camera and set up the lights, if any are used. Paper lanterns are a useful and common tool in this case, providing diffuse light across the set and minimizing unwanted shadows. Or, the cinematographer might use existing—or practical—lights that are already in a room and merely replace the bulbs for ones that are brighter, less bright, or have a different color temperature.

Shooting solely with the available light of the sun is a common choice for low-budget films, but this is also a choice that can be made on any budget. For instance, Emmanuel Lubezki, the cinematographer for $135 million film *The Revenant* (2015), used almost entirely natural light for aesthetic reasons—to make the audience feel more immersed in the story's wilderness setting. Alternatively, on the Danish film *The Celebration* (1998), cinematographer Anthony Dod Mantle set forth to use only natural light in adherence with

the principles of the Dogma 95 movement, which believed that artificial lights created a less pure cinema.

Sometimes using natural light is a choice, but other times, on a very tight budget, natural light is used out of necessity. If all that the film can afford is a camera with no lights, then the director will shoot with only the camera. In the hands of a talented cinematographer, this can yield fantastic results. But one of the challenges of natural light is that the quality and look of the sunlight varies dramatically depending on weather conditions and time of day.

For instance, shooting around noon on a cloudless day, when the sun is overhead, can create harsh, unappealing shadows on an actor's face. In those conditions, the shadows might drip down from the nose and give the actor dark circles under her or his eyes. Overcast days can give relatively stable and diffuse light, but can also sometimes look flat. Sunrise and sunset provide wonderful opportunities for shooting, when the light is full of rich colors and flattering shadows. This time of day, called golden hour, is much prized among many directors—notably Terrence Malick, who shot much of his lyrical masterpiece *Days of Heaven* (1978) during golden hour—and can turn a dreary location into a wondrous spectacle. Unfortunately, golden hour—despite its name—usually lasts less than an hour (depending on the latitude and time of year), and the light changes incredibly fast. From one minute to the next, the light will shift colors, brightness, and shadows. These conditions can make editing for continuity extremely difficult, especially when shooting multiple angles for coverage. There is not a lot that a low-budget filmmaker can do to remedy this situation, other than to be aware of the light, move fast, and shoot longer takes that will require less editing.

On a larger budgeted film, the camera department will look quite different and offer the director far more control in the look and consistency of the film. The director hires the cinematographer, and the cinematographer hires all the other positions in the camera department. Some of the more common positions are grips, who build and maintain the equipment relating to the camera, such as the tripod, mounts, dollies, and other support equipment; and gaffers, who are responsible for building the lighting design. The cinematographer will sometimes handle the camera and shoot themselves, but other times they will have a camera operator do this job. The cinematographer will likely have a first assistant cameraperson, who is responsible for maintaining lenses and the camera, as well as controlling camera focus.

The camera department might also have dolly grips, who push and pull dollies, a second assistant cameraperson, and camera production assistants. There is likely going to be a digital imaging technician, or DIT, if the film is shot digitally. This person will be responsible for the workflow of downloading camera cards onto drives, ensuring that the footage is formatted correctly, and sometimes doing a quick color-correct on set, to get a better sense of the visuals that have been captured. If film cameras are used, there is a loader responsible for putting the film into, and taking it out of, the camera. If

drones are on set, there will also have to be a drone operator, as well as any support staff for the drone.

The budget of a movie has dramatic implications for the size and operations of the camera department, but the relationship between the director and cinematographer remains one of the closest and most vital to the smooth running of a set. Let us look at the creative and process-oriented aspects of this relationship.

Conceiving a visual strategy

Developing a visual strategy for a film begins with the director. There are, broadly speaking, two central goals that a director has when it comes to developing a visual strategy: figuring out how the shots will express the action of the scene most efficiently, and how the shots will convey the emotions of the scene.

Showing the action is important so that the audience understands, fundamentally, what is happening in a scene. It is up to the director to indicate where the audience should look in a scene—where to pay attention. Which character is the audience supposed to be following? If the film introduces the protagonist during a party scene, the director will need to use the camera to tell the audience that this one character—in a crowd of dozens—is the one to follow. Regarding the emotion question, the camera is a powerful storytelling tool, but it presents a challenge: if the camera can only film external actions, how does a director create shots that express the internal life of the characters? Emotions and feelings cannot, in and of themselves, be filmed. In the earliest days of cinema, once the basic grammar of film shots was established (where directors realized they had options of shooting with the camera close to the actor, or far away), filmmakers were confronted with the task of using these shots to express the internal emotions of characters. Cinematic storytelling would remain relatively archaic until this innovation was achieved. In various countries, unique cinematic techniques were used to answer this question. For instance, in Russia, the constructivist editing style—where jarring and quickly paced edits of shots were placed together in dynamic sequences—was meant to express the inner turmoil of a character; in France, an impressionist cinema developed that used superimpositions and filtered, softened images to express characters' emotions.

Throughout the history of cinema, filmmakers have been tackling this question by finding their own solutions to this problem. Mise en scène, which refers to the composition of the shot and how the actors or sets are arranged within the shot, and camera and character blocking, are tools that can help to convey emotion and perspective. (There are examples of this in the following section that examines visual strategies of Paul Thomas Anderson.) No one shot conveys a specific emotion (there is no way to frame a "sad" close-up versus a "happy" close-up), but it is through the creation of a specific visual approach that directors can create the emotion of the scene.

Sometimes directors assume that the cinematographer will pick the shots of the film. Indeed, this does happen, but choosing the visual strategy of the film is one of the most important tasks for a director, and to neglect it is to assign, at a very early part of the process, creative control over to other people on the crew. Collaboration does not mean ceding control of the film to other departments; rather, collaboration requires leadership from the director, combined with a willingness to listen and pay respectful attention to ideas coming from others. In terms of working with the camera department, every director–cinematographer relationship is different, but a good general approach is for the director to create a shot list for the film and then review it, shot by shot, with the cinematographer. The director does not need to have every detail of the visual strategy figured out, but the director should have done enough work that the cinematographer is clear about the intentions of the director. Through a series of conversations in pre-production, the cinematographer will lend ideas that will likely improve the director's initial thoughts and plans.

The director and cinematographer will discuss the overall look and feel of the movie, and very likely watch movies together to get a sense of what visual references will be used. Will the film have the slow precision of a Todd Haynes film, or the frenetic vibrancy of a Safdie Brothers film? Will the camera mainly stay away from the subjects, or be so close that the faces are spilling out across the screen? The director should be choosing certain shots not just because those shots look good; rather, the director should consider how these shots—or this visual strategy—best tells the story.

For instance, if a character is described in the script as standing alone at a school dance while sipping a drink, the director will need to know where to put the camera, understand what that camera position says about the character or story, and figure out what the set dressing will look like, etc. The script explains the literal action of what is happening in a scene—a character stands alone at the edge of a school dance—but the director needs to bring perspective to this action. The director should have a point of view so that the audience is not just watching someone standing alone, but understanding what the character is feeling. One of the most profound tasks of the director is to figure out how actions indicated in a screenplay should be visualized on screen—to tell the story or create an emotion, or both.

Think about our example this way: if the idea is that the character is feeling lonely, then the director has to figure out how to express loneliness. The character could say they are lonely in a bit of dialogue (to themselves, or to the person dishing out drinks from a punch bowl), but it is generally better to use cinematic techniques to replace expositional dialogue. So, does the director simply instruct the actor to make a "lonely" expression? What does a lonely expression look like? One can imagine it to be an expression akin to sadness, but performance alone can sometimes be a vague indicator to the audience of what is going on with the plot. The audience could read a "lonely" expression as the character feeling intimidated or scared, or perhaps

experiencing an unpleasant memory. On the other hand, the director might choose to use character blocking to help sell "loneliness," for instance, by staging some couples dancing in front of the character. Add to this blocking the "lonely" expression, and the director is starting to create a specific emotion in the scene. Decisions about exactly where the character is standing (by the punch bowl, by the door, against a wall) will make the "loneliness" feel differently. Respectively, is the character lonely and waiting to be asked to dance, or lonely and wanting to leave, or is the director milking this loneliness for all of its pathetic potential? Is the camera moving back away from the character to emphasize the idea that the character is just part of the mass of people, or is the camera moving in toward the character to emphasize that the character is alone in a crowd? These are similar but subtly different emotions, and the camera is a powerful tool for teasing out such differences.

It is up to the director to take the words in the script and figure out what image most clearly conveys the action, while also creating a cinematic and emotional experience. This all gets figured out in pre-production, when the director writes the shot list, shares it with the cinematographer, and the two work to refine the shots and make sure that the scenes will be visually interesting, but also make sure that there is a purpose to the shots.

Shot lists and storyboards

There are several ways that a director can communicate a visual strategy to the cinematographer. One technique is using storyboards. These are sketches that show what each shot will look like. For instance, if one shot is a close-up of an actor, then the storyboard will be a sketch of the character's face in close-up. If the director wants a wide shot of a house, then the storyboard sketch will be of a house. If the director wants the camera to move during a shot, then arrows can be added to indicate movement. On films with heavy visual effects, storyboards are particularly useful for showing how the shot will look once special effects are added.

However, storyboards require at least some drafting ability to make the sketches recognizable and helpful to the cinematographer. Sometimes a production will hire a sketch artist to draw the shots. A simpler and more common technique is for the director to write down her or his shots in a list. There is no prescribed format for a shot list, but generally the script is broken into scenes and under each scene is the list of the camera setups. For instance, if a scene shows two people having a conversation at a table, and the director is planning to shoot the scene in conventional shot reverse shot, then the list might contain just three shots: a close-up of each character, and a wider shot of the two at the table. If the director is planning on cutting back and forth several times between the close-ups, this does not increase the number of shots on the list. Each shot describes only a single camera position. In this example, the first shot is a close-up of the first character; the camera will record the entire scene from this one setup, at least twice, or more times if

the director wants changes in the take. Then the camera is moved to the second position on the list, a close-up of the other character. The scene is recorded again, at least twice. Finally, this process is repeated a third time with the camera setup for the wider shot.

In the shot list, each shot is given a brief description. For instance, one shot might be "CU on John." CU stands for close-up. The next shot on the list would be "CU on Mary." The third shot on the list might read "MS on John and Mary together." MS stands for medium shot, which is a shot that generally shows the actor from waist to head. Another common abbreviation is WS for wide shot, which shows entire body of the character, head to foot.

Every director has preferences for how to frame these shots. Some directors want their close-ups to be very close (chin to the top of the head); others tend to go wider. Some directors want clean close-ups, which means that the camera frames an actor's face without another actor appearing in the shot. Other directors will want dirty close-ups, which means that (in the example above) a shoulder, or part of the head of the actor listening to the speaker, is visible in the frame. Additionally, a shot can be framed symmetrically or asymmetrically. A symmetrical single shows a character's face precisely in the center of the frame; an asymmetrical single will frame the actor's face to one side and, usually, put empty space to the part of the frame where they are looking. Symmetry can create visually arresting shots that seem to draw the audience directly into the frame. One only need to watch a few scenes from a film by directors Wes Anderson or Stanley Kubrick to feel the almost gravitational pull of a well-produced symmetrical shot. On the other hand, asymmetry has its own advantages, and can create a sense of inertia within the frame. Director David Fincher is known for composing his shots that have an action/reaction dynamic. That is, an object on one side of the frame will cause a character on the other side of the frame to react. His thriller *Seven* (1995) frequently showcases this technique, where a police detective will be framed left or right as they spot a clue on the opposite side of the frame, and then move closer toward it. Fincher's asymmetry gives the audience options for where to look as the story unravels, making for a particularly kinetic cinema.

Regardless of the decisions that a director makes about framing—wide or close, clean or dirty, symmetrical or asymmetrical—all of these choices affect the feeling and telling of a story. Part of the collaborative process between the director and cinematographer is to establish the purposes of their frames. These choices can be included in the shot list, and an experienced cinematographer will be able to read a shot list and determine if there is enough coverage in these shots; or, on the other hand, if there are too many shots, the cinematographer can find ways to combine and otherwise reduce the number of camera setups. Each new camera setup takes time. Lighting needs to be redone. Lenses may have to change. The fewer camera setups on a scene, the less time will be spent moving gear, and more time can be spent focusing on performances. This balance between having enough shots to cover a scene (that is, showing the scene

from enough camera angles to give the editor the ability to cut together a smooth scene) while minimizing the camera setups is an important skill that requires plenty of time for the director and cinematographer to discuss and figure out.

If the camera is going to move during a shot—for instance, start in a close-up of one character and then pan to a close-up of another character—then this would be indicated in the shot list. For instance, the shot might be listed as "CU of John, then pan to CU of Mary." The type of movement is a nuanced thing, and once again something to be discussed by the director and cinematographer during pre-production. For instance, a tracking shot that is handheld will feel very different than a tracking shot that is on a dolly, or shot with a stabilization device such as a gimbal. Tracking slowly on a dolly can create an ominous or methodical feeling to a shot. Alternately, a handheld tracking shot can make the shot feel improvised and candid, a real-life documentary feeling. Gimbals can make a shot feel like it is floating, while various types of shoulder mounts can give a camera a handheld feeling while keeping the shot relatively steady. The director should understand what emotional effect they want the camera movement to have, and discuss with the cinematographer how that specific type of movement might be attained and what equipment will have to be acquired. This naturally becomes a question for a producer since equipment affects the budget.

Overall, the shot list or storyboard is a tool used by the director to help communicate the visual strategy of the film to the camera department. It is also a platform of collaboration because it allows the director and cinematographer to discuss, in detail, the most efficient and evocative way to shoot the film. Communication is at the heart of collaboration. The more collaboration that happens in pre-production, the smoother everything will go on the next stage of work: production.

On set

Every director works according to their own protocol and how they want the production to run. Generally, though, there are two approaches that most directors employ: light, block, shoot; or block, light, shoot.

This first approach usually means that the actors' movements in a scene will be limited, or when they do move, they will have to be aware to hit their marks. The second approach is usually meant to give the actors more freedom, or collaborative input, in the flow of the scene. In this case, the director arrives on set and, with the actors, walks through the blocking of the scene. They will discuss where the actors move during the scene, from where they enter, and where they exit. The cinematographer (and other department heads, such as the sound mixer and first assistant director) should be part of this blocking session, and can chime in with their own ideas. For instance, the cinematographer will take note if the scene moves from a dark area to a very bright area, and will need to accommodate for this light change, or

suggest alternative blocking. Once the scene is blocked, the actors will usually head off to get into wardrobe and hair and makeup, while the cinematographer works with her or his crew to execute the lighting and camera blocking plan.

Once the actors are on set and the scene is ready to shoot, the cinematographer will frame up—that is, frame the shot and then ask the director to check and make sure it looks right. Once the director agrees to the shot, shooting can begin. The director may also observe the scene on a monitor to watch the scene play out. Some directors do not want to be on monitor, but will ask for playback after calling cut to make sure the shot looked right.

In general, on set, the director spends an enormous amount of time with the cinematographer—likely about as much time as the director might spend with the actors. Collaboration requires plenty of communication and an understanding of the division of duties; it is a partnership that is one of the most vital and rewarding of any on a film set.

2. Director case study

Paul Thomas Anderson is a director of tremendous stature in contemporary cinema, and his films such as *There Will Be Blood* (2007) and *Boogie Nights* (1997) display a mixture of profound directorial talent with references and inspiration from movies across the previous century of cinema history. To explore some of his techniques of working with the camera department, let us look at *Punch-Drunk Love* (2002), one of Anderson's less-seen movies. *Punch-Drunk Love* is a romance that tells the story of Barry Egan (played by Adam Sandler), who is overwhelmed by anxiety and enormous social awkwardness, but is hoping to win the heart of love interest Lena Leonard (played by Emily Watson). We will examine three examples of his use of the camera department from this film.

The first example occurs halfway through the film when Barry and Lena go on a dinner date at an Italian restaurant. One of the central purposes of this scene is to show that Barry and Lena are a good romantic match; they share sensibilities in humor, are attracted to each other, and are quickly falling for one another. Five shots cover Barry and Lena's conversation in a booth: a dirty close-up and medium shots of Barry, a dirty close-up and medium shots of Lena, and a symmetrical two-shot that balances Lena and Barry on equal sides of the frame. The camera does not move, except for one notable exception.

The camera positions are relatively traditional, but Anderson uses each one for specific purposes. When the scene opens, Lena is confessing that she had been wanting to meet Barry after seeing a picture of him. He is embarrassed by her story but also flattered. It is an intimate moment, and Anderson uses dirty close-ups to frame the conversation. This framing visually brings the characters together and creates physical closeness. In close-up, the audience can see Barry's blush and the twinkle in Lena's eye.

When Barry's embarrassment gets the best of him, he changes the topic of conversation to a story about his favorite morning radio personality. The camera reflects this change by cutting to a wider medium shot of Barry. He is breaking away from the embarrassing compliment, so the camera shifts position to transition with him. The camera then takes a further step back by moving to the symmetrical two-shot—that is, Lena is on the left side of the frame and Barry is on the right, and they are spaced symmetrically on both halves of the frame. Now the audience sees both Lena and Barry in equal emphasis as it shares in the humor of his story. Wider angles, which can show several characters together, are common framings for comedies because the interplay between the characters—the comedic timing of their interaction—can be shown whole and not broken up by edits.

After Barry's digression, Lena again brings the story back to an intimate topic when she asks how his business is going, and whether he sold a mysterious stockpile of chocolate pudding. As Barry confesses his secret plan to use the pudding, to take advantage of a promotional offer to buy frequent flier miles, the camera comes in again for the dirty close-ups. When he shares his secret, their intimacy returns, as does the original close camera framings. These are, admittedly, relatively simple shot choices, but a good director knows when to keep the visuals simple and effective; go wide for the comedy, go close for the intimacy. And in this case, use dirty instead of clean framings to show closeness.

A few minutes later in the movie, Barry is driving Lena home. Having bonded further by a mishap at the restaurant, the camera is even closer to their faces as they talk in the car. Barry is in the driver's seat, and Lena in the passenger seat. The camera angle sits, more or less, at the armrests between the seats. Anderson's extreme close-ups allow the blue of the street lights to flare across their faces, making their conversation feel dreamlike—almost like a fairy tale. When they turn to face each other, all the love in their eyes is fully available for the audience to see.

The position of the camera is critical, and subtle changes can have a significant effect on the emotion of the scene. For instance, in the 2010 drama *Blue Valentine*, director Derek Cianfrance stages a similar scene in a car, but in his film the man and woman are arguing. Ryan Gosling's character Dean sits in the passenger seat while his wife Cindy, played by Michelle Williams, drives. The camera angle is similar to the one in *Punch-Drunk Love*—near the armrests between the two seats—but Cianfrance sets the camera an inch or two further back, near the rear seats. This slight difference creates an entirely different emotion. Dean and Cindy's marriage is falling apart, and as they turn their heads toward each other to argue, the audience only sees a sliver of their faces. Unlike *Punch-Drunk Love*, where every turn of the head to the other brings their faces almost fully toward camera—where the audience can see the openness of their emotions—in *Blue Valentine*, each turn to the other spouse looks closed-off, protective, sneaking, and suspicious.

Let us look at another scene from *Punch-Drunk Love*, where Paul Thomas Anderson creates a very different emotion—one of anxiety. This scene takes

place in Barry's workplace, where he runs a small warehouse that sells and ships inexpensive household and novelty items. At this point in the movie, Barry is besieged by several stressful events: a stranger is trying to extort him, he is reeling from an embarrassing get-together with his sisters' families, and he has stolen a harmonium (a small musical instrument with a keyboard and pump organ) from an alley.

The scene opens with a smooth tracking shot that leads Barry from an outside parking lot into the warehouse. He passes by Lance, one of his workers, and they discuss the pudding. The shot concludes when Barry enters his office. This is, for all intents and purposes, an establishing shot; it provides a broad visual of the space. The subsequent shots show Barry—in a series of medium shots and medium close-ups—frantically calling his credit card company in an attempt to stop the extortion. Anderson keeps the camera loose as it follows Barry: when he leans forward in his chair while on the phone, the camera adjusts to keep him in frame. The camera style is unobtrusive and casual.

Barry's problems begin to ramp up at the appearance of one of his sisters, Elizabeth, entering the warehouse with Lena. Elizabeth has come in with a secret agenda to set up Lena and Barry on a date. Barry, awash in social anxiety, starts to freak out. Anderson directs the camera to show this anxiety by moving the camera faster and more erratically. As the two women enter the scene, walking at a quick pace, the camera races with them, holding them in an intensely symmetrical two-shot. Then the camera whip-pans 180 degrees to show Barry coming out of his office to cut them off. A subsequent phone call leads into another fast tracking shot toward Barry, and then another tracking shot toward the two women. Shot after shot, the camera keeps charging in toward these characters, like a magnifying glass emphasizing their shared awkwardness.

Assuming Barry is too busy or disinterested to talk, Lena leaves. The increasing tracking speeds build as the camera cuts inside of Barry's office, where a sudden, fast pan seems to throw Elizabeth at Barry in full force—she is mad at him for dismissing Lena, and the camerawork tells the audience. As he moves around his desk trying to avoid Elizabeth (while still on the phone, dealing with continued extortion), Anderson directs the camera to lurch about erratically to cover the cat-and-mouse chase. The camera is off its tracks and is now handheld, bouncing around shakily. Anderson also shifts the blocking to make the scene more chaotic; at one point, Barry exits the right side of the frame as Elizabeth berates him, and then he swings behind the camera and reappears on the left side of the frame.

The anxiety that Anderson creates is all over this scene: in the militaristic-sounding score, Sandler's deer-in-the-headlights performance, and the script, which is full of accusations and threats to Barry from every angle. But it is also in this camerawork. When Lena appears again at the doorway of the office, the camera whip-pans to find her. There are more back-and-forth tracking shots that seesaw as Elizabeth storms out of the office and Lance walks back in, looking very confused by what is going on.

Anderson then modulates Barry's anxiety, dialing it down when only Barry and Lena remain alone in the office, and a romantic tension takes hold. The camera becomes more stable—the tracking shots disappear, as do the whip-pans, and as Lena and Barry discuss the possibility of meeting up in Hawaii, the camera is used in a traditional shot-reverse-shot style. The audience sees their faces more fully, and closer, so the audience can once again see the romantic spark in their eyes.

But the scene is relentless: spells of anxiety are not so easily resolved, and Anderson ramps up the chaos and heart-pounding fear in Barry once again. The phone rings, another threat, so Anderson uses one more whip-pan to catch Barry's face as he tries to hide the call from Lena.

This rather epic scene nears its end as Elizabeth appears at the office doorway one last time, pulling Lena away, and the two women head toward the warehouse exit in a long tracking shot. For the first time in the scene, the camera leaves the warehouse and, as Elizabeth moves out of the frame, the camera continues to track with Lena. The audience wonders if she is going to drive away and lose this chance to ask out Barry, or if she will seize the opportunity. Anderson uses a new visual tool here to show her decision: the camera slows down as it tracks, slowing so much that Lena gets ahead of the camera. Up until this point, the camera had kept up the speed of the actors, or been ahead of them, like a relentless wind. But here, the camera lags behind Lena, it begins to drift, and the resulting feeling is that the whole scene seems to slow. Lena pauses at her car door. Time almost stops as the camera finally creeps up and pauses with her. She has decided to ask him out.

This scene can make the audience sweat. Barry's anxiety becomes the audience's anxiety, because Anderson's camera is constantly including them in Barry's perspective.

As an example of how the camera can create a different perspective on a character's anxiety, let us look at a scene from *Citizen Kane* (1941). Charles Foster Kane, a megalomaniac businessman who has gained great wealth and power, has just been abandoned by his wife, whose love he tried—but failed—to buy. Kane stands in her room, looking around at its decorations for which he no doubt paid lots of money to impress her. His anxiety shifts as Kane launches into a destructive tirade. He marches around the room smashing everything in sight. But unlike Barry's freak-out, where the audience sympathizes with the character, Orson Welles—who both plays Kane and directs the movie—uses his camera to create a different feeling for Kane. The audience is meant to pity Kane, to see this man of great stature as someone who is now small and pitiful. To achieve this visually, Welles keeps the camera far away from Kane. The camera pans to keep him in frame, but the camera movements are sterile, almost robotic. The camera does not get involved in Kane's explosion; the camera records it from a cold distance. The audience does not empathize with Kane as it did with Barry. Anderson's camera puts the audience in Barry's shoes; Welles' camera is a tool for critical judgment of his unapproachable protagonist.

The final *Punch-Drunk Love* scene that we will discuss takes place in a hospital. Lena has been injured by henchmen who are assisting in extorting Barry. The henchmen had intended to hurt Barry, but Lena sustained a minor head injury instead. The first shot is an overhead shot, in close-up, of Lena being examined by a medical worker. She has a small bandage on her forehead and is being checked for a concussion. The next shot is a wide shot of Barry standing near the foot of her bed. He stands stiffly, awkwardly. Her injury is *his* fault. There is a doorway behind Barry, and he is framed neatly within the doorway. This careful framing tells the audience what he is feeling: he wants to get out of this room. He is unable to deal with her injury, and he wants to flee. Without him moving or speaking, the doorway framed behind him tells the audience everything about what he is thinking. Then, a moment later, he goes through the door, sneaking out of the observation room.

It is up to the director—collaborating with the cinematographer—to figure out the shots that not only show the action, but also help to showcase the emotions of the scene. Once again, there is no shot or camera framing that, in and of itself, establishes a specific emotion. But when the camera works alongside the other elements of the scene, the camera becomes a powerful tool for emphasizing and developing another layer of the scene's overall impact.

3. Interview with cinematographer

Andrew Wonder is a cinematographer and director whose work spans independent film and commercial directing. He has worked with iconic directors such as Michael Almereyda and Paul Schrader.

TAKOUDES: Let's start by talking about some techniques for how a director can best communicate her or his vision to the cinematographer.

WONDER: In a lot of ways, it's about the relationship. The biggest thing I see with younger cinematographers, and what I had to learn the hard way, was that as the cinematographer, you think you're in charge of the look of the movie, but you're really in charge of making sure a version of the director's vision comes across all the visual departments. The cinematographer can make production design and wardrobe's lives easier or harder, because part of what a cinematographer does is figure out how to allocate resources. The best cinematographers are the ones who know how to give up money for lighting and give it to art. As a cinematographer, it's important to form a best-friend relationship with the director. And once you form a relationship of being close like friends, then it makes a lot of things easier.

TAKOUDES: Do you like to sit down with the director and watch movies, to create some visual references?

WONDER: For some cinematographers, it's useful. But I always approach a film from the story or character. I'd rather talk about how the movie *feels*. What you have to remember is that the director needs to let go of the camera. At

the end of the day, when the actor is doing their best work, the cinematographer is the one pressing record. And if the actor is doing their best work, and they're going to step right or left, the director needs to make sure that they've had enough creative conversations with the cinematographer that they know where to go.

TAKOUDES: So, what are other ways that the director and cinematographer can get on the same page about creating the look of the movie?

WONDER: I think it's important that the director starts off with a shot list, something they can go through. Some directors are not as visual. Some are more actor people. But the shot list helps to understand the vision. Also, I think that one of the most important things for me—this is simple—is the director and cinematographer deciding what a close-up looks like. For some people, a close-up is just the face, and for others, from the chest to the top of the head is the close-up. You can get rid of a lot of bickering and confusion just by knowing what that is in advance.

TAKOUDES: Communication is vital.

WONDER: For a while, the director feels like the movie is theirs. And then when prep starts, the director simply can't make every decision. So now your production designer, your cinematographer, they're making hundreds of decisions a day. If your crew doesn't understand why the director wants the shoot to be a certain way, then the cinematographer won't be able to help fulfill that vision. The director may want the movie to look, for instance, like *The Godfather*. Yeah, we all want it to be like *The Godfather*. But what does that mean? The conversation that's really important is, how do you want the machine on set to function? Some directors say they want to do a lot of takes. If that's important to you, then you and your cinematographer need to decide, okay, I want to do a lot of takes and you need time for lighting—so is it possible to light for the whole scene so we can do all those takes? Or is it better for the lighting to go like this …? You need to have an agreement. Because if someone is going to hold up your day, it's the cinematographer. That communication is very overlooked and not discussed. And I think that's why sometimes directors feel that cinematographers are running away with their movies. Or cinematographers feel that the director is an idiot. We all agree we want it to look like *The Godfather*. But there's a certain machine to how we get there.

TAKOUDES: *The Godfather* looks how it does because of a thousand decisions. So what pieces specifically are we talking about? That conversation happens in pre-production.

WONDER: Think about it this way: Paul Schrader says there's six ways to stylize an image. These are all things that can be discussed during the collaboration.

TAKOUDES: What are the six?

WONDER: Let's see if we can come up with them all. There's framing, camera movement, color, light, sound, and art and wardrobe. So you have these six tools. And you should talk through them all with the cinematographer.

But if one scene has red and neon light, and a super gothic set, and the camera's moving all over the place, and the framing looks like *Mr. Robot* ... well, that might be a lot. You can't necessarily do them all. There's no rule, but if you're doing all of it, you're probably overwhelming the audience.

TAKOUDES: It's potentially expensive, too. And it takes a lot of time.

WONDER: Spielberg can maybe do them all, but that's why we have Spielberg. Not many directors have the budget or ability, or interest perhaps, to do that. No matter what decisions you make, you and the cinematographer need the time and space to talk through everything. Like, is this a moment for camera movement? Or, what are our frames? Do people talk toward negative space? Or do we put the negative space behind them? Talk about lighting. Do you want that *Godfather* overhead light? Personally, I hate overhead light. I hate those nose shadows. People spend tons of money wanting those nose shadows. But that's *The Godfather* look. And that's where taste comes in. You make those big decisions. As a young director, the most important thing is that you know your script better than anyone. Make sure you know your script, but at the same time make sure you're ready to change it. Sometimes people will have everything shot-listed and they'll have it set in their heads. But the problem with being too set in your plans is that you lose all the beautiful things that happen from discovery.

TAKOUDES: But if you haven't established a relationship with your cinematographer, if you haven't had the creative discussions and if they're not feeling excited, it's hard for the director to be free. To adapt and discover.

WONDER: Chances are if you're directing, and you're hiring a cinematographer who works professionally or semiprofessionally, they've probably been on 20 times more sets than the director has. Use that to your advantage; don't be afraid of it. Sometimes directors want to dominate, or they don't want to trust cinematographers. But when you have someone who is as close to your position as possible—creatively—and has seen this scene go down a million ways, talk to them. It's okay as the director to ask, "What's the normal way you'd cover this?" That question doesn't show weakness. I find that directing is a mix of listening and talking. If you're not a visual director, that's fine, but you need to talk about this with your cinematographer. I've worked with directors who are just completely focused on story ... and they'll say to me, "I need it to feel really important in this moment of the scene." So, as the cinematographer, I'll translate that. And I'll say, "Well, if you want this to feel important, why not use a wide-angle close-up, so that it feels different than every other close-up in the scene?" Or maybe we have a camera move tracking with the character.

TAKOUDES: Is "I want it to feel important" useful or overly vague direction? What type of language is useful for a director to have?

WONDER: This is where interviewing and understanding the cinematographer before you hire them is important. Because you have to make sure that

they understand the way that you communicate. Language depends person-by-person. Generally, if you're going to say something vague, you have to understand that someone's going to interpret that. So, you have to be okay with the result. You have to understand that you said you wanted it big, so maybe the cinematographer put the most light on it. And you have to understand that someone else made a creative choice based on what you said. Talking to a cinematographer is just like talking to an actor. They're sensitive. They have a vision. There's a reason why they wanted to do this film. It might not be the same reason that you wanted them to do it, and you have to respect and nurture whatever it is that they're bringing to set. Cinematographers are really good at making things look good, but they're not always great at knowing why it looks good. So as a director, you're giving the cinematographer a logic to their beauty.

TAKOUDES: Because the purpose of the shots is, ultimately, to tell the story. Or explain something about a character. The cinematographer should not be just creating beautiful images in a vacuum. The shots should be motivated by story and character.

WONDER: Here's an example. *West Side Story* is my favorite movie. An important thing to know about *West Side Story* is there's only two close-ups in the entire movie. That makes sense, because it's a big musical. But the director decided those two moments when he needed the story to feel different. In the song "Tonight," the characters are singing and they're holding each other, and it gives me chills just thinking about it, but you get this close-up, because this is the one moment that they have happiness outside of their world. It takes a lot of directorial restraint to only have that close-up twice. And therefore, it means something special.

TAKOUDES: The shift in the visual strategy is what's important. The close-up works because it's coming in the context of wider shots.

WONDER: There's no wrong way. What matters is that you, as the director, know when to communicate to the audience that something is important. And you can be specific to the cinematographer and say, "I want it to feel important by using a rare close-up." But you never want to be so specific that people feel like they're just working for you. You want to ask the cinematographer about their ideas, too. When you prep, let your cinematographer talk about what makes them excited. Let them talk first. You have to keep cultivating their enthusiasm. The moment that a cinematographer feels that they're just working for you, and they just have to get a few shots done to get out of there, then they'll just get a few shots done to get out of there. Establishing a relationship with your cinematographer is as important as the practical stuff. You hire a cinematographer because you like how they shoot things, or they have a connection to the story, so as the director, you have to trust your people.

TAKOUDES: So, be sure give the cinematographer room to be creative.

WONDER: Yes, but within guardrails. You can let them be creative and do their job, but you also need to tell them, for instance, "I need 45 minutes

for this part of the scene." Remember, you're not just hiring a camera. And you're not hiring someone to just push the record button. And if you are, you may not need a cinematographer. You're hiring a cinematographer because you don't make movies on your own. And if the movie is only as good as your own ideas, then your movie is probably not going to be very good. Take the chance to learn from your cinematographer. I always ask cinematographers (and I liked being asked as a cinematographer), "What usually goes wrong on films like this?" "What usually goes right?" "What was your best shoot?" If your cinematographer is not excited, then they're not going to get you an assistant camera person who's into the film, and they're not going to get you the best gaffers and grips. Especially if you're asking for favors on your movie, then the biggest thing you want as a director is enthusiasm. Whenever you can join their ideas with your ideas, that's good. You have to come prepared with a vision, but you have to be ready to embrace the visions around you.

TAKOUDES: Collaboration with the cinematographer, taking in their advice and experience and ideas, is the best approach.

WONDER: It's also just a practical thing. You have to be ready to listen to your cinematographer, because they're going to make decisions that are hugely important to the film, without you. When they show up on set, and they've had an hour to light the room, they're going to put the lights places that they think are best. Filmmakers use light and imagery to communicate feelings and thoughts. Talk with your cinematographer about types of daylight. "Oh, I love it when it's late afternoon and you're catching to last rays of light in the room." Or, "I love it when it's overcast." But that's a different type of feeling. I like different daylight than other cinematographers. Just start talking about color, about light. You don't have to know the units; it's not your job to determine which gels to use, but you should say, "I like it when the light is really bright." There's nothing wrong as a director with asking the cinematographer, "Does this make sense?" It doesn't make you look weak to ask.

TAKOUDES: Then what does make a director look weak?

WONDER: Well, first of all, you don't want the crew to see you as weak, but that doesn't mean you need to dominate. Generally, you look weak if you're changing things all the time. If you told your cinematographer one thing, and they're doing something different, that's because you as the director miscommunicated. No matter what. Somewhere in your communication, you failed. Whether it was not being accessible in prep, or maybe you didn't look at the references and so you're not on the same page. What frustrates camera crews the most is if the director is always changing things. Remember, you're in the people business. If you're tired as the director, your crew doesn't want to be there. Because you're the most invested person, and you set the pace and the energy. Everyone can see it and feel it.

TAKOUDES: It's vital for the crew to feel invested. They're freer with their ideas, their passion, and they'll be better collaborators with the director.

WONDER: Morale means so much. Every morning, I circle the crew and I thank everyone. I'll shake everyone's hands. So that they know me as a person, and not just the person who employed them.

TAKOUDES: What if you're behind schedule on set? If you realize that you're not going to get all the shots on your list, how do you prioritize?

WONDER: Always make sure you have an action twice from two angles, and you can get out of the scene alive. But you prioritize based on the specific project. For instance, if you're working with kids, they're probably going to be good for three or four takes and then they're going to be talking about Spider-Man. Or sometimes you work with actors and it takes a while for them to warm up. You have to prioritize where you're giving tech time, and where you're working with actors. Some people like to prioritize by doing their master shots first. But for me, because the blocking ends up changing as we shoot a scene, my masters would have to be reshot. So I like to do my close-ups first, get the blocking down, and then do the master. These are things to talk about with your cinematographer so that they know how you want to work. Beyond that, I think it's a good idea to prioritize by figuring out what is the most important moment of the scene, and then using the fewest number of shots to get out of the scene after that. Every take, every shot, you should ask, "Is this important?" "Do I need this shot?" "Is it worth the time?"

TAKOUDES: The restriction of time can sometimes make a director and the crew work better.

WONDER: Yeah. I promise you that *The Godfather* ran out of time some days. You watch a movie when it's finished, but you don't see all the accidents and mistakes that happened. All the things that went wrong. But that's okay. Sometimes you'll have a shot that you're thinking about for months, and you plan for it and spend hours blocking it, and then when you get to the editing room, you realize, "Oh, the thing that happened accidentally just before that shot was actually better than the thing I planned."

TAKOUDES: And to achieve that, it's important to stay focused on shooting for story and character. That you're not just indulging yourself with fancy shots, but that you're telling a story.

WONDER: Exactly. For each scene, as a cinematographer, I write a one-sentence description of each scene, and I also have a description of the scene before and the scene after. Because you have to not only think about how to make that scene work, but how to make that scene work in the context of the scenes around it. So, if you have 10 minutes left to shoot, do you have the shot to transition to the next scene? A lot of times, the transition shot is the most important shot of the whole scene.

TAKOUDES: And this goes back to making sure that the cinematographer understands why the director wants a certain shot. And the cinematographer understands the plan and the purpose for the shots.

WONDER: The best term I ever heard for a director is *facilitator*. I first heard that word when I was doing a sixth-grade group project in school; everyone in the class had a job, and one person was designated the facilitator. And to this day, I've never heard a better term to describe a director. Because you're not a dictator, you're not a general; you're a facilitator. All you're really doing is talking to a lot of people who can do things, and you're facilitating how they do it. You're the facilitator to your cinematographer. You empower them, but you also need to create guardrails. So, as your cinematographer is going off and getting beautiful stuff, make sure that it's beautiful stuff you can use.

TAKOUDES: What else do you think about as a cinematographer? Accentuating what's important, transition shots, prioritizing … what else?

WONDER: It's important to think about arcs with your cinematographer.

TAKOUDES: Narrative arcs?

WONDER: Visual arcs. How does the look of the film change from beginning to end? And it could be as simple as when the movie starts everything is blue, because it's sad, and when the film ends and the character's happy, everything goes from blue to neutral to orange. I've done movies where I've said, "This character's lens is 35mm." And every other character gets a wider or longer lens, depending on how emotionally close they are. Maybe their overbearing mother gets a wide angle. Maybe the man or woman that the main character is in love with *also* gets a 35mm lens. Maybe the look is more diffused and then gets less diffused. Especially in a short film, a visual arc is a subtle thing, but try to come up with at least one arc. It also gives your cinematographer a guide, and it gives them something new to do every day, and it gives them some homework.

TAKOUDES: It helps to create these guardrails that you mentioned. And it keeps the conversation specific and straightforward.

WONDER: That's a great way to direct. For instance, even if you don't know anything technical, this is the one conversation you should have with the cinematographer. How close do you want your audience to feel to the conversation that's happening in front of them? Do you want the audience to be at the dinner table, on the other side of the room, or across the street? And the cinematographer can do the rest. If you say, "I want to feel like we're in the middle of the conversation," then maybe the cinematographer uses a wider lens and it feels like there's another person in the room. Or if we're spying on them, then you put the camera far away and use a longer lens. You can say, "This is a sensitive moment; I want to be with the characters in their pain." Or, "This is a sensitive moment, and I want to be across the street and just watch the characters go through it." Those are two very different emotions.

TAKOUDES: And it's a good way to think, because then you're directing with emotion, as opposed to just getting coverage or just getting beauty shots. Then you're a director who has a perspective on the story.

WONDER: And you've made a choice that your cinematographer can act on. When you're making a movie, it can sometimes feel like you're competing against all of cinema history—and it's hard to be confident. But if you're making strong choices as a director, then you're starting to explore what's important to *you* as a filmmaker. If someone wants a Coen Brothers movie, then they'll hire the Coen Brothers. But what's the one thing that you have that no one else has? The way you notice sunlight. The way you dig into characters. We're all individuals. Every film you make could be your last, so treat every day of prep, every day of shooting like it's the last day you'll ever have on a film set. Make sure it has so much of you, and your heart, and who you are. That's why the communication with your cinematographer, and all the departments, is so important: it's to make sure that stuff gets across. Make sure that you enjoy it, and make sure it's you.

4. Tasks for the director

Successful collaboration between the director and the camera department requires constant communication from pre-production through production. Below are some specific tasks for the director to keep in mind during this long process.

The producers department is described in the next chapter of the book. Given that the role of the producers is far-reaching in determining how the film gets made, it is important for the director and cinematographer to follow this check-list and be able to present a clear and strong vision to the producers.

1. Hiring the cinematographer is one of the director's most important jobs. Before hiring, the director should be very familiar with the cinematographer's previous work, to ensure that the cinematographer has experience creating the type of look that the director is hoping to achieve. The director should only hire a cinematographer whose work shows an ability to create that look, or a faith that the cinematographer can achieve the correct look. At the same time, it is important that the director and cinematographer get along personally, that they feel a certain chemistry and ease in working together. Making a movie is difficult and frequently stressful; if there are personality clashes between the director and the cinematographer, then this working environment will only become more challenging and potentially negative.

2. Early in pre-production, the director and cinematographer should meet several times to discuss the vision of the film and how the director would like the set to operate. The director should come to the meetings prepared with examples of movies, or photographs or paintings (or other visual cues), to help communicate this vision. Frequently, a director will create a mood board, which is a document of visual references to help describe what the movie should look and feel like.

3. After the initial meetings, the director will come up with a storyboard or shot list for the movie and provide time and space to discuss it with the cinematographer. While the vision of the movie comes from the director, discussions with an experienced cinematographer can help to refine and improve the vision, as well as revise and improve the shots that will be used to create that vision. The shot list or storyboard should be disseminated to the first assistant director and other key crew members.

4. On set, the director figures out the blocking of the scene—working with the actors and cinematographer—then the cinematographer will light the set and prepare for shooting the scene. After each take, the director and cinematographer will discuss the shot, if it worked for them, or if adjustments need to be made.

5. In post-production, the director should be sure to invite the cinematographer to the color-correct sessions, to make sure that she or he has a say in the final look of the film.

4 The director and producers department

1. Producers department overview

All movies, regardless of whether they are a limited-run, art-house film, or a commercial blockbuster, require a budget. Not every director has intentions of making money from a movie—movies are made for reasons other than financial ones—but every film does cost money. For the director to be able to focus their attention and time on the storytelling aspect of a movie, there is a separate department that handles the business and financial aspects of the movie: the producers department. But the responsibilities of the producers also extend even further to some creative aspects of filmmaking.

There are different types of producers who comprise this department. To watch the opening credits of a movie, the viewer will notice there are co-producers, associate producers, executive producers, and producers on a movie. For the most part, co-producer and associate producer credits are given to producers who have had a smaller role than the main producers. Co-producer is usually seen as a smaller credit than associate producer, but both are given to either younger producers putting in their dues and climbing the ranks of the movie industry, or to prominent cast or crew members who have played a broader role in the making of the film.

The executive producer credit is given out in a variety of circumstances, depending on the budget. Generally speaking, for low-budget films, the executive producer (or EP) credit is given to whoever invested a significant percentage of the budget into the film. For more moderately budgeted films, the EP credit might be given to a prominent and recognizable name who is vouching for the film. For instance, director Martin Scorsese has occasionally lent his name as EP for smaller, independent productions to help give them a boost in the marketplace and potentially find a larger audience than they might have otherwise. On even bigger-budgeted films, EP can be given to someone who owns the property on which the movie is based. For instance, writer Stan Lee is frequently an executive producer on films based on comic characters that he invented or owns. The EP may not do much actual producing, but they are nevertheless offering something

quite valuable to the film—either in their ownership of the property or the market value of their name.

This leaves us with the main producer credit. The producer is, essentially, the department head of the producers department, and while the director is the lead creative force on a film, the producer is often seen as the person (or people) who runs the entire production, and in doing so bridges the divide between the creative, financial, and logistical aspects of making a movie.

Pre-production

A director has a vision for the movie that she or he is directing, and one of the first tasks for the director in pre-production is to communicate that vision to the producers. It is vital that the producers understand this vision, and it is completely acceptable—and helpful—for the producers to ask questions, offer ideas, and provide useful critiques of the director's vision. A director should be able to defend and explain why they want the film to look or feel a certain way, and it is often through this process of helpful critiques that a director's vision will be deepened, or possibly improved. Producers come to the table with knowledge of production efficiency and an awareness of how much the director's vision will cost; a vibrant, positive, and open line of communication between the producer and director can align the vision with the limitations of scheduling and budgets.

Herein lies the core of the producer–director relationship: the job of the producer is to support, defend, and create a production infrastructure that will allow the director the best chance of realizing her or his vision. If the director is trying to create a specific type of scene, the producers are responsible for making it happen from a logistical and budgetary standpoint—or coming up with an alternative solution if the director's plans are not possible given financial and scheduling limitations.

Some producers, especially more creatively oriented ones, will help the development of the script. During pre-production on the film *The Big Sick* (2017), Judd Apatow—one of the producers—described much of his work as developing the script with the writers. He spent years giving notes on drafts. This activity—improving and tightening the script—was central for him to help the filmmaker achieve his vision of the movie.

However, other producers are more focused on the business aspects of making a film. This includes a wide array of tasks. One of the initial tasks of the producers during pre-production—and usually only when the script is revised and polished—is to raise production money. Depending on the budget of the film, the money will likely come from different places. For low- or no-budget films, it is common to see financing come from online crowdfunding sources, the filmmakers' own money, or investments from friends and family members of the filmmakers. It is up to the producers to secure the legal and financial framework for how the money is being held and used for the production.

But equity investors with deep pockets—or a group of investors—could also fund a more moderately budgeted film. Film producers experienced with fundraising, especially so-called money producers, will frequently come to a production with connections or leads to investors, and the producers are responsible for using the strength of the script and the director's vision—as well as any notable cast that might be attached to the film—to secure such an investment. The director may also be asked to help sell the vision of the film to investors.

Producers have other places to look for money as well—such as state-based tax breaks or incentives from foreign countries, if a certain percentage of the production (and hiring for the production) happens in those places. Producers can also seek "foreign presales"—selling distribution rights in other countries before the film is made, and then using money procured in those sales to shoot the movie.

For higher-budgeted films, studios and investment firms will likely finance a production, but usually these sources will require a well-known director and cast, and the movie will generally need to have strong potential to work as a commercial success at the box office.

Once the financing is in place, the producers will help to put the many other components of the production into place: a crew must be assembled, schedules made, and locations secured. If there is copyrighted or branded material that needs clearance (for instance, products that might appear in the film), the producers will handle this. Producers will also handle releases for talent, extras, and locations to appear in the film; set up insurance policies for the production and all of the locations; create bank accounts to pay for services and production needs; and have contracts for all the work that is needed. Some of this is delegated to others in the producers department (for instance, budgets are created by the line producer, and schedules created by the first assistant director, which we will get to in Chapter 6). The producers will oversee all of these tasks, and frequently use their professional connections to help bring the pieces together.

Producers could also help in the casting of the film. Ultimately, the director is the one who makes the final casting decisions, but producers can play a crucial role in bringing any talent connections they might have to the process.

All of this work happens in pre-production, and it is important to emphasize that everything going on is in service to the director's vision. But producers must have a vision as well. A good producer will be able to see beyond pre-production, and beyond production, to have a sense of how the film will fit into the marketplace. Will the film be submitted to festivals? What types of distribution is the film expected to have? Most broadly, the director's job is to tell a story in the most compelling way possible, and the producer's job is to figure out how to sell that story to the world and find an audience.

Production

One of the central responsibilities of the producer during production is to make the shoot run as smoothly as possible: that equipment trucks are arriving at the

right place, at the right time; that the cast and crew are taken care of, and everyone is getting paid and fed properly; and that any disputes on set are handled efficiently and fairly. It is common for the director and producer to communicate less during production because the director's time is devoted to the more immediate tasks of day-to-day filming—but the relationship remains important to maintain. Too much directorial freedom has sometimes been equated with directorial indulgence, but too many constraints from the producers can stifle a director's ability to work creatively.

At the heart of collaboration between the producers and the director is striking a balance, having an honest conversation about the needs of each. Trust and communication are vital to ensure that neither oversteps the other's needs and working styles. Some producers tend to be on set infrequently; they may spend their time off set, in an office, managing the production from afar while also working on other films at the same time. But other producers—in particular, the line producer, whom we will discuss later in this chapter—are very hands-on and will be on set frequently, helping to ensure that the production is running smoothly, and working as a creative sounding board for the director.

Post-production

When production completes, the director and producers will begin working closely together again. As the director oversees post-production (to be addressed in Chapters 11 and 12), the producers usually help organize the staffing and workflow of post-production, and become available for screenings of rough cuts. If a sales agent needs to be hired to sell the movie to distributors, then the producers will be involved. Compiling festival submissions, or making plans for self-distribution, are also handled by the producers, while in constant consultation with the director.

There is probably no other department of film crew that has such a breadth of responsibilities and is involved with the film for so long. Knowledge of business protocols, contracts, accounting, technical aspects of filmmaking, and a strong creative sense about storytelling are all part—in varying degrees—of what a producer must be able to do.

2. Director case study

Given the many responsibilities of the producers department, how should the director best approach this important and wide-ranging relationship? What does proper collaboration look like? If a model of the producer–director relationship is one of support for the director's vision, and stability of the production to ensure that the director can work as unimpeded by logistical and scheduling problems as possible, then the longtime (nearly 30 years) working relationship between director Ron Howard and producer Brian Grazer is an example of a highly successful collaboration.

Their storied collaboration began in 1982 with the comedy *Night Shift* (1982, starring Michael Keaton), which was a success at the box office. They then formed a production company together—Imagine Entertainment—and have since collaborated on a wide range of films, from thrillers such as *Backdraft* (1991), to dramas such as *Apollo 13* (1995), to fantasy movies such as *How the Grinch Stole Christmas* (2000). They won an Oscar for Best Picture with *A Beautiful Mind* (2001).

Over the years, Ron Howard has commented on some of the secrets to the success of their collaboration. There are three themes that Howard frequently mentions: taste, trust, and perseverance.

Unlike directors such as Alfred Hitchcock, whose canon of movies generally follow a similar form and shape (consider Hitchcock's thrillers that feature an innocent man wrongly accused of a crime), there is no prototypical Ron Howard movie. He has worked in a number of different genres and tones. And yet one thing that they all share, by Howard's own observation, is that they are all human in their focus. However extreme the circumstances of the characters' lives, Howard's focus is to find what is most relatable and common in their struggles. For each movie that he considers making, Howard looks for the human at the center of the story and wants to find a way to make the human experience the centerpiece of his stories. Brian Grazer frequently talks about stories in the same way. As a producer renowned for his intense and wide-ranging curiosities (Grazer attributes his success primarily to the power of his curiosity), what makes him most passionate about a film is not the genre or tone, but whether there are humans at the center of it. Howard sees this commonality between them as vital to their collaborative success: they share the same vision for their movies. As was discussed earlier in this chapter, it is important that the director explains her or his vision for the film to the producer, and that the producer protects that vision during the course of making the film. If the director and producers fundamentally see the movie differently, then making the movie together might become a real challenge. A shared taste and vision for the movie are essential to collaboration.

That said, Howard and Grazer are also different people, and they do not always agree on whether a certain script, or concept, has the promise to become a movie. As Howard describes their collaboration, if one of them is feeling passionate enough about a movie, then the other is open to looking again at the project, to try to see it through the eyes of his partner. Grazer trusts that if his partner sees something promising in the material, then it is worth investigating more deeply. Collaboration, though, requires that the director and producers both deeply believe in the film that they are making, and to approach this relationship with an attitude of trust and optimism in the other's intelligence and creativity. In the course of making the movie, that trust needs to continue for the director to work confidently— to know that the production is being handled smoothly and competently.

Finding a producer whom the director can trust is essential for the director to be as creative, energetic, and passionate as possible.

Finally, making a movie—even when there is shared taste and trust—can take many years. Brian Grazer has spoken about the seven years of rejections that he endured trying to get his and Ron Howard's second collaboration— the comedy *Splash* (1984, starring Tom Hanks and Daryl Hannah), about a man who falls in love with a mermaid—financed by a studio. During those seven years, Grazer needed to develop and alter the pitch of the movie, and contend with competing projects and doors closing in his face. Through it all, the two continued to work on the film as a partnership that endured the worst, while hoping for the best. A director's collaboration with some departments is short-lived—and limited to just the period of production or post-production—but the director's collaboration with the producers should be a long-standing one. The director should see the collaboration as a long haul, whether it is the seven years that it takes to finance a movie, or the decades of movies that they will continue doing together. This is a rare example of a particularly successful collaboration, but also an instructive one.

Unfortunately, when the collaboration is not successful, the movie can suffer. Mistrust, conflicting visions, and impatience can undermine the collaboration. There are some famous stories of directors having to protect their films from producers whom the director no longer trusted. For instance, when Mike Nichols directed his first feature film, *Who's Afraid of Virginia Woolf?* (1966), he believed that the film should be shot in black and white. His vision was not fully supported by the ranks of producers and studio executives who had hired him to direct. Nichols feared they were trying to undermine his vision and he had to resort to difficult decisions to protect the movie. For instance, when he was working with one cinematographer on achieving a certain look to the black-and-white cinematography, the cinematographer suggested shooting on color film and then printing it on black and white. Fearing that this approach would leave Nichols vulnerable to the movie ultimately coming out as a color film, he fired the cinematographer and hired another one who would shoot only on black-and-white film stock.

The director John Ford was also suspicious of the producers and executives who controlled his movies, and worried that they would force the editor to cut his movies in ways that he did not approve. Famously, Ford would shoot his films from so few angles, and with such few takes, that he limited editors' abilities to cut his movies other than how Ford envisioned them.

For these directors, clashes with their producers worked out in the directors' favor. But this is most often not the case. An adversarial or untrusting relationship between the director and producers, when the collaboration has fallen apart, usually makes for a painful directorial experience, and often the movie will suffer.

3. Interviews with producers

This section includes two interviews—with producer Tim Perell and line producer Becky Glupczynski. Tim has been an independent film producer for over 20 years. He has produced across a variety of genres, from the Joel Hopkins drama *Last Chance Harvey* (2008, starring Dustin Hoffman and Emma Thompson) to the John Cameron Mitchell cult hit *Shortbus* (2006). He also produced the Bobcat Goldthwait comedy *World's Greatest Dad* (2009, starring Robin Williams). Becky has line-produced films such as Joshua Marston's *Maria Full of Grace* (2004) and the Bart Freundlich drama *Wolves* (2016, starring Michael Shannon).

Interview with Tim Perell

TAKOUDES: Let's talk about what you like to see the director bring to the table to help the collaborative process.

PERELL: What I most want to see from a director is a very strong point of view. But I also want them to have open ears, if that makes sense. And that's a very challenging thing to find. I want to find a director who has a clear sense of what they want, but is also open to a conversation that's not necessarily about changing the direction of what they want, but new ways of looking at how to get there. Because I don't ever think there's one singular path, and I never think the process of making a film is black and white. There are sometimes multiple answers that still get you to the same place. And that really is about any of the key creative choices that one needs to make along the way, because, as you know, a director has to make millions of creative choices along the way to make a movie.

TAKOUDES: What are some of those choices that you discuss?

PERELL: We spend a lot of time talking about different actors for the different roles, and there are times when there is a very clear choice. And we all see the clarity of that choice. But when you don't get that person, the producer and director have to be able to discuss what that character means, and then look at it from another angle and understand that there might be other choices. For me, it's about a director who's willing to listen to a considered point of view. And as producer, part of my process before working with a director is understanding their vision for the movie. So, my point of view is always going to be within that prism, through that lens, with the same goal. But trying also to make the director look at it from a number of angles. I'm never really imposing my end goal. I look at what the end goal for the movie is, what the director wants to achieve, and I get on board in a movie when I agree that's the end goal movie that we're trying to make.

TAKOUDES: You're looking for the director to be willing to have a conversation.

PERELL: Many conversations. It doesn't mean they have to agree with me. But I want them to listen to my point of view. And to be able then to articulate

why they don't agree with me. And that for me is the most important part because I have to also be willing to continue to listen to their point of view. The director who is willing to have an ongoing conversation makes it a more satisfying experience, but I think also leads to a better movie. Also, I'll find that the conversation might lead us to an entirely different place. For instance, for an actor, I might suggest A, and give a host of reasons why A is the right decision, and the director might say B. Through this ongoing conversation, we might realize that C is the best choice. And C is not necessarily a compromise; it's because through the conversation, we've been better able to define the reason for the choice, and realize that we're both kind of a little bit off base, and this person is even better. And that extends to when we're trying to hire the cinematographer; we'll have the same conversation. We've had the conversation about what the look of the movie should be. At the end of the day, I'm looking for someone who's willing to have a considered conversation, because I think that process of having to think and discuss and be challenged makes me better as the producer, and it makes the director better.

TAKOUDES: Specifically, how does the director explain their vision to you? Do you look through the script together? Do you watch comparable movies?

PERELL: Every director is different. Every director articulates their vision in different ways. You have these free-ranging conversations where you're talking about what the meaning of the script is, and the meaning to the filmmaker. That's always an important thing. The filmmaker needs to be able to articulate why they want to make this movie. And look, sometimes it's like, "I'm making this movie because I got hired to make it, and I'm going to make some money." That's fine. It's a job. But really, in the creative process, I want to understand why the director is making this movie. If you're a writer/director, why'd you write this movie? If you're a director who's signed onto this script, what is it?

TAKOUDES: Are you looking for the director to have a personal connection to the material?

PERELL: It could be. It could be a number of reasons. But for me, as the producer, to understand that motivation is one piece to understanding their vision, and what the lens of decision-making is. Some directors will explain themselves by talking about other movies. Or music, photography, painting. Or you're talking about politics, culture. Every director has different interests. All of these things help me understand what kind of movie they're wanting to make. I have a movie right now that is in search of a director, and it's on the line between being a Jason Statham straight-ahead action movie or being like an early Christopher Nolan *Memento* movie. When I'm talking to directors about it, it's interesting to see if they're attracted to the complexity of the narrative or to the adrenaline rush. And that's something that tells me ultimately the kind of movie they're going to make. And inevitably, you always talk about actors. Who do you see in

this role? It's always an indicator of do we see the same thing, or it helps me to define what they're seeing. Are they seeing something more comedic?

TAKOUDES: Because once you get in their head, you can help them to fulfill their vision.

PERELL: That's my approach to it. If they bring me those references, and the movie I saw was a bright comedy, but they're looking to do something dark and moody, then we need to talk about it. And if they're really entrenched in this idea, and I can't come around to that idea, they don't convince me of that idea, then I'm not the right producer for it. I want them to be able to convince me. Or at least make me understand where they're coming from.

TAKOUDES: So the director needs to be a strong communicator.

PERELL: An actor was once talking to me about a movie that he did with a very accomplished director and a very accomplished actor. He asked a question about the why. And the director had no answer for him, and it killed him. It was like he didn't know what to do. So, he needed to retreat and figure it all out himself; he needed the ballast of the director to give him a place to point. He found his own way. But he lost faith in the director because the director didn't have an answer. And you can, as the director, say, "Look, I'm not entirely sure, but this is what it means to me." It might mean something else to you. I don't think a director needs to be categorical. But yeah, they need to have a rationale for why something's there.

TAKOUDES: Ballast is a good word for it. So what else are you doing with the director during pre-production?

PERELL: We're hiring the other department heads. There's a joke about this that a designer once told me. I'm usually married to the director for three years having these conversations. And once we start pre-production, the director is only dealing with the department heads. I'm not involved in the day-to-day meetings between the director and the cinematographer, or the director and the production designer. It's like the director is having affairs with all these other people in front of my eyes, and then they come running back to me during post-production, when everyone else goes away. But before then, there's a long period when it's just me and the director setting up the movie.

TAKOUDES: And getting the financing together.

PERELL: Financing, yeah. Making financial models. Packaging actors. Finding out what are the priorities of the director. And by that, I mean, is total creative control and autonomy critical? Or is getting the most amount of money for the movie critical? I made a movie recently where the filmmaker had been toying with an idea for about 15 years. It was the movie that meant the most to him. So he was like, "I'm only making this movie if I have total autonomy." That's fine, but then we're only going to get so much money to make it. With less money, that means production

challenges, and we have to have those conversations very early on. It means five less shooting days, or 10 less shooting days. The director and I both have to agree to that. We have to define our priorities. I have a movie right now where we packaged it, and it's the perfect cast for the movie, we brought it to the market, and the value of that package was not what we needed to make the movie. So the director and I had to have a conversation. Do we replace that cast, even with the great actors we have, and recast to get the extra $2 million for the movie, or do we cut $2 million from the budget and make it with this perfect creative cast? And that's a conversation we have to have.

TAKOUDES: So, the producer is always balancing the creative with the budgetary issues?

PERELL: Yes, but at the same time the director needs to have a strong sense of priorities. Where does the director want to spend their time and money on the shoot? What's most important to them? Sometimes the line producer will come to me and say, "Oh god, the production designer and director have been conceiving this thing, and we can't afford it." So, I'll have to talk to the director and say, "We can't afford this," or, "Let's talk about doing it in another way." And sometimes they'll say, "Look, it's critical that we do this, and then it's okay," which is fine if it's really that critical, but we have to talk about these three things somewhere else in the shoot, and change them, so we can afford it.

TAKOUDES: Collaboration means that sometimes the producer has to say no to the director.

PERELL: Well, it's incumbent on the producers to not only say no, but to give solutions. Now, they might not necessarily be the solutions that the director wants, but the director is also going to need to be able to prioritize within the movie. A director can't give everything in a movie equal priority. The best directors are the ones who can identify the scenes in the movie that have the most importance. Because that allows the other department heads to allocate their resources properly. If we know that one scene is the dramatic crux of the movie, then let's give it the time and not rush it. But inevitably, that means we're going to have to rush other things. If there's an expensive location that is critical, then we have to hang onto this location, but let's know where we're going to economize. The director has to be able to have those conversations. As the producer, I might identify the other locations we need to compromise. They might be the wrong choices, and that's totally fine, but then the director has to be able to say, "What about these other choices?" It's just got to be a conversation. In the same way that the producer has to present solutions, the director has to engage in the conversation, and arrive at an answer. Especially in independent film, where you never have enough time to shoot the movie. I think that's the most interesting part of being a producer, especially in the low-budget indie world, being able to connect the creative and the budget.

TAKOUDES: What does the collaboration with the director look like during production?

PERELL: It depends on the movie and depends on the director. Certain directors will lean on me more; some directors won't lean on me at all. Sometimes I'm on set just waiting for a problem. It's great to have a presence on set to show that the movie matters, and it counts. And by leaning on me, I mean that some directors want me on monitor, and they'll ask me, "Do you think that was a good performance?" If it's a studio movie, you're obligated to be there all the time. I once had a movie that was so off the rails that I needed to be there to keep the movie on the rails as close as possible.

TAKOUDES: But if you see a problem with performance, for instance, how do you handle that?

PERELL: I always talk to the director first. And always privately. Never in front of anyone else. I will whisper it to the director. There are some producers who will make a big show of it. For me, if there's a major problem, then I'll have a sidebar with the director at lunch. I try to never have conflict, but conflict happens. It's the nature of making a movie. Now, it doesn't need to be yelling and screaming conflict. You can have a difference of opinion with the director and work it through, but I prefer to not put the director on the spot. I would never say to the actor, "I don't think you got that." I think that diminishes the director's relationship with the actor. The director and I will have a private lunch. And nobody wants to have that lunch. Everyone is miserable when you have that lunch. Because everyone just wants a break. But sometimes you have to.

TAKOUDES: So conflict resolution is another important skill for a producer to have.

PERELL: Definitely. But that also goes back to the thing about the director being willing to engage in a conversation. If I feel passionately, I don't have an ego to think I'm always right, but the issue should be discussed. Some producers rule by fear. That's not me.

TAKOUDES: Once the movie is shot, how does the collaboration with the director continue into post-production?

PERELL: Usually, after we wrap, I'll leave the director alone for six or seven weeks while they're cutting with the editor. And I'll tell the director, "You can come to me when you're ready and I'll see what you have." We'll talk once a week, more if they have a problem. Maybe a problem with the editor, or if they're scared about the footage. And then when a rough cut of the film is on its legs, I'll come and see it. And we'll have other people see it. But I'll also be talking about the other components. If there's a composer that we haven't talked about. Or if they've got $5 million worth of temp music in the cut, we'll talk about how we don't have that money in the budget for that music. But overall, they know I'm here if they have worries and problems. Sometimes I'll have a director come in

and say that we need to shoot three new scenes, and I'll say, "Let's wait. Let's show it to some people. Let's talk about it." And then it might be, "Oh we really do need these," or we can fix the problem another way. Maybe we can fix it in ADR [additional dialogue recording]. If we need to shoot new scenes, then maybe we have to cut some of the music. It's back to the creative and money balance.

TAKOUDES: It sounds like the producer is working as a bit of a therapist in post-production.

PERELL: It's different for every director. Some directors even hate shooting. The director and I might have a lot of fun before the shoot, and a little fun after the shoot, but during production it's a lot of therapy and handholding. But for most directors, at some point in the process there's that fear that the movie isn't working. So, part of the role of producer is therapist, for sure.

TAKOUDES: There are so many parts to a producer's job. Creative, budgetary, conflict resolution and therapy. How do you learn it all?

PERELL: You get better each time you make a movie. I will understand how all the pieces of a movie fit together, but I don't see the movie the same way a director sees it. I don't see the creative architecture. I can say, "You should get a close-up, and here's why," but I could never conceive the visual strategy. My job as producer is to understand what the director is doing and help them achieve their vision. But I can't direct. I can give script notes, but I could never stare at a piece of paper and write anything. I can see the overall picture, but I also know my limitations.

Interview with Becky Glupczynski

TAKOUDES: I'd like to start by talking about collaborating with a director during pre-production, and what you like to see a director bringing to the table.

GLUPCZYNSKI: I think it's important for the director to know what is the story that they're trying to tell. When I worked with Mike Cahill on *I, Origins*, I understood very clearly his vision, and when dealing with the budget, I could help guide him in certain choices that he was making. Because filmmaking is always a compromise. If I know that one element in the film is very important for him to have, and I understand why, I can give him that element while also saying that we might have to cut on these other things. It's because I understood what the movie was that he wanted to make, that I could make informed decisions on the budget. I could take his vision and be logical about scheduling and budgeting to film. But that can only take place if there's a clear understanding of what the director wants to do with the film.

TAKOUDES: Given a line producer's responsibilities, scheduling and budgeting, and helping to hire some of the department heads, how does a line producer help protect the director's vision?

GLUPCZYNSKI: Well, first, I usually can't budget until I do the schedule. I have to break down the script, and I have to know what are the days, how many actors we'll need, and what are the sets. So I do a rough breakdown.

TAKOUDES: And does scheduling come after talking with the director? So that you can get a sense of their priorities?

GLUPCZYNSKI: Absolutely. I recently did a film with [director] Bart Freundlich, where I already knew what he wanted because it was our third project together. We didn't have to have that conversation. Although I did have a couple of questions for him. But I usually like to go through the script with the director. I'll have all of my notes on the sides of the script.

TAKOUDES: What types of questions do you have to help you schedule?

GLUPCZYNSKI: Like, how are they thinking of a scene being shot? When I did *Maria Full of Grace*, Josh Marston and I had a conversation because I couldn't tell how he wanted to shoot it. Part of our conversation was there are no high-angle shots in the film, or mostly none, because everything is at Maria's level, to make the film feel like a first-person story. You don't really have any shots that are above her head. And it is entirely handheld. That can help me to inform the budget. If I'm reading things in the script ... let's say there's a wedding in this film ... then I want to know how many guests? How big is the wedding? If it's not clear in the script, I'll ask questions about special effects. The director Ben Zeitlin is a writer who comes from animation. So, he writes things that are literally only possible in animation. They defy the laws of gravity. His writing is very impressionistic. So, I need to go through the script with him and figure out what parts are more to describe the environment, what parts are more atmospheric, and what parts are practical. I can take what he says, and it informs me how many days this will actually take to film, based on what the material is and what it's serving in the story. Is this special effects or something else? And when I hear the director talk about each thing, I can also gauge their commitment to it. If one shot is going to be expensive, and I know they really want to get it.

TAKOUDES: You'll find an alternative.

GLUPCZYNSKI: Yeah. With someone I've worked with a lot, I can start pinpointing logistical things I see that might be a problem, and I know we could do something else instead.

TAKOUDES: So, in pre-production, you're building an infrastructure for the director, based on schedule and budget, to help them realize their vision. How does this collaboration extend to production?

GLUPCZYNSKI: Well, now I have a timed schedule. On set, I know in advance what each day is supposed to look like. I always start the day on set until first shot, because that is immediately going to let me know how the schedule is going. If it's a 6:00 a.m. call, and a shooting call at 8:00 a.m., but then we don't get the first shot until 10:00 a.m., you already know ...

TAKOUDES: It's a problem.

GLUPCZYNSKI: Yeah. So, I'll immediately start doing projections on what that means. I'll ask the director, "Are we dropping shots?" I also get a shot list at the top of the day. I like to know from the director, from the first assistant director, and from the DP, "Are were dropping shots?" "Are there shots that can be combined?" "What are the most important shots of the day?" "We're in this location tomorrow; can any of these shots be done tomorrow, or is that just going to set us behind for the rest of the week?" It's doing a lot of that kind of management. I need to know what the shots are in order to do that. In order to be effective. Or, if we're late and going to run into a meal penalty at lunch, I need to know, is it worth it? Because if we take the penalty and pay overtime, and it's an emotional scene, and the actor is there, then maybe we'll take the penalty. But I'm involved in that conversation because I'm the only one standing there with my hands on the budget. I'm the one who's responsible for it.

TAKOUDES: You have the most knowledge, on the ground, for what everything on set means for the budget.

GLUPCZYNSKI: This is where my accountant is my right-hand person. I'll call her or him and say, "We went over today, what does that mean for the rest of the week?" I'll have them help me with projections if I can't do it. If we hit three meal penalties, what does that mean for the rest of the week?

TAKOUDES: And what do you do with this information?

GLUPCZYNSKI: It depends on the situation. Usually, your first week is the most challenging because everyone is just getting their sea legs. You're adding a lot of new people to every department. So, I always feel like the first week is everyone gathering their bearings in this new environment. But if you start to sense that happening in the second week, it's time to pull the stops a little bit. It's usually a conversation that I'll have with the first AD, to look at the schedule and say based on this past week, "Have we overestimated anything?" Let's say we have this actor who's been getting everything in two takes, do we think we can save some hours on these other days now that we have an understanding of how we're working together, to compensate for other overages? If it's a no, then it's just a conversation with me, the first AD, the director, and the DP. That may be a moment when I go back to the script. That's a good way to talk to the director about things that we had discussed as possibly not being necessary. That's when those conversations happen in a more real way. It takes me understanding the director's aesthetic, but also how things are progressing in real time.

TAKOUDES: Is it the same dynamic with high- and low-budget films?

GLUPCZYNSKI: I've come to understand that there's never enough money. You always have constraints. So, with every film, the strategy is the same.

TAKOUDES: How have you seen the director communicate their vision to the crew?

GLUPCZYNSKI: Location scouting is a huge way to do this. Just to get an idea of what the spaces are helps the director communicate what the vision is. The

more houses you see, the more you get a sense of what the director is looking for. On this film that I'm doing now, there's a house that is central to the story. It's a big, fancy rich person's house, and there's so many different qualities, or types of rich houses. Is it a McMansion, or is it this, is it that? And then when you start to scout, I think it's an ability for the director to start communicating what is right with a location, what's wrong with it. What's the color palette that they're thinking? If you're looking for a location like an office, what are the elements in that office? It's more than just a desk and a computer. The more detailed conversations are about the backstory of the characters, then those elements can be woven into their clothing choices, into the knickknacks on their shelves. I think the more time that the director has to describe the backstory, it creates a richer feeling and look. And that also helps with the comradery on set; it can create a more united vision and a certain magic on screen.

TAKOUDES: That's interesting. How else does a director create that comradery?

GLUPCZYNSKI: Part of it has to do with graciousness. I've seen some of the best films made with directors who are gracious. I do think that that helps. Because it's stressful, it's long hours, there's always limited resources. But it's about more than just being nice. A director also needs to know how to give constructive criticism when they don't get the result that they want. The better a communicator the director is, the more it helps other people. Communication and graciousness.

TAKOUDES: Everyone has to feel appreciated.

GLUPCZYNSKI: Right. The tone and the attitude on set starts with the director. I did a movie in Montserrat, and right before we got to the island one of the generators for the island broke. There were rolling blackouts across the island during the entire time we were there, during production. So, everyone is sitting in the office wearing headlamps. We were constantly running around the island chasing electricity. Everyone was into the spirt of things.

TAKOUDES: How did those conditions not become demoralizing for the crew?

GLUPCZYNSKI: I think for that one, it's the type of people who were hired. The project was so challenging that it self-selected. We had a location that we had to hike a mile up a hill, so there's a certain person who's going to do that. But again, it's up to the director to keep everyone motivated. To be grateful. To thank people for what they're doing for your film. You make sure that everyone feels invested in the collaborative effort. To set the right tone at the beginning of a project and allow people to do their job – to let them work to the best of their ability, and for them to know that the director is grateful.

4. Tasks for the director

The director's collaboration with the producers usually represents one of the longest-standing relationships during the life of a movie. Producers are some of the earliest people to get involved with a movie, and they are deeply

involved with pre-production, production, post-production, and especially into the distribution phase of a movie's life. Collaboration occurs during all phases of this relationship.

The following chapter in the book is about the talent department, which is one of the most nuanced and vital collaborations that happens on a film set. The closer that this checklist is followed, the more organizational clarity there will be in pre-production and production, freeing up the director to spend necessary time with the actors.

1. If a film does not already have a producer attached, it is important for the director to find the right producer for the right film. A useful strategy is to look at the credits of films with similar budgets and genres to the director's film, and then create a list of the producers' names. It is likely that the same names will start popping up. Many producers have small production companies whose contact information can be found online. After the screenwriter has registered the script with an organization such as the Writer's Guild of America (in order to document proper authorship of the script), the director can email a pitch to those producers and ask to send the script for the producers' consideration.

2. Once a producer (or producers) is secured, early in pre-production, the director should explain her or his vision of the movie to the producers. This is an extensive conversation and will likely incorporate the director's and producers' views on the development of the script, to make sure that the director's vision is clear and fully supported by the producers.

3. The director should ask the producers' goals for distribution of the film. Generally, which festivals are they aiming for, or will the film be self-distributed, sold to a distributor, and on which platforms (such as streaming, theatrical, etc.)? These decisions are the domain of the producers, but the director should make sure they are well-informed and in agreement with these plans.

4. During pre-production, the director should work with the producers to set up meetings with the department heads so that updates on getting the film ready can be explained, and problems or challenges raised. This process should be transparent for everyone, and while it is up to the producers to assemble these department head meetings, it is important for the director to make sure that they are happening.

5. The director should work closely with the line producer (and first assistant director) to go through the schedule and budget, and make sure that everything makes sense and is agreeable to the director.

6. After the film is shot, the director will want to discuss with the producers a schedule for post-production. Given the many different moving parts of post-production, the director should know the producers' plans for how long each part should take, which vendors will be used for the editing and sound mixing, etc.

7. Movies are made to be seen. Finding a way to bring the movie to the audience is the domain of the producers, but again it is up to the director to remain informed and in agreement with these plans. A distribution plan should have been established in pre-production, but now that the movie is finished the director will need to ask about the timetables for executing that plan, and if any changes to the plan are warranted.

5 The director and talent department

1. Talent department overview

The director Paul Thomas Anderson was once asked about the thing that excites him most about movies. He answered that all he watches are the actors, and nothing else on the screen compares to what the actors are doing. It is certain that he—and the audience—are paying attention to more than just the performances, but the spirit of his message is meaningful. A movie may have a very low budget, so low that it cannot afford basic production design or a worthy camera, but as long as the performances are right, there is something to watch. The film can still work. This faith in the power of good performances to carry a movie, more than any of the other departments, was what Paul Thomas Anderson claims made his earlier, lower-budgeted films work—when he could afford very little production but could nevertheless inspire terrific performances. Unlike special effects or set design, a great performance costs nothing—other than the rate of the actor. But it also does not come easily. From casting to rehearsals to blocking, to gaining the trust of an actor, directing strong performances is one of the most important and nuanced tasks of a director.

This chapter examines some of the key steps to working with actors, to gain insights into the actor's craft, so the director can hone in on making the most out of this department.

Casting

Depending on the budget of a film, casting can happen in a variety of ways. We will look at some practical methods for finding actors in a moment, but the director must first consider what they are looking for in a role. Certain actors come with a financial value that can be a determining factor in casting. For instance, if a $20 million budget needs to be raised for a film, then the lead actors will likely have to be well-known faces whose celebrity will motivate audiences to come out and see the movie. This might be a decision based mostly in financing and budget. Of course, casting also requires a highly creative decision-making process. Why does the director choose one

actor over another? What is the director seeking in an actor? Talent? The right look?

Too often, directors' views on casting can be too narrow. One of the great gifts available to a filmmaker while making a movie is the gift of being surprised. A director's vision for what they want is just as important as, and should be balanced with, flexibility to allow new creative ideas and energies to improve and build up the director's original intentions. Casting is a wonderful opportunity to allow that process to happen.

The actor and director Chris Rock once put it well: when asked about his casting process in the capacity as director, Rock said that he hires the entire person. Not just a face. Not just someone who can say a line a certain way. He hires all of the intelligence and creativity, and the full spirit, of what that actor has to offer. Actors will often—and probably too often—get pigeonholed into doing a certain type of role, sometimes based on their appearance or previous work. Directors, as anybody might do in real life, can be susceptible to underestimating the depth and range of what actors have to give. Spike Jonze has spoken about casting Cameron Diaz in *Being John Malkovich* (1999), and how it took consideration to see past her sunny personality and physical beauty to cast her in a role (of Lotte) that had neither of those qualities. She offered more, in her performance, to that movie than most people might have guessed because Spike Jonze was willing to look deeper into her abilities as an actor. He allowed himself to be surprised by the range of her talents.

Casting is a process for finding the right actor, but also about discovering possibilities for who this character is. Directors should generally steer away from casting by type, or merely by a certain look. Casting is a brainstorming process where the director comes in with a vision for who the character is, but is also open-minded about how a range of actors make this character sound and behave. Casting is about both finding and discovering the character.

If the director finds an actor who brings forth a compelling vision for a role, but it is an actor different than originally imagined, the director should consider whether this unexpected casting choice has ramifications for the movie. For instance, does the script need to be adjusted to make the best use of the specific talents or charisma of the actor? Also, does this casting choice affect other roles? If an older or younger actor is cast than what was originally envisioned, then—for example—the love interest for that character might have to be cast differently to fit this new characterization. Do not be rigid; understand that bringing the character to life is more important than rigidly following what is on the page. A strong or unexpected creative choice might well create a domino effect of other choices that need to be reconsidered.

The casting process will look differently based on the film's budget. For moderately and larger-budgeted films, a casting director plays an important role in the process. The director will meet with the casting director to describe what types of actors the director is seeking for the film. The casting

director will usually supply headshots and reels of actors, and then use the casting director's professional connections with agents and managers, or the actors themselves, to organize auditions.

On smaller-budgeted films, where hiring a casting director is financially not always an option, the director may need another way to find actors. Contacting local theaters and schools, placing ads in theater and film magazines and websites, and getting the word out on social media are common ways to find actors. But directors can find actors anywhere—even among family members and friends. The director Trey Edward Shults cast his real-life aunt in the lead role of his 2015 independent hit film *Krisha* (2015). The actress, Krisha Fairchild, did have acting experience, but other films, such as Joshua and Benny Safdie's *Daddy Longlegs* (2009), starred Ronald Bronstein (an accomplished filmmaker and writer) in his first acting role. What the Safdie Brothers saw in Bronstein was a man of great creativity and spirit, and an unorthodox charisma, who could carry their film and bring the lead role to life.

In cases such as *Krisha* and *Daddy Longlegs*, there is no audition process. The director sees in the actor the collaborator that they need, and the pre-production moves forward to the next stage of planning. When auditions are held, it is best to keep the process organized and efficient. A video camera is useful for recording the auditions because performance can look very different on a screen as opposed to real life. Also, it is common for the director to feel one way about a casting choice in the room, but after a few days of thinking and reviewing the audition tapes (possibly with the producer and other key members of the team) to come to a different conclusion about which actor is right for the role.

Depending on the role, and what is required of an actor, the director might want to consider the possibility of working with non-professional or untrained actors. Correctly cast and directed, such actors can sometimes give a rawness or realism to the role that might be otherwise difficult to get from a trained actor. It can sometimes be hard to get non-professional actors to memorize lines of a script and recite them naturally—these are skills that trained actors spend years refining. But if allowed, to a degree, to "be themselves" and improvise on a set where they feel safe and encouraged, then non-professional actors can shine on screen.

Indeed, mixing professional and non-professional actors can also make for a potent dramatic mix. In David Gordon Green's drama *Prince Avalanche* (2013), actor Paul Rudd performs in a scene with a non-professional actor—an older woman named Joyce Payne—who, in the film, is looking for her pilot's license in the wreckage of a burned house. Green met Payne during the filming of his movie and learned that Payne's actual house burned in a forest fire. Green directed an improvised scene of Rudd speaking with Payne as she explores the ashes and debris of what was once, in real life, her home. This extraordinary scene mixes Rudd's talents as an actor with Payne's raw and true descriptions of the fire and her previous life in this home.

Every director runs their auditions differently, but it is a good idea to let the actor read the part initially without any direction, to see where their instincts for the role are. Then the director can give direction and see how the actor responds to those notes. That being said, the types of direction given to an actor during audition should stay away from suggesting how an actor might improve their performance or their craft; this type of feedback can be insulting. Instead, the direction could be an idea about a different way to approach the scene. For instance, the director might suggest that the actor try delivering the lines as if they had just heard some awful news, or great news, or otherwise change the dramatic circumstances of the scene, as a way to gauge if the actor will be able to adjust and grow their performance beyond their first instinctive read of the material.

In many ways, casting is an opportunity for the filmmaker to explore the possibilities of her or his film.

Rehearsals

Rehearsals are a time to build trust between the director and the actors. It is also a chance to deepen the understanding of the film. There is no prescribed way to run rehearsals—the process is different for every director, based on what they hope to achieve—but there should be some broad goals.

Actors frequently come to the script with a finely tuned sense of whether a character's actions and words are natural, honest, and believable. Given their training, actors are particularly adept at seeing honesty and sniffing out contrivance. It is a common occurrence that actors will come into a film with questions—wondering why a character would behave a certain way in a scene, for instance—and possibly suggesting other ways that the character might speak or act in a given situation. The rehearsal period—which can begin with just a one-on-one conversation with the director, or a group meeting with the actors and the director—presents a key opportunity for the director to explain anything that may not be clear in the script.

Different directors enjoy different amounts of rehearsal, but all directors should pay attention to their actors' needs. The director Mike Leigh famously stages rehearsals that go on for many months. Rehearsals for a Leigh film have included actors living the lives of their characters in the real world—taking on their characters' clothes and behaviors, and dedicating significant time to being that character in their day-to-day lives. During rehearsals for the film *Good Time* (2017), actors Robert Pattinson and Benny Safdie engaged in a similar activity. In the film, Safdie (who also co-directs) plays a mentally impaired man and Pattinson plays his protective older brother. They have recounted stories of being in character together in New York City, going to a donut shop on one occasion, ordering food, and gauging how strangers responded to them. Pattinson was so deeply in character, and costume, that he was never once recognized by the public.

Other actors, though, like to keep the material fresh and save their performance for when they are on camera. Due to scheduling issues and the expense of rehearsals, not all productions will be able to support this type of rehearsal. More commonly, rehearsals take the shape of the actors and director meeting in a room and working through the script. But what entails the work? What is the goal of rehearsing? Directors can sometimes fall into the trap of treating rehearsals as a time to simply run through the scene over and over. But rote repetition of the scene can damage or deaden an actor's performance, and is not a good use of anyone's time.

Generally, rehearsal is most useful when focused on blocking each scene. How and from which direction will an actor enter a scene? Where will the other actors move across the set in response? How will the actors leave or finish the scene? Figuring out spatially where everyone will go in a scene helps to give a physical shape to a scene, gets everyone thinking creatively, and allows the director an opportunity to think about where the camera should go to capture this blocking. Blocking can happen even if the location where the scene will be shot is not yet known. Whether the scene takes place in an office, inside a car, or on a circus trapeze, the general parameters can be imagined while working in a rehearsal room. Once on set, naturally, the space will look and feel different than everyone imagined during rehearsal, and adjustments to blocking will likely have to be made, but the general placement and movements of the actors are already settled. This will help save time on set solving problems in the blocking of a scene that could have been figured out weeks or months prior.

Beyond blocking, rehearsal is a useful time to explore the emotional and dramatic parameters of the scene. The actors and director can try different reads of lines or approaches to scenes. Inconsistencies or contrivances in a scene may be revealed, and a rewrite of a scene might become necessary. The director who listens to her or his actors, and takes their reactions with sensitivity and respect, is in a better position to inspire stronger performances on camera. This certainly does not mean that the director needs to take every note that an actor utters—to do so would be to surrender the director's vision of the movie—but for the director who hired these actors *as a whole person*, with all of their intelligence and experience, it makes sense to listen and at least consider the actors' instincts and creative thoughts on the scenes. It will also matter a great deal to the actor to know that they are being heard. This dynamic builds trust, deepens collaboration, and inspires riskier, better performances.

The director should not expect to see a perfect, complete performance in rehearsal. Rehearsal is not finishing work; it is not about refining or perfecting performance. In fact, doing so might be counterproductive. It is common for actors to want to just understand the emotional parameters of the scene, and the physical space of the scene, and save delivering their fullest performances for set. Some actors talk about giving 50 percent of the emotion of a scene in rehearsal, if even that much. Remember, the actor is already hired;

rehearsal is not a time where the actor needs to prove anything to the director, or to show what she or he is capable of doing.

This issue relates to the question of how long the director should rehearse the actors. Every director has a different approach to this question, but as a general principle directors should be wary of letting their actors' performance peak too soon. There is no hard and fast rule for knowing when this happens, but awareness comes with experience. If rehearsals get to the point where there seems to be nothing left for the actors, or the director, to discover about the scene, then rehearsals might have gone on too long. There is a certain magic that happens when a scene is being uncovered, when its secrets reveal themselves to the actors and director. That magic comes across in the performance. You can see it: the scene will feel new and fresh and exciting during this period of exploration. When the blocking has been figured out enough for the scene to run smoothly, but there are still unknown elements, mysteries waiting to be figured out, when there is a rawness still to the performances, then that is a good time to end rehearsals on that scene. This gives room for some discoveries to yet be made when the cameras are rolling, which is a strong position for the director. It is nearly impossible to recapture that early magic of fresh discovery. As the director, leave room for you and the actors to be surprised on set, without having to spend time figuring out the basic blocking.

Production

The pace of work in pre-production can seem positively luxurious compared to the rushing and tight schedules that can be all-consuming on set. There rarely seems to be enough time to get every camera angle the director wants, or do as many takes as the director would like. Working with efficiency—while also staying creative and flexible—are important (and yet sometimes frustratingly incompatible) goals to have on set. Successful rehearsals can help the director save time while directing performances and ensure that the actors can do the work they are capable of doing. If there was sufficient communication and time spent discussing the script with the actors, and exploring the drama parameters of the scenes, then frequently a type of shorthand develops between the actors and director. The Francis Ford Coppola film *Apocalypse Now* (1979) is infamous for its production problems, including an ill-prepared Marlon Brando arriving on set and not understanding his character or the book on which the script was based. Production on that movie was halted for days and weeks as Coppola and Brando discussed the script, so Coppola could answer Brando's questions. This is an extreme example, but the lesson is appropriate for any director: these deep discussions should happen in pre-production, during rehearsals or meetings with the actors. When filming begins, everyone should be on the same page, so the director can spend time watching the performance and refining what is playing out on

camera, rather than having to start from zero and explain the fundamentals of character and story.

Direction on set is often best when it is both specific and open-ended. One instructive bit of direction comes from the late German choreographer Pina Bausch. During a performance, she was known to have told a dancer, who was about to step on stage, "Go out there and scare me." The emotion of this direction is specific, but the interpretation of how the dancer should go about "scaring" Bausch is left for the dancer to figure out and execute. Film directors can learn from this because it allows the director to remain in control of how they want the scene or performance to *feel*, while also trusting (and therefore empowering by virtue of this trust) the actor to be creative and take a risk.

Film direction should stay away from ever telling an actor *how* to act. A film set is not an acting class, and the director is not an acting coach. Directors who implore their actors to do things like "act happier," or "act more sad," or "act more excited," will find themselves undermining the actor's performance. These are common mistakes for directors to make. For an actor to be told to "act happier" can be confounding because it is telling the actor what to do instead of allowing, or inspiring, them to do their craft. To "act happy" is not open-ended direction: it shuts down the actor's interpretation of a scene, or a moment in a scene, and encourages the actor to merely pantomime the emotion, rather than discover the right emotion of the scene through discovery and creative interpretation.

Something else to be avoided is over-directing. This happens when a director tells an actor too many things, gives too much information, or tells them too often what to do. When actors say that they have favorite directors with whom they like to work, frequently those actors feel safety and freedom with that director. It has been said of Orson Welles' direction that he made his actors feel like they could never fail. That does not mean every choice an actor makes is right for the scene, and naturally the director needs to step in and make sure the actor's choices work for the scene. But if the director can make the actor feel safe and valued enough to explore and experiment, to stretch themselves as far as possible, then the director is likely to get that actor's best work. It is up to the director to set this tone on set—to make every actor feel valued and welcome to ply their craft. To collaborate.

In the meantime, the director should stay away from "line reading" an actor—that is, when the director says the line how they want the actor to say it. This type of direction could make an actor feel patronized, or like they are merely a "hired hand." It creates pantomime, not performance. Just as the director would be insulted if a producer ever told the director how to direct, the actor would feel insulted by being told how to act or how to feel. The great director Mike Nichols once said that most of a director's job is to explain the scene to the actor, so that everything makes sense to them, and then to let them do their job.

The actor is the most vulnerable person on set: they must weep, scream, be funny, or expose their character's sexuality in front of a camera crew. The emotional risk and vulnerability that actors are willing to make should be respected, and if the director can understand that, then they have already made headway into becoming a better actor's director.

That said, the director must retain control of the scene. The director has a vision and cannot let that vision slip away. So, how does the director shape the performance without shutting down the actor's voice and abilities? If a director wants the performance to go in a different direction than what the actor is offering, the director must come up with a language, or set of scenarios, to guide the actor. The "specific but open-ended" approach is useful, and often directors will create little scenarios to put in the actor's head.

"Imagine you've received tragic news before entering the scene, but you can't let anyone know."

"Play the scene as if all you want to say is you love them, but you've promised yourself that you won't, so you're saying the other lines from the scene instead."

"Try your lines like they're pillow talk."

"Remove one line of dialogue and say it with your eyes instead."

The direction needs to work within the parameters of whatever the scene is, and the director needs to be comfortable with what scenarios they might paint. However, these types of direction can get the actor to deliver a different type of performance for the director, without the director patronizing or judging the performance, while also allowing the actor to remain creative.

At the same time, the director should be aware of how each individual actor prefers to work. Steven Spielberg has spoken about how he makes himself into a different director for every actor. He gives the example of directing *Close Encounters of the Third Kind*, where his notes to Richard Dreyfuss tended to be rather mechanical; Dreyfuss preferred hearing practical corrections to his performance, such as to move his mouth slightly one way or another, or to open his eyes wider on the next take. However, when directing Melinda Dillon, Spielberg would have deeper conversations about character and motivation with her, because she preferred working from a place of internal discovery, and then allow Dillon to make her own choices about the mechanics of her performance. It is up to the director to conform to what the actor needs, and work in the methods of how the actor likes to work.

Other directors like to keep things fresh on set by introducing new elements to a scene while filming. There are times when the scene is not working, and everyone seems stuck and unable to figure out how to fix the problem. Often the director will not even know what the problem is—they will just see that it is not working. A quick script rewrite can bring new energy to the scene. The director can also try to introduce some improvisation. For instance, if one character is meant to walk out of the room, the director might whisper to another actor to attempt to keep them in the room, no matter what. If the actor who is supposed to leave encounters a new element

in the scene, something they did not anticipate, then this improvisation might open a possibility for how the scene flows that could make it better. As the director, feel free to experiment on set—as long as the actors are willing to go along for the ride and feel invested, and as long as whatever new element is introduced into the scene (or if some element is removed), the scene will still work in the context of the rest of the movie.

Directing actors is one of the most critical parts of the director's job. A movie can be shot beautifully, and written well, but if the performances do not work, then the movie does not work. Directing actors takes experience on the part of the director—knowing who to cast and how to collaborate with them. Ultimately, every director needs to find her or his own methods that work, but these guideposts can help put the director on a useful path of discovery.

2. Director case study

This case study looks at two directors—John Cassavetes, the so-called godfather of American independent cinema, and Robert Bresson, the French master of poetic cinema. Cassavetes coaxed his actors to perform in the extreme, baroque emotions of film acting, He preferred to work with actors who were also close to him personally; he was married to one of his most frequent leading actresses, Gena Rowlands, and was lifelong friends with his frequent starring men, Ben Gazzara, Peter Falk, and Seymour Cassel.

Bresson, on the other hand, directed performances that were restrained and quiet, and came as close as any filmmaker, perhaps, in depicting the raw human soul on screen. He preferred to work with his actors only once, and was known to seek a detachment and distance from his actors, sometimes rarely even talking to them on set, an approach that helped bring the overwhelming loneliness of their performances.

Both directors managed to get their respective actors to turn out some of the best work of their careers, and their directorial techniques yielded worthwhile insights into their craft. There is no single correct way to work with actors—there is only the director's vision and how she or he wants their film to look and feel. Based on this vision, the director will approach the actors with various methods. Let us look at a few of the methods of Cassavetes and Bresson.

There is a scene from the Cassavetes landmark film *A Woman Under the Influence* (1974) where the character Mabel Longhetti (played by Rowlands) is having a mental breakdown. She had suffered another breakdown earlier in the film, which led to her being admitted to a mental hospital for six months. Having struggled mightily with the separation from her three young children and husband Nick (played by Peter Falk), both Nick and Mabel are adamant that a hospitalization never happens again. However, Mabel and Nick are on different courses: Nick feels he can hit, shout, and generally use force to control her and make Mabel sane again, whereas Mabel is seeking desperate,

animal-like escape from him, even by way of suicide. This is a scene of alarming intensity, and one of the most brilliant pieces of acting ever performed on screen.

So, how did Cassavetes direct these performances? Let us start with a seemingly minor detail. There were no marks on the floor. Marks, on traditional movie sets, are bits of tape or other markers, hidden discreetly on the floor, that indicate where the actor is supposed to move during a scene. After setting the lighting and focal lengths on the camera, the director might instruct the actor to land on a certain mark before saying a line or doing an action. The actor's pathway through the scene is often proscribed with precision to ensure that they are in the correct light, and in focus, at key moments in the scene. Such stagecraft can make the production quality of a film high, but such restrictions on movements can be limiting for some actors. They must match their emotions to the particulars of the physical set—the lights and camera—sometimes at the diminishment of their performance. Films with heavy doses of special effects, such as superhero movies, often do not showcase the actors' best work because, in part, their performances often take a back seat to make sure they are hitting the many marks required for visual effects.

Cassavetes gave his actors freedom. Without marks on the floor, his actors were able to make decisions about where to go on set based on their creative impulses. He lit his sets with a more general lighting scheme, so they would be in sufficient light no matter where they went. Camera operators on a Cassavetes set had to be ready for the actors to behave differently from one take to the next, and to follow them—almost documentary style—wherever they went. The feeling on set was made electric and unpredictable—a cauldron of actors and the camera operator all working independently, each having to think quickly to keep up with the flurry of activity. For a director who wanted to create an environment where the performances felt desperately alive and unpredictable, Cassavetes' priority on set was toward allowing the actors to fully perform their craft, sometimes at the expense of the other departments. Because his films wound up feeling so "real," audiences frequently believed that Cassavetes' films were improvised; in fact, they were fully scripted. Cassavetes explained that the lines of dialogue were written—he would write and rewrite his scripts for, sometimes, years—but the *emotions* of the scenes were improvised. He allowed the actors to do what felt right for their choices for the characters. Famously, he gave his actors little to no explanation when they asked about their characters' backstories or motivations. His belief—even when they grew frustrated with him for not guiding them—was that the actor knew the character better than he did. Cassavetes might have written the characters, but once the script landed in the hands of an actor, in Cassavetes's vision of filmmaking, the actor was in charge. The lifeblood of cinema for Cassavetes was performance.

He would reliably roll another take when an actor asked to redo a take. If there was some other aspect to the scene, or character, that the actor wanted to explore, then Cassavetes gave them the faith and trust to do it again.

Likewise, he never stopped a take if an actor "messed up." Everything that happened in a scene—whether planned or unplanned—was potentially useful for Cassavetes. After all, unexpected things and accidents happen all the time in real life, so why not in his movie, as well? Cassavetes listened to and observed what was happening on set—what his actors were feeling and doing—and would incorporate these elements into the scene. For instance, in the scene where Mabel is having a breakdown, and Nick is trying to control her, the initial thought on staging the scene was that Nick would put their three young children to bed, and then subsequently the confrontation would play out between Nick and Mabel. But when it became clear that the impulse of the child actors was to stay with Mabel during her crisis—the children had become very bonded with Gena on set, and did not want to leave her side during a moment of crisis, even within the context of the film—Cassavetes listened to what the children naturally wanted to do—be with their mother—and incorporated this into the scene. In the film, Nick keeps trying to put the kids to bed, and the kids continually escape and rush back to their mother's side. This dynamic, and added blocking, adds tremendous depth and stakes to the scene.

Cassavetes was more interested in people—their behaviors (good and bad) and their needs and wants—than he was in having a movie that flowed with traditional dramatic structure. Allowing his actors to be themselves, to dig deep and experiment, he found those human impulses within the actors' performances that helped create such powerfully acted films.

At the same time, Cassavetes did not just bow down to his actors' whims. If a performance did not feel right or was not honest enough, Cassavetes was known to use a host of tricks to shake things up. In one case, he leaped onto an actor's back during a scene and made the actor carry him around during the scene, tickling the actor as they went. He cajoled, laughed, became furious, and did everything he could to inspire his actors to do more, dig deeper, and not be complacent or predictable in their acting choices. On his films, rehearsals blended into filmed takes, and frequently the actors were not quite sure what was going on. Were the cameras rolling? Was this real life or the scene? Who was the camera supposed to be filming—them or another actor? Non-professional actors worked alongside professional actors, keeping everyone on point and unsure about how the performances would play out—were the actors responding to each other as real people, or as characters? Cassavetes kept an electric presence on set that kept everyone moving, guessing, ready for the unexpected. To watch his films—especially a scene such as the final breakdown in *A Woman Under the Influence*—is to witness film acting that is wild, enigmatic, and deeply brilliant.

The performances in a Bresson film are also quite brilliant, but differently than a Cassavetes film. Bresson worked to find the internal world within his actors—he wanted to film their thoughts, as impossible as that sounds for an external medium such as film. He wanted to record the quiet and the isolation within their souls. He and Cassavetes shared a similarity in that both directors were

highly interested in people, and viewed humans as endlessly fascinating creatures. Indeed, it is likely that most directors who work well with actors are likely to have a great deal of curiosity about the human condition and to be highly observant about people in general. Bresson was known to have claimed that he directed people, not actors. There is some literal truth to his statement: he frequently worked with non-professional actors.

But Bresson's approach was highly formalized, where he would rehearse his actors to the point of exhaustion. Asking them to repeat the same lines over and over, repeat the same physical actions within the scene—often doing up to 30 or 40 takes of a single shot—Bresson would turn the actors' performance into something that was ritualized, rote, and void of emotion. Bresson suspected that many humans sleepwalked through life, and he wanted to portray that same deadened, monotone quality in his actors' performances. If this sounds like the making of boring, emotionally flat scenes, it is not. There is a saying that if a speaker is addressing a crowded, raucous room, the speaker's instinct to quiet everyone down might be to shout louder than everyone else—to make himself heard above the din. In fact, a more effective strategy to quiet the room might be to begin speaking softly. The crowd will quiet down to hear the quieter sounds. Everyone leans in, focuses stronger, increases their awareness to listen. This dynamic is akin to a Bresson movie. To watch his films is to feel one's sensitivity to the human condition grow, one's awareness of others deepen.

In the opening scenes of Bresson's film *Pickpocket* (1959), we see the protagonist Michel stealing a wallet from an unaware stranger. The theft makes him feel elated, with "the world at my feet," he states in voice-over. Moments later, he attracts the police's attention and winds up in a car ride to jail. During each of these scenes, Michel's expression barely changes. The actor does not emote in any traditional sense of film acting. And because the actor (under Bresson's tight direction) gives the audience so little of his own emotion, the audience internalizes his circumstances. The performance leaves a gaping hole where another actor might put their emotions, and in that empty space the audience puts its own emotions—feelings of nervousness, elation, and despair—to the scene. The connection to the performance is intense. Bresson flattens his actors' performances, refusing to let the actor approach the audience, so to speak, and instead forcing the audience to approach the actor. The actorly affectation was gone, and what remained were the very subtle traces of humanity. In one scene, Michel—who has fallen in love—addresses the man who is proving to be a rival for the woman's affection. Michel asks the man, "Do you love her?" A moment later, Michel asks, "Does she love you?" Michel's voice drops to a slightly lower tone while delivering the second line, and in this slight shift we hear the desperation that he feels so deeply but would never publicly reveal. Michel is a cautious speaker and loathe to reveal his emotions, and he barely does at this moment. But we feel it strongly because Bresson has been coaching us to become more attentive listeners to such slight shifts.

Whereas Cassavetes ran around his sets full of energy and excitement, Bresson was monk-like. These are unorthodox techniques for directing actors, but they show the power of directorial style to creating certain types of performances. Cassavetes' performances fill the screen messily; Bresson performances fit tidily within the frame, packed neatly and requiring effort by the audience to find the seams and unbox them. But both directors were powerfully consumed and endlessly curious about the human condition. Directing actors is as much about the techniques outlined in this chapter as it is about understanding people and finding a method to bring about the types of behaviors and performances that most interest the director.

3. Interview with actor and casting director

There are two interviews in this section. The first is with Daniel Sauli, an actor whose work has appeared in both television and film. He has had roles in *United 93* (2006), directed by Paul Greengrass, and the HBO dramatic series *The Deuce* (2017). The second interview is with Rebecca Gushin, a casting director whose credits include the feature film *Allegiance* (2012), directed by Michael Connors, and who worked as a casting associate on the television show *Billions* (2017).

Interview with Daniel Sauli

TAKOUDES: In your experience, what types of direction do you feel are most useful to you as an actor?

SAULI: Directors need to be specific with what they want. If the actor's not doing what the director wants, they either need to be really well versed in what the actor's work is, which allows them to use kind of trigger phrases, or sentences, or they just need to be super specific. You need to have a director who understands what the emotion is supposed to be.

TAKOUDES: And be able to talk in a way that is helpful to the actor. To not sound confusing or patronizing?

SAULI: Yeah. Any endeavor, if you're trying to understand the craft of something, you understand that it has precedence and it has different elements that hold the thing up. And acting is an integral one to directing. So, the director needs to understand the ABCs of acting. The idea is like, don't say, "When you're getting into character …" or "When you're building a character …" No, no, no. None of that. Talk about the emotional connective tissue of what's going on. The director has to have an idea of what they want the moment to be, and they need to figure out a vocabulary to trigger the actor to go in that direction.

TAKOUDES: Is that at the heart of the collaboration between the director and actor?

SAULI: A collaboration is when a director says something and it immediately makes sense to the actor. So, what does that mean? It means the director needs to know what they're talking about. And that means they either need to be an actor, or they need to know something about acting, or just be super clear on what they want—and be able to transmit that to the actor.

TAKOUDES: I'm curious about the types of triggers a director might use.

SAULI: Well, for instance, I've directed. And the best things I've done as an actor who's directing is just to guide. I'd set up a question, with a note or an idea, and then I'd let the actor resolve it. So, it could be a simple thing like, "Okay, you're going to come over here and pick that thing up. But then when you put it back, put it back with a different quality."

TAKOUDES: Would you say what the quality is?

SAULI: No, that's the point. You let the actor figure it out. All you're doing is giving a framework for that actor to do their work. They know that something has to change there.

TAKOUDES: And you let them figure out the change.

SAULI: Yeah. But it's all about casting. The director's intuition on casting is really going to make or break the project. You hire them, and sometimes it's important to know when to leave the actor alone.

TAKOUDES: Mike Nichols once said that most of the director's job is to make sure that the actor understands the parameters of the scene. If the director can guide the actor through the events of the scene, then you let the actors go. But to do that, of course, you have to cast correctly.

SAULI: I can't possibly presume to know any more than Mike Nichols, but that seems to make sense to me. You have to cast your film well. And I know that's easier said than done, and there's a lot of factors that go into it that are difficult and pose a lot of challenges, but as the director you need to reduce the amount of work for yourself. Casting is nerve-racking. But when an actor is bringing things to a role that the director never imagined, that's the dream.

TAKOUDES: As an actor, do you ever find yourself looking to the director for an answer?

SAULI: No. I'll do it, and if it doesn't work they'll tell me. And if you don't hear from them, you're either doing what they're seeing, or someone's not paying attention and you'll see it later. There's a problem with overdoing analysis and overthinking it. Do whatever work you need to do to get relaxed, get comfortable, and then go do your work beforehand. And you may not like the director, but you just go and do what you do. A collaboration with the director is not an immersive thing for me. The whole project is immersive. And the outcome can be immersive for the viewer, but it's not like you sit there and psychoanalyze. You show up and you're loose enough to jam, to think on the fly.

TAKOUDES: To be clear but also open-ended. Like directing the actor to put the thing down differently.

SAULI: And that goes back to casting. If you're not open-ended, then why'd you cast me? Or if you're not open-ended to this being something better than what you envisioned, then why are you setting forth and doing it in the first place? Making a film, it's not architecture where if you get an angle off then your structure doesn't work. It has to breathe. Films change and live and breathe. Go back and read about that happened in *There Will Be Blood*. Look at the twin role with Paul Dano. It makes no sense. Go back and read about what happened.[1] It was a casting thing. And was that not a masterpiece? It was a masterpiece. All these things that happen by accident … you have to be open to it. Some directors get neurotic and nervous. There's money on the line, or they feel like *this is my shot*. But it's a piece of art, for lack of a better phrase.

TAKOUDES: And in order to let the film breathe, the director needs to let the actors breathe.

SAULI: The director needs to have a basic understanding of psychology, and also needs to understand what acting requires. Not like individual technique of a person, but having some kind of inner idea about the emotions of the scene, and transmitting it. You get a director who respects acting as a mysterious thing. Maybe all they'll be able to do is give the actor a response to what the actor is showing. Which is good. That's a good collaboration. A director who doesn't presume to know is fine. But they have to create a comfortable and safe environment and then they can work with what the actor is doing.

TAKOUDES: How have you seen directors create a safe feeling on set?

SAULI: Well, the energy is discernible.

TAKOUDES: The energy from the director?

SAULI: Yeah. The energy from the director trickles down and everyone on set feels it. Directors can sometimes mitigate the fear that happens on sets with this energy. The actors feel the energy from the director. And I've seen it affect performances.

TAKOUDES: So, a director who responds to an actor with clarity, who creates a safe environment, and who respects the actor's process, that's helpful to the collaboration. And it's important that the director allows the actor room to be creative and do their work … and not over-direct them, right?

SAULI: Over-direct?

TAKOUDES: Tell the actor too many things about what they're supposed to do.

SAULI: Directors do that because they don't know what they're talking about. Or they do it because they're nervous. The highest-caliber directors that I've seen, they're attentive. They establish the parameters for what the scene is, and then let the actor do their work. To think on their feet. I've seen it where the actor proposes something that saves the whole scene. The director needs to be attentive. I don't think there's much mystery to the actor–director relationship, beyond the mystery to the whole process, which is very mysterious.

Interview with Rebecca Gushin

TAKOUDES: Casting is one of the most important tasks that a director does on a film. Can you talk first about how you begin the process of working with a director to cast?

GUSHIN: I start by looking at the script and at the characters, and also talking to the director. Before I get hired, I want to make sure that the director and I have a similar take on the material and on the characters, because if I'm way off base then I might not be the right person to cast it. But other times that could mean we won't see eye to eye. And maybe that means we have a different take on the material. And the director needs to find a casting director who has the same take and taste that they have. But how I approach it is, you want to talk with the director about who a certain character is—where the character starts and where they end up in the story. What I try to do is give the director a thing that I tend to term "what you're looking for *and*."

TAKOUDES: I love that term.

GUSHIN: Yes, it's an actor who fulfills what is being discussed about the character—certain qualities—*and* brings something unexpected. Something new. Because generally speaking, no actor is going to be exactly what the writer wrote, and I think what is important is to be open to that idea and accept possibilities. The director is just not going to find someone who is exactly in their head. And I know some people write with a particular actor in their head, someone famous, but they know they may not be able to get that actor. They just used that actor as a visual or a voice. Which is fine. But then when you're casting, you have to go away from that, and that experience can be very difficult for some people because they get locked in to what they've envisioned. I think a director has to be open to something new and something different. Someone who comes into the audition, and you look at them and you see aspects of the character embodied in that person, but you also see something different. Of course, that something different might be wrong for the character—but sometimes it's really interesting, and it deepens the character. Without taking the script in a totally different direction, the *and* brings other aspects and qualities to the role, and that's what I think is really exciting, and that's what I tend to look for.

TAKOUDES: So, casting decisions can shape the character on the page. Perhaps bring out a new lightness that wasn't written in the script …

GUSHIN: Or a darkness. Or a sexiness. Whatever it is. And that can be really difficult when you can't audition the person. It's one thing if the actor comes into an audition and they read, and you see that *and* happen. It's really exciting. Usually, for most people, they go, "Wow!" But a lot of times for first-time directors, or on some short films, you don't always get to audition the lead role. But you can look at their previous work and see what they can do, and something that's really intriguing. Some directors need to hone the skill of looking at an actor based on their previous work

and just seeing their range, and seeing their ability, and seeing that they can do something different, even if you haven't seen this exact character in their work. That's something that casting people do, and we see, and we know, and sometimes a casting director has read these people for other parts and they can say, "I've worked with this actor. I have a sense of the person that I can communicate to the director." But the director has to trust me, trust the casting director. So, that's at the heart of this process, too. If you cannot audition the actor, and you're looking at some film and you're not seeing the exact character, sometimes that's why we suggest that actor: because we know they can do it. We feel that it would be fun for them, that they'd want to do it because they haven't done it before, as opposed to something that they do a lot.

TAKOUDES: In a way, the casting director can have a deeper sense of the character than even the director does. The director sometimes has some blind spots because they've been living with the character a long time and maybe they're a little stuck, or stubborn, in who they think the character is.

GUSHIN: Most casting people have worked on more films than their directors. A director sits with a film for a very long time and it can take years. A director might have five films under their belt, but a casting director will have worked on many times more than that. We have a mental database of actors, having auditioned people throughout our career, that we can come in and say, "I get what this character is, and we've talked about it and we're on the same page, so I'm telling you that these three actors are going to be it." Especially for a smaller film, you're often looking at more up-and-coming actors. So, those are people who have done a bunch of guest star spots, or recurring roles on TV, and had a nice scene in a movie, and *those* are the people who casting directors see many times, because they come in for auditions as they're moving up the ranks. They're not people who directors, even if they watch a lot of theater and film, are necessarily going to be keyed into.

TAKOUDES: Let's talk about how to know who to choose for a role. One factor is thinking about how the cast, as a whole, will work together.

GUSHIN: My original mentor, my first boss, talked about casting as feng shui with people. What you're looking for is visual balance. The director has created a world, and I'm looking to populate that world. Make it come alive with people. From a visual standpoint, I don't want all the actors to look the same. I think it makes the visual palette more interesting when the characters have different looks. Which isn't to take it to extremes. Maybe there are characters who are mirrors of each other, and I think it could be interesting, but especially for a short film I think that's problematic because you don't have time to draw out the differences. So that's part of it, too. In a short film, you have to be very visual because you have to understand the characters more immediately.

TAKOUDES: I think some actors are a slow burn; it can take time to see their craft and personality emerge. Which is fine for the right role. But other actors just pop immediately on camera.

GUSHIN: The slow burn works if you have more time with that actor on screen.

TAKOUDES: Right. And another issue with casting is how long is the actor going to be on screen? If it's for a short period of time, then it's an issue of what is that person bringing to the role and how fast can they bring it?

GUSHIN: Yeah. A certain actor can have a very strong sexiness, which might be a shorthand for the audience to understand what that character is doing. There are actors who will bring a certain quality, and they'll have it in spades so the audience doesn't have to reach for it. I usually shy away from typecasting, but sometimes, if there isn't much time on screen, it can be helpful. The actor naturally has a quality that you don't have to spend a lot of time reaching for it, or stylizing them to have that quality. It's just there.

TAKOUDES: So, you want to cast for the big picture, to think about the balance of variety of looks, when it's appropriate. What about chemistry reads, when two actors audition together to see if they have a natural spark together?

GUSHIN: I think that when you do chemistry reads, the spark is obvious. You just know when people have chemistry.

TAKOUDES: As soon as they start interacting?

GUSHIN: Yeah. It happens or it doesn't. It's not something that you can create. And you should feel it in the room, I believe, as well as see it on the monitor. The camera will pick up the chemistry, but I don't believe that the camera can supply chemistry.

TAKOUDES: Let's talk about that, what an audition feels like in the room versus on camera. Actors can come across differently in those two ways. What's your experience with this?

GUSHIN: Some people do just really pop on camera. It's almost a model thing. The camera likes their features. There's some sort of relationship with the camera that just happens. I don't think it's something that can be taught; I think it's organic. It's an interesting phenomenon that someone can be a good actor, and you can like them in the room, but it just doesn't quite happen on camera.

TAKOUDES: What are some of the things a director should be doing during an audition, to get what they need out of it?

GUSHIN: I think the director shouldn't be afraid to direct. And I think that's something that a lot of younger directors realize after they've done their first project. Actors want to be directed. And that's not just talking about in the audition room, that's talking about on set, as well. The director has lived with this material for longer than the actor has. The director knows more about the script. The director knows what they want the movie to be. Or, at least in theory they do. So, the actor wants to be guided. They want it and they need it. In the audition room, if there's someone who has

some kind of quality that's interesting, you might as well get in there and give them an adjustment. If they're not doing what you want and they have a wrong take on the material, maybe it can be fixed. Maybe it can't be, but you might as well see.

TAKOUDES: Talk to me more about the *and* quality as it relates to something the director should be open to. Clearly, the director and actor need to be on the same page about the material, and the actor needs to be able to take some direction to see if they'd have a good working relationship. But where does the *and* quality come in?

GUSHIN: It's because the actor is a human. They're a human with experiences and opinions and a take on the material. No one will see a script entirely the same. That's impossible. You can only see the world through your own eyes, so yes, the actor is going to bring something else, something different than what the director is expecting, because they're a different human from the director. You can direct them as much as possible into the area that you want, but how the actor is going to explore that area, or find it, comes from the actor. And things will come out of the actor that feel organic or true, and hopefully within the director's parameters for the role, but are based on what the actor is feeling in that moment as they're exploring that scene.

TAKOUDES: That means that even in the audition room, there is some discovery about who the character is.

GUSHIN: There has to be. Of course, comedy writers are often less open to this, for reasons that I understand, because they've set up a joke. If you change a line, then the joke won't be set up properly. But a lot of people rewrite the script after the audition process, because they've taken some discoveries made in the audition, word changes or whatever. The director is hearing the lines and going, "Oh, that works," or "That doesn't work," or "That sounds weird." And actors often, just organically, even if they don't mean to improvise, will kind of change little things to make the words come out of their mouths better, that feel more organic. Because the actor's job is trying to make the part sound real and feel natural. I think it's great when directors allow actors to improvise a little, to tell the actor that they don't need to be word-perfect, because you will find things about the script, or about certain lines, during the audition. The audition is an exploration in many ways—to hear the dialogue, to find the right actor, to discover the *and* quality.

TAKOUDES: I love the idea that you can provide backstory to a character just by the casting choice. You suggest a certain life that the character has lived by how you cast it.

GUSHIN: Often it's a quality that's behind the actor's eyes. There's something intriguing going on. The actor is a human and they've lived a life, and therefore they're bringing that life to the character. They're giving themselves to the character ... and that's for free, almost.

TAKOUDES: It's writing that the writer didn't have to do.

GUSHIN: Exactly. The director can look for these qualities. For me, I think the most interesting acting is the acting that's done without lines. The silences in between lines. Or when you see someone react to something. I think the most interesting stuff is not when someone is crying, but the moment *before* they're crying. When they're trying not to cry. Because there's a whole world of emotions going on. Once you're crying, there's just the one emotion.

TAKOUDES: How does a director look for quiet and silence in an audition, when there's so much going on? Actors coming in and out, a new space that can feel artificial, and a schedule to keep?

GUSHIN: As a casting director, I do my best to make the room as welcoming and friendly as possible. Actors are going to have nerves. And sometimes the nerves are going to help. But at the same time, you want the room to be as welcoming as possible so that the actors feel confident. Try not to rush the actors. You also want a good reader, someone to read the lines with the actor. You don't want to have a casting director who is flat and doesn't give the actor anything emotionally. Good acting is reacting. Listening. But if, as an actor, you're not getting anything, how are you going to give a good performance? Because then it's just all self-generated, and to me that means it's automatically a little bit false. The actor is having to create something that's not there. Part of the trick of a good audition is to have a good reader.

TAKOUDES: I get the sense that a lot of casting directors have backgrounds as actors.

GUSHIN: Yes, most. But not all. I think it's pretty natural to come to it through that process. For whatever reason, you don't want to live an actor lifestyle, so you become a casting director. Casting directors have to be able to speak actor. They have to be able to speak agent. And they have to be able to speak, to a certain extent, director. So, those are three languages of the casting director. I think the reason that many actors make good directors is not necessarily because they're good visual stylists, but because they speak actor very well. And it behooves a director to be able to speak actor. That means to take a couple of classes as an actor. A director has to know the actor lingo so that you can help to direct them most effectively. You can talk to them about action and intent. That helps the director do a better job, to speak the actor's language. But it also helps the director break a scene down as an actor would—not as a director would, but as an actor would. You see it from the standpoint of what the actor needs.

TAKOUDES: And this allows the director to collaborate with the actor

GUSHIN: All of film is a collaborative process. The director has to be open to the wardrobe person, and to the cinematographer, to all the department heads. The director has to be open and accepting of all these people who are coming in as experts in their respective departments, who come to the director and say, "I think this is the best way to get what *you* want." We're all here to serve the director's vision, and we're saying, "This is the best

way for you to get it." Every department head needs to understand what the director wants, but the director also needs to be open to hearing that there may be a better way to do something—that during the audition process, there might be a different way to bring a character to life.

4. Tasks for the director

Successful collaboration between the director and the talent department largely depends upon strong casting choices, developing trust, and communicating in positive and effective ways in rehearsal and on set.

The following chapter in the book discusses the director's relationship with the assistant director and unit production manager, whose management of set operations are fundamental for allowing the director and talent to work as they best see fit. Below is a list of tasks for the director to use when collaborating with the talent.

1. The director should make notes on each character before casting and be sure that other key members of the team—such as the producers and casting director—have access to these notes. The process should begin with a clear vision of the character, but the director should be open-minded and willing to be surprised by the audition experience.
2. After the roles are cast, find a time to meet with the actors to discuss the character and the script. The director can then assess how the actor likes to work and create a rapport. One-on-one, in-person meetings are often the best for this type of meeting. The director should come prepared to discuss her or his perspectives on the material, talk about their connection and vision for the movie, and to hear the actor's perspectives and questions about the script.
3. For rehearsals, the director should feel free to consult with the producers about where the rehearsals should take place (someone's home, a rented rehearsal space?) and how many rehearsals they might be able to get out of actors. Depending on schedules, some actors might only have time for a single rehearsal. This should be figured out ahead of time so that everyone's expectations are clear. The director should come to rehearsals with specific goals (Is this just to figure out blocking? Will there be improvisation?), as well as a clear sense of which scenes they will be rehearsing. Letting the actors know all this ahead of time helps ensure that no one is caught off guard.
4. On set, it is a good idea for the director to come prepared with notes of reminders for each actor. Whatever discoveries were made about blocking or performance, the director should have these written down and easily accessible for quick reference. A brief reminder to an actor about their goal for the scene, or a performance discovery that they had made in rehearsals, can be an effective directorial shorthand.

Note

1 Two actors had originally been cast to play the roles of Paul and Eli Sunday in *There Will Be Blood*. However, soon into the shoot, director Paul Thomas Anderson made a casting change and both roles were given to the actor Paul Dano. This "twinning" of the brothers wound up being a source of confusion for some audiences (many wondered if the brothers were supposed to be the same character), but also created a compelling layer of mystery to the Sunday family.

6 The director and assistant director department

1. Assistant director and unit production manager department overview

On a film set, organizational clarity is vital for allowing the director to focus on her or his creative work. If there is confusion about shooting dates or locations, actors and crew members may not know when to show up on set, or even where the set is. If department heads are unclear about how much money they have to spend, budgets can spiral out of control. The filmmaking process becomes overwhelmed by dealing with logistical crises instead of actually making the movie. Additionally, confusion on set tends to diminish morale. Cast and crew feel less invested, and consequently work less hard, when they lose faith in leadership. While no set runs perfectly, significant organizational problems can undermine an entire movie.

The first assistant director (first AD) and unit production manager (UPM) are two key positions that keep a shoot running well. To do their jobs properly, they require collaboration and regular communication with the director. Both positions are members of the Director's Guild, so they are aligned closely with the work of directors, but their responsibilities are also heavily logistical. An easy way to understand the difference between the two positions is that the first AD manages time and the UPM manages budget. Depending on the scope of the production, each of these positions may have support staff. This is especially true on bigger films with unusually complex shooting schedules and set operations. The first AD may have second and third ADs working for her or him.

On lower-budgeted films, if there is not enough money to hire a UPM, this work will sometimes be consolidated into other positions. For instance, the line producer may also act as UPM, or if there is no line producer, the producer might take on these responsibilities. If there is not enough money to hire a first AD, those responsibilities might be shared by the producer and director. However, there is a significant risk in neglecting to hire a first AD. Managing time and set operations requires significant time and energy, and even on smaller crews the position is seen as necessary for the film.

Let us look more closely at the jobs of the first AD and UPM, as well as key points of collaboration.

First assistant director

The job of the first AD is to create an infrastructure—in the schedule and on the set—that gives the director the time and workflow to achieve their vision for the movie. The first AD is usually strong on organization skills and has a knack for process: she or he makes sure that everyone on set is where they need to be, that deadlines are kept, and that cast and crew are arriving at the right times to the correct places for shooting. The first AD is the person who keeps an eye on the clock as the director gets through the shots, and keeps the director informed about when they are running behind schedule. Added to the workload of this busy position, the first AD also directs the background players (or extras), and—at the director's discretion—is sometimes the person who calls "action" and "cut" for each take.

First ADs are known to have one of the loudest, most commanding voices on a film set; they move fast and seem to have the ability to be in multiple places at the same time. However, first ADing is not a one-size-fits-all proposition, and not all movies require the same approach to running a set. Meaningful collaboration between the first AD and director begins with sitting down to discuss the schedule, and also figuring out the appropriate tone and mood that the director wants to create on set. Let us begin by looking at how a first AD thinks about schedule.

Choosing the order in which the scenes are shot is a decision based on many factors. The conventional wisdom of first ADing is that the initial days of shooting require an adjustment period. Cast and crew need time to adapt to each other, and to the workflow and locations of the film. Therefore, logistically complicated or highly emotional scenes usually should not be shot on the first day (for short films) or first several days (for feature films) of production. Shooting more simple scenes early will create a feeling of victories for the cast and crew, and give them confidence as they head into the more challenging scenes.

Similarly, it is common to refrain from scheduling difficult or emotional scenes at the end of a shoot. Making movies is exhausting. On feature films, the many days and weeks of production can feel like an endurance test. By the final day, or days, of a shoot, the actors and crew simply may not have the energy to complete challenging scenes as well as they might have midway through production. Understanding which scenes will be more exhausting than others, and how to schedule shoot days in accordance with this, is an important topic for the director and first AD to discuss.

Of course, the schedule depends on many other factors. The availability of actors and locations, and the distances that have to be traveled between locations, are all matters that the first AD must consider. The director may have to compromise and not get their preferred schedule because of this. However, the

more the first AD understands the director's scheduling preferences—as well as the reasons motivating those preferences—the more likely the first AD will be able to create the most workable schedule possible.

The schedule will have implications for the budget of the film, so the schedule usually needs to be approved by the producers departments (the producers and line producer), and the UPM will also need to understand the relationship of the schedule to the budget. The producers will have feedback on the schedule, but to help ensure that the director gets her or his say, it is important that the schedule originates as a collaboration between the first AD and director.

However, the director should communicate early and clearly about preferences setting the mood on set. Because the first AD is heard and seen so prominently on set, their style and approach to the job is a significant factor in making a set that feels rushed, or slow, or intimidating, or welcoming. A movie set is more than just a piece of machinery—it is also a place where creative work is happening. The director needs to decide what is the best mood on set to allow that creativity to happen, and this decision will be different for every director, and for every movie. Some directors do not mind an aggressive first AD; other directors want the first AD to act with more calm.

An important factor in this discussion is whether there are sensitive scenes, such as scenes involving nudity or sexual material. These scenes will likely need to be handled by the director and first AD with more sensitivity. Directors may choose to have a "closed set," where only the most vital people needed to get the scene done are allowed on set. These choices need to be initiated by the director and explained to the first AD.

These conversations frequently happen as face-to-face meetings, but they also happen during tech scouts. In the weeks before shooting, when the director and key department heads travel to each location to plan and troubleshoot, the first AD will need to be there figuring out set logistics. The first AD will have to decide on a place for holding. Where will the cast and crew wait when they are not on set? Is there bathroom access? Where will cast and crew eat? Is there room for every department to be able to work? Additionally, the first AD will usually want to have a copy of the shot list during the tech scout, to plan how long each shot will take, and further refine the schedule.

Unit production manager

If the first AD is on set during production, the UPM is usually in an office keeping track of production expenses and making sure that costs are as expected. The UPM reports to the line producer, who keeps a more general eye on the budget—but the UPM is more entrenched in the details of the costs. If the line producer is big picture when it comes to the budget, then the UPM is small picture and keeps on top of the granular details.

Because the UPM has far less direct dealings with the cast and crew, there is naturally going to be less collaboration that the director will have with the UPM than the first AD. However, it is still important for the director to give attention to the UPM and explain the reasons behind certain costs on the budget. It can be helpful for the UPM to understand the director's priorities and vision; this can help to avoid any misunderstandings about spending money, and also help the UPM to feel more invested in the film, connected to the director, and motivated to help the film succeed.

2. Director case study

Steven Soderbergh, a famously productive filmmaker, is known for running sets that are unusually time-efficient, organized, and precise. Soderbergh not only directs his films, but he sometimes takes on the responsibilities of being the cinematographer and camera operator, as well as the editor. Wearing so many hats, it is clear that Soderbergh is a director who knows—aesthetically and in the narrative of the story—what he wants. His vision is notoriously precise. The speed at which he works—shooting scenes in one or two hours that would take most other Hollywood directors twice or three times as long—means that he needs to have a first AD who can keep up with this pace, and run a set that allows for such quick transitions to scenes and company moves.

It is not surprising that Soderbergh has a longtime working relationship with his first AD (and a director in his own right), Gregory Jacobs. Jacobs' understanding of Soderbergh's unusually speedy directorial style allows Soderbergh the freedom and latitude to do his best creative work. There is a certain orthodoxy to set operations—that is, a traditional way that most sets are run. But every director has particular strengths and vision, and will likely have (or want to develop) a workflow that caters to the final product they are trying to achieve. It is entirely okay for a director to do things differently (such as Soderbergh's strikingly short, sometimes nine-hour shoot days, and his desire to operate the camera). But it is vital that the first AD is told of this vision, and understands the reasons for it, so that she or he can run the set according to the director's needs.

Consequently, when unexpected problems creep up on set—such as Soderbergh struggling with how to shoot a particular scene during the production of *Ocean's Thirteen* (2007), and sending away the entire cast and crew so he could think through the problem by himself, in quiet and without pressure—Jacobs, as his first AD, knew how to smoothly enact and support these types of decisions.

Many of Soderbergh's films feel like experiments. From *Bubble* (2005), a crime drama shot only with non-professional actors who live in the small town in Pennsylvania where the story takes place, to *Unsane* (2018), shot with an iPhone, his unorthodox filmmaking process is partly what makes Soderbergh such an exciting filmmaker. In interviews, he has compared the filmmaking machinery to a toolbox, and it is up to the director to fully

understand the function of every tool in that box. To those ends, his career has seemed to be an attempt to invent new tools, or at least to repurpose new functions to existing tools. There are many lessons for filmmakers to take from the trajectory of his career, one of them being the enormous plasticity that exists in how one sets about making a film. There is no one, correct way to do anything. But the end product depends upon the means, and the way that a movie is shot is going to affect what kind of movie is made. Known as a filmmaker who establishes specific aesthetic rules on his sets, the means are vital to Soderbergh's ability to turn out films that are so varied from one another. Soderbergh can shift gears so much, in part, because, as Soderbergh has explained, Jacobs is the person whom he talks to most on set. Jacobs is a creative sounding board for Soderbergh, as well as the person who creates the environment for Soderbergh to do his work.

3. Interview with first assistant director

Theodore Schaefer is a producer and director, as well as a first assistant director on films such as Keith Miller's *Five Star* (2014) and Ben Hickernell's *A Rising Tide* (2015). He has been working in the New York independent film scene for many years and also lectures at the School of Visual Arts.

TAKOUDES: When you begin working on a film as a first AD, what are your initial responsibilities?

SCHAEFER: The first thing I do is break down the locations because I'm trying to figure out how unwieldy it is. I want to figure out how many different locations there are, how long we're in those locations, and then start to figure out how to organize it. It's very much a puzzle. One of the reasons I like doing this job is my mind likes to organize things and create puzzles. But I think it's important to also maintain an idea of what the content of every scene is, so I write a log line for each scene. Often I'll be on set and I'll know the script better than the director. I'll know on what page something happens. It's like taking notes in school—as soon as you write it down, it's easier to remember. And because I've broken it down scene by scene, as opposed to writing a whole script, it's much easier to remember the parts.

TAKOUDES: At this stage, what are your conversations like with the director?

SCHAEFER: I'll usually talk to them about "What are the things that are important to you?" Because there are different strategies for directors. Some of them will choose to have 60 different angles on a scene. And I'll go, "All right, but then you're not going to get many takes." And that's okay, but we have to have an agreement. As long as we're on the same page at the beginning, it's easy to do it. I need to know what's important to the director up front. In the indie world especially, you either get shots or takes; you can't have both. You have to make a decision. So, it's figuring what those strategies are and why. I don't want to be a robot and just do what

the director is telling me; I want to understand why the director is making these decisions because then I can do my job better. I want to know what their intention is.

TAKOUDES: And if they want 60 angles, which of course is fairly ridiculous, then maybe there's a better way to achieve the effect they're trying to create.

SCHAEFER: Right, maybe there's a better way. Or if I know why there are 60 angles, I know why shot 16C is important, but do we really need 16F? Probably not. Because I know what they're trying to get and that's not necessary. I can have that conversation that we're running out of time, and I think that 16F can go away because we need to get these other shots. So I have to understand the director's priorities. If the director wants to focus on performance, then I know they need more rehearsal time, and we can set them up with the actor while we light, just so they feel more comfortable going in. If that's what they want. Other directors don't want any rehearsal—they want it all fresh. I need to figure it all out because everyone is different.

TAKOUDES: And it's not just the logistics of the process, but are you also trying to figure out with the director what they want the tone on set to be?

SCHAEFER: Yeah, we'll have extensive conversations about it. And I'm pretty up front about how I run a set. I do think that my way ends up with people feeling the best. My ideology is that you need to be able to get people to work hard, but be happy working hard. If they're just working hard because you're cracking a whip, then they're not going to be putting any heart into it. We're making movies and art, and people should care. Especially department heads should care. They shouldn't just be doing it because they have to.

TAKOUDES: How do you and the director create that feeling of being happy to work hard?

SCHAEFER: It's a buddy-buddy thing. Especially with the department heads. The gaffer, the DP, and the director are the keys to me. I need to feel comfortable and friendly with them so we can have a quick conversation about, for instance, "What do you need to get this scene to happen quickly?" And it's being able to have that conversation without sounding like I'm bugging them. I come from a grip and electric background, which helps a lot. I ask, "What do you need for this setup?" and I understand what they're saying. I also know it may take longer than they say. People lie about time all the time because they don't understand it. No one really understands time. It's the first AD's job to understand time. As soon as you're doing a job, then you're not thinking about how long it's taking to do it. So, I can come in and go, "Do you need that element? Is there a way we can do this quicker?" I don't want to make a bad movie, so I don't want to just rush people to get it done. If the AD's goal is just to complete the day, then they're not going to do a very good job of making a good movie.

TAKOUDES: You're not just rushing them; you're putting it in a context of choices. Shots or takes, for instance.

SCHAEFER: Yes. It's not about who's fastest. I'll even argue for things that might take more time, because if the director gets to the edit and they see that the movie doesn't cut, then that's my fault. I take responsibility for making sure that we are getting enough to cut the scene. So I'm also thinking about the edit.

TAKOUDES: The first AD is in the Director's Guild, which makes sense because there are also directorial elements to your job. I imagine the shot list is important for you to see?

SCHAEFER: The earlier I see the shot list, the better. Some directors don't shot-list, or they rely on setting up a list of rules with the DP, so that even if you go off the shot list, you want to have a sense of the overall principles for how you're going to shoot the scene. Terrence Malick did that on *The Tree of Life*. It's brilliant because even if you fall behind on the shot list, you understand the heart of what the visual strategy is. I try to get that out of the director and DP: "What is your overall visual strategy?" "What's important to you visually?" "What is your style?" If we have to do things really quick, then I can be an asset and say, "Wouldn't this get you what you want quicker?"

TAKOUDES: So, you're offering ideas, choices, but also keeping everyone on schedule and moving along.

SCHAEFER: I think you realize quickly that the relationship between the director and first AD can seem adversarial. And I think a lot of people still see it as adversarial. But that's the worst way to do it. Those are the worst jobs when the director and the first AD are competing. The AD will sometimes look at the director as the impediment to completing a full day. But my goal is to get everyone happy and get the movie to work, not just to finish the day.

TAKOUDES: What do you need from the director to not make it adversarial?

SCHAEFER: It's about making decisions ahead of time, and making sure that the director, DP, and I sit down early on when we're shot-listing. So that I can be a voice. First, so I can see what the plan is; and second, so I can check to make sure that we need each one of these shots. There's no reason to do something that I know, for a fact, will be cut. I don't want to be on set and know, already, that the plan won't work. Part of it is about getting the DP to be honest, because sometimes the DP doesn't want to say no to the director. But if we talked about it a month in advance, then we all agree that it's unrealistic to do six Technocrane shots on this day. But the director has to trust me, and that's huge. The DP has to trust the first AD, too. It's specifically those three that need to be trusting of each other. That's the trio that really determines everything on set. Usually, the director and DP are making all the decisions, and I'm helping to guide them to make sure that their decisions don't destroy the rest of the day. And then I need to disseminate the information to everyone else on set. Because literally, communication is the most important part of the job.

TAKOUDES: The first AD has to do this while watching the clock, because no one else is doing that in such a disciplined way.

SCHAEFER: Except for maybe an actor who has concert tickets that night. I won't go into a day if I'm not comfortable that we're going to make it. You've always got to be thinking ahead, because if we get more done on this day, then on the day when there's some really emotional scene, that's all we need to focus on.

TAKOUDES: Set operations need to get discussed in pre-production as well, right? The order of lighting, blocking, and shooting, for instance.

SCHAEFER: Some directors are more visual, and others are more actor-focused, and some are a mix. Okay, so let's talk about what you're focused on more. If a director says that they really trust the actors to make anything work, then great, we know we have more time to light. And then we might not block the actors, and only use stand-ins. But other directors won't do anything until they block the actors. And I don't care, but I need to know. The basic question is, does the actor move to the camera or does the camera move to the actor? And that will determine whether we're blocking or not, and whether we can start lighting right away with stand-ins, and we can get the actors into hair and makeup right away.

TAKOUDES: So, you're communicating with all those other departments, too?

SCHAEFER: It's why I develop a relationship with those departments. I also know that the director may not be talking to those departments as much as they need the director to. So, I'm going to help those department heads, and that'll help my schedule. If the director doesn't direct hair and makeup, then they might choose some hairstyling on the actors that I know will take a long time. And the director may not care, but I'll be there and suggest something quicker as long as it's right for the character. I'm lucky because I've worked with so many of the same people, I have a rapport with them.

TAKOUDES: I'm curious about tech scouts and what you're looking to get from the director when you're visiting the locations before the shoot.

SCHAEFER: Tech scouts are so important. They help you foresee any problems. Like, electrical problems, holding options, bathrooms. Where are we going to put everyone? Where are the exits? You have to start figuring out those kinds of solutions. But I also want the director and DP to start looking at the shots. And it's going to be different than on the day of shooting, but it's going to be less different if we start framing up shots on the tech scout. I usually want to go through the whole shot list, on the tech scout. Because then they can see that a certain shot may not work.

TAKOUDES: And that may have ramifications for your schedule.

SCHAEFER: Yes. And we can see things like, "Oh, these windows aren't facing east, so we can't get the morning sunlight, so we have to shoot in a different direction." If we're losing light, what is our backup? Especially if we're shooting in the winter when you start getting short days and you only have nine hours of sunlight, then you have to get precious about it. You have to

talk to the DP about maybe shifting the shots. Can we save the close-ups for later in the day by the windows, or whatever it is? You can really start to schedule out each shot on the tech scout. I keep a list of everything. And I need to figure out: Where's everyone going to be? Where is holding? Where is hair and makeup? I need to organize the flow, and that's a whole other puzzle. How can we use the layout of the space to make everything efficient?

TAKOUDES: It's interesting that you help to communicate and provide infrastructure for the director's vision, but I feel like the first AD is one of the few people on set who's telling the director *no* if what they want isn't feasible or realistic.

SCHAEFER: That's sort of the job, to say no. But that's the trick for the first AD, how to say no. It's like how a director works with the actor, because the actor is being incredibly vulnerable in their performances. It's the reason that the director is very careful with the actor emotionally, and how they work carefully to get a certain performance out of an actor. It's not that different in the relationship between the first AD and the director, if the AD makes the director feel badly or upset. The director is not necessarily being vulnerable like the actor is, but the director is being creative. And if the director feels constrained, and technically restrained, and time-constrained, then they're going to have a harder time being creative and they're going to do worse. That's why I like to make sure that people are having a good time on set, unless of course it's very serious. That the mood is up, but it's not chatty. So, people feel that they can be playful and come up with ideas. If I'm just going to the director and saying no all the time, then there's going to be a bad mood on set. But if I say, "I don't think we have the time to do this and here's why, but … we can do this other thing," we can make it a creative choice, something to figure out together. Instead of me just saying, "You have to cut something." Because then I'm putting it on the director and being negative. It's really about harboring a dialogue. If the movie is only in the director's head, then we need to communicate about it.

TAKOUDES: Because that vision needs to get relayed not only to you, but to the entire crew.

SCHAEFER: Yeah, and that's also why part of my job is protecting the director from spending too much time talking to every department head about every single issue. I want to be able to quickly answer those questions for the departments. So, I need to know as much as the director knows about the movie. And if I don't have the answer, then I'll get it from the director when the time is right. Because if I just let every department head ask the director a question whenever something comes up, then it's going to be chaos on set. I'm trying to field as many of the questions for the director, and then slowly feed them out to the director if I can't answer them. I'm trying to be the liaison between the director and everyone else.

TAKOUDES: What happens when things on set go awry, for one reason for another? You fall off schedule, for instance.

SCHAEFER: It's easy not to respect people's sleep. Sometimes you have to push people, but you want to make a question to them, a request, and not a command. It's not like, "You have to do this." I want to give people agency in what they're doing, because then they'll be better at their jobs and they'll be more willing to do it. If you decide to do something, then you can believe in what you're doing. But if someone tells you what to do, then you're going to feel bad and be resentful.

TAKOUDES: That's human nature, I think.

SCHAEFER: That's right. I'm in charge of managing time, but really what I'm doing is managing people. And it's easy for a first AD to be manipulative in that position. But that's not the right way to do it, because people understand when they're being manipulated. They'll get upset and won't care. But if I'm being honest about what the actual problems are, then we can all talk out the best solutions while executing the director's vision. If there's a communication gap between the director and first AD, or if I don't understand, then it's going to be hard. The director needs another brain, essentially, and that's what the first AD is. A brain to focus on the order of things on set. A director's attention is so sucked up on the creative decisions that they need another brain. Efficiency and creativity don't necessarily go hand in hand. I'm there to take as much information as possible off the director's plate so that they can focus on more important creative work.

4. Tasks for the director

The first AD plays an unusual role in the work of the director, as both a logistical taskmaster and a creative bounce board. Effective collaboration helps to reduce the adversarial traps that sometimes undermine this integral relationship, and gives the director organizational clarity to be able to be as creative as possible.

The following chapter of the book looks at the locations department, and the first AD is closely involved in preparing the shoot for each location. This list of tasks will help to ensure that the first AD can work as efficiently and with as much information as possible.

1. During pre-production, the director should discuss with the first AD how the set should run; the desired mood, energy, and protocol of set operations should all be discussed. The handling of scenes that might be particularly difficult or emotionally sensitive are also important topics to cover.
2. The director should review the schedule with the first AD. Some important factors to cover are actors' schedules, location availabilities, day and nights shoots, and the emotional and logistical weight of certain scenes.
3. The director should bring the first AD to tech scouts for all locations, and discuss the general blocking of each scene at those locations.

4. During production, it is important for the director to keep in close contact with the first AD about time schedules and other set operations. Have an agreement in place about how frequently the first AD should remind the director regarding how much time remains for each scene or shot.

5. The director should review the budget and schedule with the UPM and the first AD. Building communication and rapport is essential, so the UPM feels they have easy access to the director or first AD if budget problems arise on set.

7 The director and locations department

1. Locations department overview

The locations department is responsible for finding the locations where the scenes of a movie will be filmed. Whether a scene is supposed to take place beside a river, in the penthouse of a Manhattan skyscraper, or a roadside diner, the location manager—assisted by one or more locations scouts—will be tasked to find an assortment of options for each location, so the director can choose the best setting. Let us look at techniques for how the director can approach collaborating with the location manager.

Locations as storytelling

The location of each scene is indicated in the slug line in the script, which shows whether the scene takes place inside or outside, and if the scene is happening during the day or night. All of this information is vital for the location manager, but before any of the scouting takes place, there needs to be a series of conversations between the director and location manager, to get more information about each location.

For instance, if a scene takes place in a barn, what type of barn is right for the story? A classic, red-painted barn that suggests a family farm? A decrepit barn where a portion of the roof is collapsed, suggesting the farm—or some of its operations—have been abandoned? Or a concrete barn that one might find at an industrial farm?

The location manager reads the entire script before meeting with the director, so the context of the scene and the broader story will, to a degree, suggest what type of barn the director wants. If the movie is about a young, struggling farmer who inherits a modest parcel of land that has been farmed by his family for generations, then it is fairly obvious that a massive concrete barn will not be right. The classic red barn might work better. But within this choice, there are many variables. Is the paint peeling off the barn, due to neglect over the years? Or is the barn in pristine shape? This choice will suggest what type of family the farmer comes from—one that took good care of the property, or one that let everything go. If the father farmer struggled

with alcohol and depression, for instance, that would indicate a certain condition of the barn, since this character might have had troubles even taking care of himself.

Each type of barn, or the condition of the barn, tells a different story about the family, and with this observation it is important to note one of the primary functions of how a director uses this department: locations are, in and of themselves, a storytelling tool. Locations can establish tone (if the movie is a horror movie, then a barn that is falling apart and looking spooky might be perfect) and suggest a character's personality or backstory. It is important that the director and location manager not just find a location that is described in the script, but talk about what that location says about the story.

In the 2015 film *Me and Earl and the Dying Girl* (directed by Alfonso Gomez-Rejon), the movie opens in a public high school. The protagonist of the film, Greg, wanders the hallways of the school explaining, in voiceover, how he manages to get along with most students without belonging to any one social group. This is how he survives socially amidst the many cliques. His voice-over is heard over shots of the school, which has astonishingly high ceilings, filthy windows, broken ceiling tiles, and hallways that converge at odd angles. The location feels institutional, maze-like, and intimidating. The hallways are crowded with students, and yet parts of the building are so large as to appear abandoned, as if entire wings of the school have fallen out of use to neglect. Greg never needs to tell the audience that school feels like prison—the location says it for him. He also never needs to tell us that life, in general, is a confusing labyrinth because—once again—the location is telling us. A well-chosen location not only adds another layer of storytelling to the narrative, but saves the script from relying on poorly written or on-the-nose dialogue.

Budgetary differences in location management

The budget for a movie is a significant factor for a filmmaker's ability to access, and use, a location. Some locations (such as a museum) are expensive, while others (perhaps a local bar) are not. For a filmmaker working on a low-budget film, it might be hard to afford to shoot in a mansion, unless there are personal connections or other factors that make the use of that location free, or close to free. Some locations require the filmmaker to supply an insurance policy for any damages that might be incurred while shooting in the location. These policies can be expensive, depending on how much insurance the location's owner or manager requires.

On films with large budgets, shooting on location is not always a necessity because sets can be built for the exclusive purpose of shooting that film. This allows the production to have complete control over the set; for instance, in *Psycho* (1960), director Alfred Hitchcock had the Bates Motel and nearby mansion built on the backlots of Universal Studios. A constructed set allows the filmmaker to totally control the lighting, sound, and other physical parameters,

such as being able to remove walls or otherwise manipulate the space so the camera can move freely.

Also, movies with larger budgets can change the appearance of a location that already exists in real life. For instance, in the drama *The Tree of Life* (2011), director Terrence Malick shot many of the scenes in a real town, but then modified the look of the town by having a 65,000-pound tree planted in the front yard of the protagonists' house.

The location manager is instrumental in working with the owners or managers of a location to create goodwill with the production. Shooting a movie in someone's house, for instance, is likely to be an inconvenience to the residents. It is up to the location manager to negotiate with the location owner, to ensure that necessary insurance policies are written, that specifics on the equipment being used and number of crew and cast members who will be present are clear, and that payment—if any—for using the location are handled dutifully.

For larger-budgeted films, a location manager will likely have a pre-existing database of locations to show the director. On smaller-budgeted films, where a location manager may be less experienced, or could be someone on the crew who is also working in the capacity of a location manager, online maps—with corresponding photographs—are an excellent resource. An advantage of using this type of software for location scouting is that distances between locations can be easily determined, and the locations can be clustered together to ease the number of times the production has to move from place to place. The director and location manager (and typically in consultation with the producers and line producer) should discuss limiting how much travel the production will have to make from one location to another. Travel between shooting locations—called company moves—are time-consuming, potentially expensive, and open up the possibilities of logistical problems. Vehicles getting lost on the way to a location, flat tires, and unexpected traffic are just some of the unlikely—though not to be unexpected—problems that can happen whenever the production leaves a location to shoot in another location. Of course, for films that take place in more than one location, there will be company moves. But with each move—and as these moves become longer in distance and travel time—the problems, expenses, and fatigue on cast and crew increasingly become factors.

When it comes to budgetary and logistical issues, other factors to be considered are access to food, bathrooms, medical services, and housing. A location deep in the woods might be perfect for a film, but if the cast and crew will need to hike a mile through difficult terrain—hauling equipment, no less—then this consideration needs to be weighed. If the director believes that the location is so perfect that the sacrifice of time and energy is worth it, then that can be a strong and good choice. However, the cast and crew should be given ample and fair warning about the location, the assistant director and line producer will need to work together to build in extra time, and the producers will likely have to allot additional expenses

to provide the basic services. For instance, portable toilets may have to be rented and brought to the location. Generators might be required to power lights or computers. If the location is remote, it can be useful to have a guide and a medical technician on hand as well—and all of this costs money.

On lower-budgeted films, if the director decides to make a strong choice on a challenging location, this means that the time and money spent will have to be made up on other locations—and therefore the other locations might have to be chosen more for their cheapness and ease rather than aesthetic preference. This balance of where to commit and save resources is a continual discussion between the director and the department heads.

Making locations cinematic

Collaboration between the director and location manager means finding locations that not only work for the story and budget, but also offer cinematic, visual opportunities. The topic of how to dress, or design, a space will be further discussed in Chapter 8, but for now let us examine the raw space of a location itself.

In seeking a location, many directors ask for a set that has flow. This term refers to a set—be it a house, a forest, anything—that has one space moving into another space. For instance, a room with windows or halls that leads to other rooms or a yard, or a spot in the woods that leads to a clearing. These are important because they open possibilities for creative camera and character blocking. Characters can move about during a scene and the camera can follow, or the camera can cut to a new angle that is made possible by an adjacent space. Locations with flow give the director room and ideas to conceive a complex visual strategy. Flow gives a shot depth and dimension.

Depending on the story, not every location needs flow. The location should be chosen to fit the feeling of the scene and how the director plans to direct it. If the script calls for an interrogation room, where a character is meant to feel walled in and oppressed, then a room with flow could be counterproductive. In that case, a basic room with no access could be perfect. But if too many scenes take place in blocked-off locations, then the cinematography can start to feel static.

Part of this conversation between the director and location manager will also likely concern production value. Given what is appropriate for the story and the tone of the film, does the director want high production value (locations that look expensive and elaborate) or low production value? Director Kelly Reichardt, whose films often concern lone characters living on the margins of society, frequently chooses to have locations that appear trodden and grim. This is a strong choice that helps to establish the world—and worldview—of her characters. However, other directors might choose to create high production value, whereby the film appears to be more expensive and elaborate than the budget actually is. There are many tricks in other departments to help

create the illusion of higher production value (for instance, in the camera department, using image stabilizers and gimbals on the camera, instead of hand-holding the camera); for locations, the more expensive a location appears, the more higher-budget the movie can feel. There should be a conversation between the director and location manager about whether the added production value is appropriate for the film, and worth the expense and time that the location manager will have to dedicate to the task.

Finally, the director and location manager should also discuss—with the cinematographer—the field of view that a location offers. For instance, if the location of a green pasture is right for a pastoral-feeling scene about a character laying in the grass during an idyllic afternoon, then a location manager might find the perfect green pasture—were it not for a huge factory sitting across the street. In this case, the field of view that is available for filming might only be 180 degrees. The camera can point toward the field to capture the scene, but could not point in the other direction or else the factory would be in the frame. This situation can work perfectly fine but might affect the visual strategy for how the scene is shot. The less field of view that is available in a location, then the more constrained the filmmaker will be in how they choose to shoot the scene. If the director is hoping to shoot the pastoral scene with a camera movement that moves 360 degrees around the location, then this will have to be a conversation between the director and location manager. They can also work creatively, however, to stitch together locations. For instance, if the scene calls for a quaint cabin to be across the path from the field, then the cabin could be shot in another location entirely, but made to seem as if it is right next to the pasture. By managing the field of view, locations can hide unwanted details, or locations that are far apart can be made to seem close together.

Overall, collaboration between the director and location manager means discussing the script, the tone of the movie, the visual strategy, and the lives of the characters. The director should provide plenty of information to the location manager so that they can most creatively and effectively do their job. Location tells story; it also tells characters and tone. It can tell theme as well. A location manager should feel empowered to help the director fulfill these many possibilities, and it is up to the director to inform the location manager, to empower and give her or him tools to find the best locations to fit what the director hopes to achieve. Budget and time constraints can limit what a location manager is able to do, and finding locations—as well as acquiring permits and negotiating their use with the owners of the locations—is a laborious process. The earlier this collaboration begins in pre-production, the better for the film.

2. Director case study

There is a common phrase used to describe the locations of some movies, where it is said that the location is itself a character. There are few filmmakers

to whom this idea applies more than Orson Welles. However, worded more cinematically, what his use of locations did was create a visual representation of the personalities and psychology of his characters. In his most famous film, *Citizen Kane* (1941)—which tells the story of megalomaniac Charles Foster Kane trying to use power and wealth to buy love and happiness, only to die alone and broken—Welles used sets that displayed extreme depth to deliver the emotion behind Kane's futile quest. Xanadu, Kane's fictional mansion on the Gulf Coast of Florida, features one room so vast that its fireplace dwarfs Kane when he stands beside it. This room, like other rooms in the mansion, is equally vast and nearly empty of any furniture. Cavernous and cold, the locations suggest the emptiness in Kane's heart—how big his ambitions are, but how empty his soul is. Welles' use of deep focus and low camera angles emphasized the impact of these locations in his films, and turned Kane into a ghost roaming aimlessly inside a house that he could never hope to fill with the family that might turn it into a home.

Welles did more than just use his locations as a backdrop or symbol of his characters' inner struggle. Part of Welles' genius as a filmmaker lay in the variety of his techniques. He also knew well how to place a character within a location, while also moving the character and camera *through* a location in a way that heightened the drama of his stories.

Let us look at Welles' noir film *Touch of Evil* (1958), a story of crime and intrigue in a town on the border between Mexico and the United States. In the film, a drug enforcement official, named Miguel Vargas, from Mexico, is about to go on a honeymoon with his new wife, Susie. However, when a fatal bomb explosion occurs on the American side of the border, tensions develop between Vargas and a corrupt U.S. police captain, Hank Quinlan (played by Welles). The border town, as a location, is important to the telling of this film—so much that Welles seeks to capture both the tone and geography of the town in an elaborate three-and-a-half-minute tracking shot that travels from one side of the border to the other. The location is the lifeblood of the film; it is the *raison d'être* for the central conflict, and the battlefield where that conflict will be waged.

Later in the film, Welles uses location not just as a symbol or a field of play where the story will unravel, but as a combination of both: a physical obstacle course around which the scene is staged while constantly commenting on how the characters are faring in the scene. The location is a seedy motel room where Susie has been kidnapped, drugged, and tied to a bed by the family members of Joe Grandi, who is attempting to discredit Miguel. Outside the window of the motel, a neon sign blinks on and off, shining a pulsating light into the room. Hank shows up in the room and decides to kill Joe, as a way to keep what happened to Susie a secret. The action of the scene is straightforward: Hank lunges at the significantly smaller Joe and strangles him. Welles, however, splits the action into three separate zones around the otherwise simple location. Finding every nook and cranny of the location that can be dramatized, which many other filmmakers might

overlook or disregard, Welles creates a profoundly cinematic experience. Here is how the three stages look.

First, Hank advances on Joe, stepping toward him and briefly fighting. Joe slaps Hank away, then backs up toward a low, sloping section of the ceiling. It is the type of feature on a wall that is seen in rooms stuck below sloping roofs, where the roof cuts down at an angle across part of the wall. By having Joe press himself against the sloped ceiling, the location emphasizes the feeling of just how trapped Joe is, cornered on several sides. Then, when Joe slips out of this sloped corner, a reverse shot shows Hank rushing toward camera from behind the sloped corner. Instead of Hank advancing in a straight line toward camera, Welles again uses this architectural feature of the sloped ceiling—having Hank barrel forth from the cramped space—to give Hank an exaggerated sense of speed.

Second, Joe climbs a chair and reaches for a small, high window in the room. He breaks the glass, attempting to climb through, or at least call for help. He is grabbed from his perch at the window and dragged to the floor. By incorporating the window into blocking, Welles now introduces elevation into the fight. Joe does not only try to go left or right to avoid Hank, but he is also trying to go up. This allows Welles to use dramatic low- and high-angle shots to emphasize the action, and it adds more desperation and surprises to what could have been a far simpler strangulation scene.

Third, after being thrown to the floor, Joe finds himself at the bottom of a bed. He spots a gun underneath the bed and reaches for it. Joe presses his face into a decorative metal grate beneath the bed, and stretches his arm toward the gun, making him appear like a caged animal. Hank drags Joe to his feet and finally kills him.

The scene is a masterpiece of showcasing how to exploit a simple location for its fullest dramatic possibilities. Welles took a scene that could easily be a simple and straightforward bit of action, and used the location and its unassuming features—a high window, a bit of low ceiling—to transform the scene into something grand and harrowing. During this sequence, a blinking neon motel sign outside the room pulses a garish light into the room. This acts as a visual metronome, keeping the action marching forward and adding shadows that make the location appear grim and scary.

Alternatively, by using a few props and set decoration, the location can also be transformed into something far more interesting than the raw space itself. This transformation does not need to come at a high cost to the location or production departments. It only takes a bit of ingenuity. Let us look at a film that reimagines Welles' use of location in a more contemporary setting. *Brick* (2005), directed by Rian Johnson, is a noir detective story set in a high school and the surrounding town. The protagonist of the film, Brendan, has descended into the lair of a local drug dealer, named The Pin, to find Brendan's girlfriend, Emily. In order to show that these characters—while acting like adults—are very much youngsters, The Pin's drug lair is the

basement den of his mom's suburban (and strikingly normal, middle-class) house. The director, Johnson, is trying to have the location both ways: a regular suburban home that has a nefarious quality. When Brendan is brought to the house to meet The Pin, he is led down the stairs that lead toward the den. The lights are out, but we can see enough of the stairs and hallway to see that it appears normal. However, when a hallway light is flipped on, we see the hallway is lined with a wall of teenagers standing at attention. It is a frightening visual reveal, and a way to transform the location—narrow and low-ceilinged—from something ordinary into something highly strange and extraordinary.

A bit later in the film, Brendan is lurking in a basement room searching for a stash of hidden drugs. When Brendan is discovered by The Pin's hench-man, he attacks Brendan and attempts to strangle him, in a similar way to how Hank strangled Joe. The basement lacks the low, sloping ceiling from Welles' hotel room, but Johnson adopts two other features of the strangula-tion scene: instead of a neon light throbbing through a nearby window, Johnson uses a swinging mirror to pulse a beam of light onto Brendan's face, and when the henchman gets his hands on Brendan, Brendan's head is jammed up into the edge where the wall meets the ceiling. Using this simple architectural piece of the fairly stripped-down and bare location adds the same sense of feeling trapped that Welles summoned almost 50 years earlier.

3. Interview with location manager

This interview is with location manager Samson Jacobson, who has worked in the locations department for such films as *Inside Llewyn Davis* (2013), *Bird-man or (The Unexpected Virtue of Ignorance)* (2014), *Good Time* (2017), and *If Beale Street Could Talk* (2018).

TAKOUDES: I'd like to start the conversation by hearing about the first steps you take when working with a director.

JACOBSON: Every director has a different way that they like to work. When I get the script, I sort of have a photographic memory that I draw from. I grew up in Washington Heights in Manhattan, and I've spent the majority of my life in the tri-state area, so I have this catalog of information in my head, so that when I'm reading a script, I see where it takes place. I start thinking about certain areas and ideas that I know to present to the director, to see what they're feeling. It's more like it's a collaboration because I have my ideas about locations, which I pre-sent, and see if those ideas make sense based on the conversations that we have. It evolves from there.

TAKOUDES: When you read a script, what are the first questions you ask your-self about the locations?

JACOBSON: It all starts with the question of feasibility. You can think of any location you want to put on a page, but how are you going to shoot it?

One of the things I do is logistics as far as the location. For instance, I could find the coolest place that you'd ever see, but if there's no way to get gear or a camera in there, then what's the point? Why are we here? The location manager is sort of a performer, and I'm trying to figure out what's the best show to put on for the director and production designer. When I take them out to a location, you want to show them the space, but also take them to a good lunch, and make sure everyone is entertained, and you're selling them on your vision of what a location is, if they don't necessarily see it.

TAKOUDES: Before you take them to the actual locations, do you show them photographs first?

JACOBSON: Yes. The real nuts and bolts process that I like to do is, when I read a script, I like to put together photo files that I have in my database, and friends' databases, and I'll put it together. It used to be that you went to a storage unit and pulled out file folders of photos. The scouts would go out, shoot photographs of places, then go to a photo store and print their photos and paste them all into photo files. When you'd start a job, you'd go to your storage unit and get a couple of banker's boxes of photos and start putting together ideas. Now I do it all online through a photo-sharing website. I'll put together a presentation of ideas based on photos that I have in my database. I'll present them to the production designer, or directly to the director. We'll look at photos and they'll come back and say they have an interest in certain locations, and we'll go out and we'll physically see those places.

TAKOUDES: What information do you like for the director to come to you with, to make the collaboration really work? Also, so that time isn't being wasted?

JACOBSON: It's all about having the conversation. I always like to get as much information from the director as possible. When I get a script and I know the job is moving in a serious direction, then I start getting my pictures. My pictures of locations are a way of jump-starting that conversation with a director. Almost always, the director has notes. Every director I've worked with, whether it's Darren Aronofsky, the Coen Brothers, Barry Jenkins, the Safdie Brothers … once you start inspiring them with the pictures of locations, they start offering notes. Or, they have lookbooks. However, I don't like lookbooks. People are using it as a way to pay homage to the movies that inspired them, and the looks that they want to see—but I feel like it takes all of those projects and it cheapens them down to a brochure.

TAKOUDES: I've heard of cinematographers making similar complaints about lookbooks. That too many films just end up referencing the same movies anyway.

JACOBSON: Yeah. I think that every project is different in terms of what starts the conversation with the director. Personally, from a location standpoint, I like providing little flip-books of locations. When I shoot a location to

present to the director, I shoot it as a story. This is what the house looked like when I was walking up to it, this is the front entry, this is what it looks like when you look out of the house ... now, let's walk from the living room to the bedroom and take them on a little photographic tour. This is the way I learned how to do it. To tell the director a story about each location, but it's good because that's what filmmaking is. Telling each other stories.

TAKOUDES: I once heard about a director and cinematographer who discovered the look of the movie based on the location manager's photographs of the locations.

JACOBSON: It's great when the process is organic like that. Filmmaking is a collaboration.

TAKOUDES: After you go through the photographs with the director, and have the conversations and get notes from them, what is the process like when you're looking at the real locations?

JACOBSON: I need to get the director to feel the vibe and energy of a place. That's always my intention: to get the director in the car and get them to these locations, because when you make a film, you're building worlds. Every script, you're building a world and logistically you want to be as centered as possible, to keep the locations near each other. I think a little bit like a producer, so it's like thinking about what are going to be the most production-friendly ways to put together a project. Sometimes you can control that, and sometimes you can't. That's part of the whole presentation process. I'm trying to find the location that fits the story and the vibe, but I also have to consider all of the variables of logistics.

TAKOUDES: How do you balance seeking a location that's totally authentic and true to what the scene is, versus finding a location that you're going to dress and, to a certain degree, fake.

JACOBSON: As a location manager, I have to constantly balance the real world with the fictional world. I've seen that with a lot of younger directors, that they truly believe in shooting in real locations because they believe that a real location will impact the actor's performance. They want everyone to feel the tenseness and energy of the actual location, and there's a belief that the location can draw certain elements out of the actor's performance.

TAKOUDES: That sounds ideal, but is it impractical sometimes?

JACOBSON: Well, I've been in some pretty crunchy situations with locations. Once we went into a location and someone picked up a box and there was an explosion of bedbugs. The whole location was put on hold while I got the building exterminated. Some locations you just can't do, for a variety of reasons—safety or logistics. It can become a losing proposition for the production. And there's a certain point when a director will understand that, if there's a location that just can't happen. But then you come up with a solution with them about how we're going to figure this out. You can dress a location to make it work. It doesn't take much to paint walls, to bang up walls a little bit. I'm always in favor of using the art department to

create a location, and really the inspiration is finding the good bones of a space and giving the production designer the ability to use it as a palette and use it as they see fit.

TAKOUDES: How do you know if a location has good bones?

JACOBSON: In general, I'd say it's about depth. Whether anything is in focus, whether you're shooting wide open aperture or not, everyone wants depth. Everyone wants to be able to put a light three rooms back and have depth. It's cinematic. It looks good. You look at all the classic pictures of great photographers, everything has depth. It makes sense. So when you see a place that has no depth, or it has walls that are in a way what makes the location feel claustrophobic, I instantly shut it down—unless I'm looking for some kind of labyrinth for the scene. I've developed a good eye for what is cinematic, and it's largely based on depth.

TAKOUDES: How much blocking is figured out before the locations are found, versus coming across a location and then figuring out the blocking based on the real space?

JACOBSON: Every director is different, and it can happen either way. For instance, I'm dying to work on another Coen Brothers movie. I've still never, to this day, seen anything quite like it. They have everything so well planned and thought-out and storyboarded before shooting. For *Inside Llewyn Davis*, they had every camera angle that they wanted before we even went to the location. Then when they went to the location, to director-scout it first and then tech-scout it, every single time they'd confirm every angle that they originally wanted. They knew what the game plan was. There was no deviation. I've never seen another director operate like that. Closest thing I've seen is Barry Jenkins. You see it in certain directors. Other directors have a different style. Everyone should be their own style. Except, if the director has no vision, then it's going to be a nightmare. But when a director has a plan and they work to execute it, and they put in the care, it'll also help for the budget.

TAKOUDES: Of course, when you're dealing with locations, you're also dealing with the owners of the locations. Talking to them about what you'll be shooting and what's going to happen on the location.

JACOBSON: And that depends on the production. For *Beale Street*, that project was a group of people who intended to get together and make a movie with a lot of love. A lot of care and intimacy was put into making that movie. When I was searching for locations, it was almost too easy to find places because we gravitated toward people who were willing to build a relationship with us. One of the things that I do as a location manager is I believe in all of this work being built on relationships. If I get a bad vibe from a location owner, I will start working to convince the production to go somewhere else, or I will find a better option.

TAKOUDES: Some locations might look perfect, but I imagine are challenging to shoot in. There's the very intense chase scene in *Good Time* where you

filmed in the New World Mall, in Queens. Did you shut down the location to shoot there?

JACOBSON: No, we didn't shut it down. You can't afford to shut it down. There's an amazing food court mall that does so much business that even for a studio movie, it's going to be very hard to shut it down, just based on what the vendors make in the food court. So, we made a deal with the mall to just coexist during the shoot. We put up our signs that said "This is a filming area." The owners of the mall gave us permission to film. We did put plants in there, like 10 or 15 people scattered throughout—but for the most part, what's in the movie is the live New World Mall during the middle of the day. Most people don't shop then, which is why we were able to get it for a six-hour window.

TAKOUDES: That's one of the things you bring as a location manager, understanding the dynamics of a location, whether there are seasonal restrictions, or what kind of traffic is going to be there at various times.

JACOBSON: Exactly. And that's logistics, too. You need to know if the location can actually tolerate the size of the production. If a location requires that you only use a few people, and you're shooting *Spider-Man 2*, it's going to raise alarms for the production. You won't be able to scale the production down small enough. Whereas on *Good Time*, it was no problem to scale down the production because that's what we were already doing. The whole movie was running around with a couple of cube trucks and some sprinter vans, not tractor-trailers. Everything is based on the production and the scope of the project, and it's my job as a location manager to come to understand what's doable and feasible with each space that I present to each project. But locations are also a time capsule. When I do locations in New York City, I feel that I'm cataloguing the history of this city. A location manager is a historian. When I pitch certain locations to the director, I really care about the people in the neighborhoods where we shoot. I treat the people in that location with the love and respect that I think the place deserves.

4. Tasks for the director

The location manager plays an important role in not only finding locations that build the world in which the film takes place, but also ensuring that the locations will be safe, secure places for the cast and crew to work.

The art department, the focus of the following chapter, works closely with the locations department. Completing these tasks will help the location manager understand the vision of the film and coordinate effectively with the art department.

1. The director should sit down with the location manager and discuss the tone or feeling of the major locations. Explain the characters who populate this world, so the location manager has a better sense of the homes

and offices where these characters live and work. Describe the visual look and feel of the film; for instance, should the locations feel claustrophobic or have cinematic depth?

2. Once the location manager has found options and photographs for locations, the director and first AD should meet with them to talk about creative and practical issues. The creative issues are how fitting the locations are for the film, and the practical issues are the accessibility of the locations, and how to cluster the locations to minimize the number of company moves. Some location options may be determined to be logistically unrealistic, and the location manager may need to find new options.

3. After the best location options are found, the director should make at least two visits to the locations prior to shooting. The first, called the director's scout, is done in conjunction with the location manager and, ideally, with key department heads, such as the cinematographer and production designer, to make sure that the locations are right for the film. After the locations are formally chosen, the second trip to the locations—called the tech scout—should additionally involve the production sound mixer and first AD, as well as a producer, to begin the specific planning and blocking for the shoots.

8 The director and art department

1. Art department overview

The art department is responsible for creating the colors, textures, and physical items that fill a location. The director's collaboration with the head of the art department—called the production designer—is instrumental to achieving a compelling and cinematic look to the movie. In the previous chapter on the locations department, location manager Samson Jacobson described a location as the "bones" of the set. The art department bridges the gap between the location and the camera departments by determining how that location looks and feels on camera. The art department, essentially, puts the skin on those bones. When the director collaborates with the art department, it is helpful for the director to imagine each scene in terms of colors, surfaces, furniture, and props. What will the actors hold, carry, throw, or break? What do the walls look like that the characters will be walking past? What furniture will they be sitting on, hiding behind, or jumping onto?

Imagining how the characters interact with the set can help lead to more visual ideas about how to film each scene. Indeed, the physical space that an actor occupies is of magnificent importance not only for the actor to experience a credible world with which they can interact, but to establish, for the audience, the world that this movie is creating. All movies, including naturalistic ones, create a specific world where the story is taking place—a world that looks and feels, even subtly, different from reality. Directors tell stories that have a specific worldview; the writer, actors, and cinematographer help to tell that story; and the production designer helps to build that world.

The art department is responsible for a wide range of activities, from building sets and furniture, to graphic design, to researching props and materials for historical or geographic accuracy. Collaboration with a department head is often based on the director having specific ideas about what she or he would like to see from each department. For a director to be able to lay out a vision for the film is necessary for the film to feel coherent. However, along the way to executing that vision, there are always roadblocks and challenges. Budgetary, scheduling, and logistical issues threaten to undermine every movie production. An experienced and motivated department head will often

be able to come up with solutions to fulfill the director's vision while also staying practical to the real-world challenges facing that department. A production designer's knowledge of everything from set construction and prop manufacturing to realism and aesthetics is deep and extremely valuable. A less collaborative director might well feel lost in the enormous range of options and possibilities, and limitations, for the sets' design. In order to help the conversation and the collaboration, it can be helpful for the director to organize her or his thoughts and start the collaboration with two general concepts: set dressing and props.

Set dressing

The set of a scene can inform the audience about the inner lives and backstories of the characters in a film, and also about the mood of the world in which the film is taking place. The set can also reflect the naturalistic space in which the characters are living their lives. Either way—whether the set is stylized and expressive, or naturalistic—the production designer has a key role in creating the world of the film. Is the furniture going to be gilded and overstuffed, or ragged and threadbare? Will the colors of the walls be rich and saturated, or mute and desaturated? Will the space feel empty and new, or cluttered and old? The relative brightness or darkness of a set is also within the domain of the designer, as well as the cinematographer, and quite often those two department heads will be in close conversation to complete the look of the set and how it appears on camera.

There are many reasons the director might want to use a specific color scheme or style of set dressing. Is the world of this film an inviting and kind place, or a dangerous and austere one? If the mood of a scene is meant to be somber and melancholy, then this mood might be difficult to capture if the walls are painted bright greens and blues. In Francis Ford Coppola's *The Godfather* (1972), the dark and serious opening scene is dressed with blacks, browns, and tans. In Greta Gerwig's *Lady Bird* (2017), which has a brighter tone and faster pace, the colors are brighter, tending toward reds and yellows. Interestingly, the colors often match the reddish hair color of the lead actress, Saoirse Ronan, suggesting that the look of this film is aesthetically organized around the identity and perspective of the lead character.

The equation between the tone of the film and the color scheme does not always need to be so literal. Looking again at the Safdie Brothers' film *Good Time* (2017), the tone of that movie is often dark and frightening, and yet the color palette is frequently bright with reds and greens. However, the *types* of reds and greens used are important to observe: they are glaring and neon, so bright as to almost hurt one's eyes, and suggesting a luridness and a dreary, unhealthy glow.

Some filmmakers use the psychology of color theory to help inform the film's palette. For instance, in the famous scene of Steven Spielberg's *Jaws* (1975) where the shark is seen claiming its first victim, Steven Spielberg

uses iconic accents of reds and yellows—and occasional vertical stripes—in his set dressing and wardrobe choices. A great deal of film scholarship has been written about this scene, with some observers positing that those colors, in combination with the striped pattern, suggest the markings of dangerous insects or snakes, and create a subconscious response of fear in the audience. Whether or not this coloring creates such an effect can be debated, but regardless, broad aesthetic choices (wanting the dressing to resemble the markings of a poisonous snake) at least provide a direction and a set of cohesive choices for the director and production designer to make. It puts them on a specific, creative pathway that—given the alternative of having no leading set of principles, and therefore leaving the director with no clear ideas about the look of the dressing—is extremely useful.

Props

Props can be part of the set dressing—objects that adorn a set—or they can be objects handled by the characters and play a part in the scene. If a prop is going to be featured in the scene, or will be handled or operated by an actor, it is called a hero prop. The director should communicate to the production designer how the props will be used, or how prominently they will be featured in a shot, and to give the designer enough time to acquire or build them. Given the subject matter of the film, some props—such as weapons or historical objects—may be difficult to find and take time to ship. Production designers frequently deal with prop rental houses, and the director and production designer can look through photographs of available props to see what may work for the film.

For more specialized props, the director and designer should also consider finding an expert or consultant to help ensure that the acquired prop is realistic, but also that the actor knows how to use it accurately and reliably.

Budgetary differences

Budget can have a significant effect on the art department. Dressing sets and acquiring props takes time and effort, and sometimes materials are expensive. A higher budget means that the production can hire a bigger crew and spend more time researching, prepping locations, and building sets. But this does not mean that smaller budgets are not able to make strong use of their art department. The following section, on director Xavier Dolan, explores many techniques for how he used the art department on a smaller budget.

Often transparency in the collaboration process between the director and production designer can help save money. For instance, it is important for the director to share the shot list with the production designer and be clear about how the scenes will be shot. If only a small portion of a room is going to be in view of the camera, then the designer should be aware that she or

he only needs to dress that specific part of the set. Alternatively, if the director is going to use a looser approach and allow the actors to move around the sets in a more improvisational way, then the designer should be aware that more of the set needs to be dressed. If the director wants to use wider-angle lenses, then more of the set will be seen by the nature of how wide-angle lenses capture more space around the characters. This means more time and materials (and possibly more crew) are required for dressing. Long lenses, on the other hand, provide a tunnel-vision look and will show less space around the characters.

A single prop or piece of set dressing can suggest an entire room or world in which a character is living. For instance, an old leather wallet falling apart at the edges might indicate a character's financial difficulties. A kitschy porcelain water pitcher on a dining room table might suggest the personalities or styles of the people who live there. Dressing an entire room may not be required.

Budgets can profoundly affect what an art department can achieve, but clever and creative art direction can be a useful tool for the director.

2. Director case study

Xavier Dolan is an extraordinary and highly prolific filmmaker whose use of art direction ranges from the minimalist to the baroque, and from the beautiful to the beautifully grotesque. The art direction in his films serves as a storytelling tool, and the range of his budgets—from low- to moderately budgeted films—shows his abilities to work both economically and, when budget allows, with grand visual ambition.

Let us look at a few examples of his use of art direction, starting with his earliest feature film, *I Killed My Mother* (2009), and then examining two of his more recent films. *I Killed My Mother* tells the story of a teenage boy caught in a complicated, stormy relationship with his mother. Dolan wrote and directed the film, and plays the role of the teenager, Hubert, whose mother is Chantale. Partially financed by Dolan on a limited budget, the art direction is used to help tell the ups and downs of Hubert and Chantale's relationship.

For instance, early in the film when the mother and son are sitting down for a meal together, and arguing back and forth with a series of dark insults, the set is designed to look brown and drab. Closed curtains with a muted pattern, the basic wooden railing of a staircase, and a wall with a meager strip of wallpaper help to create the mood of the depressive scene. However, at the same time, the art direction is not boring. The curtain pattern may be muted, but there is a pattern to behold. Same with the bars of the railing and the wallpaper: they look dreary, but they also give a sense of texture. Dolan makes sure that his frames do not feel empty, or devoid of shape or accents. This is a delicate balance, made even more complex by providing a single splash of color to the scene: a second, small table in the background, covered

in a bright floral tablecloth, with a stained-glass lamp illuminating from above. It is a simple piece of art direction that gives depth to the framing, which helps to make sure that the dialogue-heavy scene remains cinematic, while providing a metaphoric relationship between the characters and their elusive happiness. Indeed, happiness exists in the world, but not at the table where they sit; happiness is something to be found, but it remains, at least in this early section of the movie, rife with conflict and anger, beyond their reach.

This art direction is paid off about 15 minutes later in the movie, when Hubert decides he is going to settle his grievances and make amends with his mother. Biking to a nearby store, he buys a selection of fruits to make breakfast for his mother. A brisk, music-driven montage of the fruit being cut, filmed from overhead with clean cinematography, supplies the frame with all the color that Dolan had been putting out of reach in the earlier meal. Yellows and reds and blue splash across the frame. In a bit of ingenious art direction on a budget, Dolan includes a scene of Hubert riding his bike with the bags from groceries. The bags are balanced on the handlebars: on one handle, the bag is green; on the other handle, the bag is white. The two types of bags bring more color into the frame, and also suggest that Hubert has traveled to at least two different stores to buy his ingredients. This detail suggests the added effort he is making to appease his mother. To this latter point, the art direction is giving context to the movie by implying what happened in scenes that were never even shot. At the breakfast table itself, there is now a bright light over the table where Hubert and his delighted mother eat. And the previously illuminated table in the background? That light is now turned off. Happiness is closer in this scene; indeed, it has arrived at the very table where they sit.

The point here is that art direction can help carry the metaphorical and tonal weight of the movie. It can also help tell some of the story by filling in the gap of scenes that were not worthwhile or feasible to shoot. But Dolan will also look at art direction in purely aesthetic terms. The visual style of the film is to keep the camera locked down—with the camera on a tripod keeping the shots still. This choice allows Dolan to create clean frames, but a risk of this approach is that the movie may feel visually uninteresting. Without camera blocking, camera framings can sometimes look stiff and rigid. In one scene, where Hubert has lunch with his French teacher, the entire scene is shot in three, unmoving camera setups: a wide shot of the two characters sitting side by side in a booth, and then a closer single for each of them.

To keep his frame visually dynamic, Dolan makes use of the paint on the walls. A swirl of pale green and bright yellow adorn the wall behind the pair; they sit in a red, curved booth. The simple geometry of swirls and swoops helps give visual life to this scene. The condiments that are set out before the characters—shakers, sweeteners, ketchup and mustard bottles—are placed with visually arresting perfection. The conversation between Hubert and his teacher is well-written and well-acted, but it is long, so Dolan keeps our eyes

busy, looking for the rhyme or reason behind this mysterious friendship, which plays like the flirtatious color twirls and twists on the walls.

Other times, Dolan uses art direction to reinforce, or provide a foil to, the emotions on screen. For instance, in one scene when Hubert learns that he will be attending a boarding school, a place that he hates, he goes into his mother's bedroom and begins wrecking the room. He flings bedcovers and raises a coveted decorative plate overhead to destroy it. His fury is played in slow motion; his destructiveness is played out on a massive scale. But the art direction offsets the anger; flowers adorn the room in planters and pots, and the comforter of the bed is also printed with a delicate, floral design. The beauty of the art dressing of the room plays against Hubert's anger, and turns a scene about fury into something more nuanced. It reflects this complicated soul, a boy in love with beauty and besieged by hatred, a boy who both loves and despises his mother all at once. In the context of budget and how it relates to the art department, this is an example of how a minimal amount of expense (dried flowers and a sheet-and-comforter bed set) can have a profound effect on the overall feel and function of a scene.

Similarly, in a later Dolan film, *Laurence Anyways* (2012), about a male writer who risks his romantic partnership with a woman, and his career, to live his life as a transgender woman, Dolan dresses many of the sets with monochromes and bare walls. The school where Laurence teaches features pale gray walls, and Laurence's home is cast in browns. Occasionally, during some emotional scenes, there are shades of orange. But when Laurence visits a commune—a palatial building taken over by artists and perceived social outcasts, much as Laurence himself feels—then the art direction becomes very different. Gilded furniture, bountiful amounts of glistening beads, checkerboard floors, and vaulted ceilings define this new space. Colorful beyond measure, cheerful, messy, and baroque, the art direction is an embodiment of Laurence's personal freedom. The location, and its dressing, are expensive compared to Dolan's budget for *I Killed My Mother*. This amount of set dressing and art direction takes time, but the way that this dressing and color palette plays against the soulless feeling of the school, and the claustrophobia of Laurence's house, works to powerful effect.

A more recent Dolan film, *Mommy*, which touches upon a similar story-line to *I Killed My Mother*, where a teenage boy and mother clash and struggle in a mighty war of wills, Dolan lays a less heavy hand on the art direction. Indeed, art direction does not always need to make a symbolic statement about the characters or stories, and if it did the results might be exhausting. Dolan chooses a naturalistic approach to the art direction, using somber tones and unremarkable props to establish the working-class life of the main characters. The art direction does not say much other than to reflect the world in which the characters live. Part of the reason for this is the film's unusual aspect ratio (most of the film plays in a vertical orientation, much like a cell phone screen held upright) means that less of the set will be seen. Its impact upon the audience is bound to be

smaller than the magnificent close-ups of faces that loom and pass across the screen.

Restraint is the lesson here: Dolan knows that the characters will be left to tell their own stories in this film, and the art direction is appropriately muted. And yet subtle art direction does not mean that there is no art direction. For instance, in the main characters' house, Dolan chooses furniture and walls that that range from yellows to browns. A brass-hued serving set brought out for a guest. The setting is quite ordinary. However, Dolan allows this domestic palette to play differently depending on the light: during an evening dinner, the warm, soft lights in the house transform the browns and yellows into golden hues. But in another scene, an argument during the daytime, the harsh sunlight makes the browns and yellows appear dreary and functional. Dolan relies on the colors of his lighting scheme to shift the art direction from one mood to another. This is a subtle but effective, and relatively inexpensive, choice.

Xavier Dolan's cinema is an ecstatic one, full of ideas and drama and tears and genius. His use of art direction is varied according to the story he is telling, and the budget with which he is working. Each new film of his presents a new way to consider the role of art direction in filmmaking.

3. Interview with a production designer

Maggie Ruder is an experienced and talented production and graphics designer who has worked on a range of feature films, such as *I, Origins* (2014, directed by Mike Cahill), and television shows, such as *The Marvelous Mrs. Maisel* (2017).

TAKOUDES: I'd like to start by hearing about your creative process. Once you read a script, what are your first steps in planning the art design of the film?

RUDER: I like to reread the script a bunch of times. And I like to meet with the director early on, to make sure I'm going down the right alley. I had a meeting last week for a feature film, and I'd read the script and it's a script that focuses on life in high school, and the production company is specifically making things for high school kids. I wondered, is this going to be a Molly Ringwald type of high school, or *Saved by the Bell* ... or is this going to be a grungy high school? Because those are all very different directions. So I have to have that moment with the director when they can give me the tone of the film, and then I build out from there.

TAKOUDES: How is tone created through art direction? Where do you start?

RUDER: I usually look at characters first, so my first style boards always include costumes, because I'm looking at the characters and what they wear and what they'd have on their person. I'm thinking about their character and then expanding to reflect what are their spaces.

TAKOUDES: It's interesting that you're a production designer, but you design the sets by thinking about wardrobe.

RUDER: I like those details. I think about what their backpack is. Even their posture, their body position. How does the character sit in their bedroom? Because unless you know the character, you can't really know what their bedroom looks like. You can't dress the set.

TAKOUDES: And what are the conversations like with the director at this early stage? What information are you getting from them?

RUDER: Usually, I find with directors that they can reference movies and television shows really well. They want to talk about films as a way to explain the tone. But that's not usually as helpful for me. I don't think that way. I'll look up their references, but I find that it's helpful to reference images that aren't necessarily from any movie or show. I tend to walk into a meeting with the director and show a bunch of images of specific objects, or styles, or photographs. I have a lot of photographers that I follow, and a lot of photography curation websites that I'll pull from. Historical pieces are big for me. I like to know what wallpaper and certain objects really looked like historically, and that's why I don't tend to reference movies—I reference images of materials that haven't yet been stylized. It's the authentic piece from the period.

TAKOUDES: You're investigating the character through real objects, not movies.

RUDER: Yes.

TAKOUDES: It makes sense because a movie has already stylized the item or the object. You want to go to the primary source, as it were. It can help you to examine the character in a richer way.

RUDER: I like dealing with the primary resources, the original pieces themselves. For me, the movie references aren't necessarily where you start because the movie is where you wind up. So, I'll show the director these boards with these photographs and objects that I pulled, and then if they want to talk about certain movie references, then we can integrate those references with the images that I pulled.

TAKOUDES: Is the cinematographer part of this early collaboration?

RUDER: That's the best-case scenario. When you've met with the director and cinematographer, and they show you some ideas for how they're going to frame their shots—how the sets will be filmed—that's really helpful. Because if a scene is not going to be handheld, for instance, and the shots are going to be tight close-ups, in that case you have a lot more leeway because not every angle in the room will necessarily need to be dressed. Because it won't be seen on camera. A lot of time when the budget is fairly low, or if I'm doing television, you don't that the luxury of time to get that information. In those cases, I have to assume that the whole room will need to be ready to film. Everything will have to be dressed. That's the reality sometimes in low-budget filmmaking—so a lot of my recent experience is thinking about scale.

TAKOUDES: Scale? Meaning what?

RUDER: When I started out in movies and there were tiny budgets, and we would say, "Okay, we can afford a bed and a dresser, but we can't fill the whole room." So, there were limitations on what could be shot. But now, I think more about how we fill everything in the room so that we can shoot in larger scale pieces, as opposed to just dressing with one or two bigger items. We can bring in fabrics or something to make the whole space feel interesting, as opposed to just getting a piece of the set.

TAKOUDES: And how the entirety of the room expresses who the character is.

RUDER: Character, and place and time, too. All of it. I once did a movie in Spain where we had to build a New York apartment. It was actually cheaper to shoot a New York apartment in Spain than shoot the movie in New York. It was interesting to think about the little details that really tell you're in a New York apartment. Like, if you have moldings on the wall, then you can't just paint them—you have to paint them over and over like five times, because it's an old tenement building. There's layers and layers of paint on the walls in those old apartments. So, I like to fill the spaces with those kinds of details that tell you about the characters, the history of the place, or about the story. I like the art to tie everything in the script together.

TAKOUDES: Is it helpful for the director to give you specific ideas about these details?

RUDER: It can be—but at a certain point it can be hindering as well. I've worked with directors who are exacting about those details, and they get exactly what they want. But it's potentially limiting because then those directors won't be surprised by what my ideas were. They can lose the opportunity to tap the creativity of the team that they hired. Yes, I can deliver a checklist of props, and if you want to give me these 20 things to put in a room, you're probably not going to get the other creative ideas, or more subtle ideas, or the other opportunities that we could also use, because I'm trying just to make sure that I get the director's ideas hammered down.

TAKOUDES: What's an example of a collaboration that went well, where you had enough information from the director to put you on the right track, but you also had the freedom to bring forth your creativity and expertise?

RUDER: When I was meeting with Wyatt Cenac about a project, they gave me the pitch that Wyatt loves technology and wanted it to be incorporated into the set. Then I met with him, and he was referencing movies about technology and he described how they made him feel a certain way— thoughtful and adventurous. And that was it. For me, it was great. I can watch those references and think of the pieces that he mentioned that he likes from them, and then translate all of that into something that he is thinking for this project. It worked out well. I already knew the feeling that he wanted, but we ended up getting to that feeling in these really interesting ways by how I used the wallpaper and saturated colors on set. These were design elements that I don't think he was originally thinking about, because they weren't from his references, but the tonality and the

emotions of his references were there. I'd rather hear from the director about the tone and emotion that they want, and I'll be able to capture that feeling. That's a better collaboration than to just be told that I need to find one specific object.

TAKOUDES: I want to touch on the word you mentioned—surprise. Directors need to have control of their sets, but they should also be open-minded to the ideas of their cast and crew. Surprise opens doors to inspiration.

RUDER: So much of our jobs are so hard, and it's nice to open a set and get to show the director the extra details that are going to make them feel happy and excited, and creative and ready to, like, conquer the day. Having a director who gives you that freedom to be creative feels amazing. There's nothing better than showing up on set and being, like, "I have a surprise for you. You're going to love it." It's rewarding and it makes you feel like a team.

TAKOUDES: There's a certain amount of chaos on sets. Maybe the blocking is going to be different for some reason, or there's a last-minute problem with a location. How does this affect your work?

RUDER: It can be hard. So often with the art department, 80 percent of the art is never even shot.

TAKOUDES: Why?

RUDER: Because if there was going to be a wide shot and we were going to see the whole set, but now it's just tight on someone's face, then all that set dressing isn't going to be seen. It's a hard lesson when that happens. I think art gets stepped on sometimes. The director and cinematographer are completely free to change things last minute—that's the nature of filmmaking —but that should get communicated to the art department.

TAKOUDES: Especially because art can sometimes take longer to shift directions. Re-dressing a set or bringing in new props takes time.

RUDER: Even knowing the day before is helpful. The director communicating equally with the cinematographer and the production designer is something that our industry needs to continue to work toward.

TAKOUDES: Is it important to have regular meetings, then?

RUDER: It's actually not a lot of meetings. It's more about accessibility to the director. Everyone is putting in a lot of time and hours, and treating your crew members' ideas with respect, and being willing to hear them out, goes a long way. The director is going to get a better product when that happens.

TAKOUDES: Motivating departments is huge. And accessibility is a key to motivating the departments.

RUDER: Right. And back to the point about meetings, it's great to have a meeting at the beginning of the process, but usually I don't do that more than once or twice. We have the first meeting to talk through tone and feeling, and then we go about our business. If I have a big idea, then I'll send it to them. Or if there's some prop that they want that we're trying to find, I'll stay in touch with them. But it usually just comes to a show-and-

tell in the second meeting where I show them what I've found, this is everything that we're planning. Coming out of the first meeting, you get a sense of where the director's interests are. And usually, hopefully, they're interested in your interpretation of the character, as long as you're not trying to guide the narrative. Which you don't do.

TAKOUDES: It's also important for the production designer to be a part of the location scouting, too, right?

RUDER: Absolutely. Most of the time is spent sitting in production vans going to a location.

TAKOUDES: And what do you want to see in a location?

RUDER: Usually, I'm looking for the bones of the place. The overall feel and layout of the space. For the most part, it's rare to get a location that totally works. You always have to do something. So, you're looking for a location that has the majority of what you want, and has the right feeling, and you need to augment it or make it right for the period. I did one project where we drove from mansion to mansion to mansion out on Long Island, and we saw about 15 mansions because it's amazing the different personalities they have.

TAKOUDES: Also, you need a sense of how much work is needed to transform a location. Painting a wall may not be that big of a deal, but other things might take more time.

RUDER: Right, like moving billiards tables, for instance, is a very big deal. There are a lot of challenges and you have to be able to say yes to the director a lot, but it's a yes *if*. You can make any location work, but only if you have the right budget. Often we'll be between several locations and the director might love one aspect of a location, and we'll say, "Okay, but this is what it's going to cost you visually for everything else." A lot of my job is giving the director their vision without comprising elements that the director may not be thinking about. Directors think about actors, and they think about space, but they think about it differently than the art department does.

TAKOUDES: How do you see things?

RUDER: I look for authenticity. I look if the walls aren't aged. If the artwork or graphics aren't realistic-looking. You see it sometimes in sitcoms where a character is reading a book, but the book spine doesn't have a logo on it or a barcode on the back. Those details are what I look for.

TAKOUDES: And whether the art is right for who the character is.

RUDER: I think about that, too. I do graphics as well, and it's interesting because we see so many characters on their phones now. Looking at a character's phone, you can learn things about them.

TAKOUDES: Like what?

RUDER: Like what's their background image? It says something about them. If you open the phone, what are the apps that you see? So many shows are screen-heavy that the screen has become an entry into the character's world. I also love going into a character's bedroom because you see not

only who they are, but who they once were. You see who they thought they were going to be when they were younger.

TAKOUDES: By what's on their walls?

RUDER: Absolutely. I like to pay attention to the old electronics they have, how clean the room is, where their laundry is kept, how the closets are organized. There are a million different small dynamic choices you can make that tell you something about that character. There's one scene I did for a movie called *Take Me to the River* [directed by Matt Sobel], shot in Nebraska. There's this culminating scene where the family is sitting around a table after a whole big fight, and it's very uncomfortable and ends with lots of people crying, and we were trying to think about, "What do they have in front of them at the table?" And we ended up with those red plastic cafeteria cups that were ubiquitous in the '60s.

TAKOUDES: With that bumpy texture?

RUDER: Yeah. Everyone's at their grandmother's house. Those were the cups the kids grew up with. So, when they're meeting around the table for this uncomfortable talk, that's their safety childhood cup. There has to be a reason for why I wanted those specific cups, and I didn't just want to use clear plastic cups. But if the director is not always on board with it, then I'll sometimes arrive on set with two options.

TAKOUDES: Allowing you to think creatively about that kind of detail is important, because the director won't be able to think of every possible detail.

RUDER: As long as you and the director are on the same page as far as the tone and what the audience are supposed to get out of the character, that's good. A good director is always going to listen to your ideas.

4. Tasks for the director

The art department's responsibilities often require extensive planning; procurement of props and dressing of sets can be a time-consuming process. The earlier in pre-production that the collaboration with the director begins, the better. Here are tasks to complete during this process. The next chapter in the book looks at the production sound department.

1. The director should go through the script with the production designer and discuss the desired feeling and tone for the scenes. This discussion should also include a conversation about props that the script requires, and ideas for dressing. A schedule for the art department should be established soon after this initial meeting. Ideally, the cinematographer is part of this meeting, so the two department heads can get on the same page about how the movie will be shot, and how that visual strategy will affect the set dressing.
2. If possible, the director should have the production designer join the location scouts. This helps the designer understand the director's vision, and refine the art department's time and budget requirements.

3. As production nears, the production designer and director should meet again to look through the props and set dressing pictures, samples, and choices, and make any necessary changes.

4. If any of the props require special handling or are used in specific ways, such as tools or weapons, or that take some getting used to, allow the actors time to handle the props and become familiar with them. The director should consider finding an expert or consultant to help train the actor on how to use the prop if their facility with it plays into the story.

5. On each production day, the director and production designer should walk through every set and have a final look at the dressing and props—this is called "last looks"—to make sure everything is right for shooting.

9 The director and production sound department

1. Production sound department overview

The production sound department is responsible for recording sound during the filming of a movie. Ensuring that the dialogue and ambient recordings are clean is the top priority of this department, so that in post-production the sound elements can be edited and combined with new sound elements—such as sound effects and score—to create a rich soundscape full of creative possibilities.

Pre-production and production

The head of the production sound department is the production sound mixer. Depending on the budget, the sound crew might be one person—the sound mixer alone—or a slew of positions that include one or more boom operators, who are responsible for positioning the boom microphone to record the scene's dialogue or ambient sounds, to a range of sound assistants. Production sound mixing is a job that requires technical ingenuity and extreme focus to solve an array of audio problems; among these are noisy locations, actors speaking at various volumes, and certain wardrobe or upholstery materials that can be loud when an actor interacts with them. It is up to the sound mixer to figure out how to record clean sound in these challenging environments, and because of the highly technical nature of this work, the sound mixer is one of the more autonomous department heads on a film set. All too often, this autonomy means that directors can tend to overlook the sound mixer and fail to involve them in the broader filming operations. At the heart of collaboration between the director and production sound mixer is creating a relationship based on involvement and communication. This happens at several different stages.

In pre-production, the director should share the script with the sound mixer so the mixer understands the scope of what is needed to record the sound: How many actors will be speaking in a given scene? What sorts of spaces will they be in? Also, the script will help indicate to the sound mixer any obvious sound problems or challenges with how scenes are staged. For

instance, if the director wants to have a scene of a conversation between two people driving down Manhattan's Seventh Avenue in a convertible car, the director might be excited about the visual possibilities of such a scene, but neglect to consider the significant challenges of recording dialogue with all that wind. Having the sound mixer's input and awareness early in pre-production means that problems can be addressed before shooting, and give time for tweaks or rewrites in the script if any changes need to be made to accommodate sound.

Moreover, in pre-production, it is important for the sound mixer to visit each location before filming. After the locations are confirmed, the director will go on a tech scout with several key department heads. Every director manages the tech scout differently, but having the cinematographer, location manager, production designer, first assistant director, and sound mixer present is critical. The sound mixer will need to determine how noisy the locations are and create a plan for where to place recording devices for the scene.

During production, at the start of shooting at a new location, the director will walk through the scene with the cinematographer, sound mixer, and actors. This is a chance for everyone to understand the specific camera blocking and character blocking of the scene. Knowing where the actors will go allows the cinematographer to plan the lighting scheme, and also allows the production sound mixer to know where to set up microphones, where the boom operator should stand, and how to make sure everything that happens in the scene will be recorded cleanly. If the sound mixer is not aware of the blocking, then she or he might be put in an unfair situation of placing microphones that wind up being seen by camera, or having the actors travel to a spot on set where the microphones might not record clean sound.

The larger issue is this: the director needs to not forget about, or neglect, the production sound mixer. There is, perhaps, no other department head who winds up being more overlooked than the sound mixer, and when this happens—either in pre-production or on set—the result is often poor sound. Poor sound is not necessarily the sound mixer's fault; the director has the responsibility to invite the sound mixer to important production meetings and location scouts, to make sure the sound mixer understands each location and scene. There is not necessarily a creative collaboration that occurs between the director and production sound mixer, but there is a collaborative mood that the director sets through awareness and communication with the sound mixer. The more that the sound mixer is invited to relevant production conversations, the fewer chances she or he will have to improvise solutions that could have been figured out days or weeks prior.

The consequences for having poor sound quality are significant. When dialogue is difficult to understand, or if the soundtrack is full of distracting noises that are not part of the intentional storytelling of the film, it is easy for the audience to be taken out of the movie. The spell of cinema is broken when the sound quality degrades. Documentaries have more latitude when it comes to sound quality; there is an implicit understanding by audiences that

the conditions of documentary filmmaking are less controlled by the director. But narrative films must achieve a higher bar in terms of audience expectations for the basic technical attributes of a film. Even for low-budget films, or films shot in gritty and improvisational ways, the camera can fall out of focus, action can spill out beyond the frame, and jump cuts can dominate the editorial process—and the audience can remain engaged in the film. But as soon as the sound falls apart, the audience is likely to disengage.

On set, directors tend to focus most of their time working with the cinematographer or actors—and with reason. These elements are fantastically important. But many directors do not have as much facility or interest in sound. They tend to take sound for granted or do not recognize its storytelling potential. Additionally, it is common for the production sound mixer to be physically further away from the director than other department heads. This simple fact of geography contributes to many directors forgetting to give the sound mixer attention while on set. A director will often listen to the sound on a headset, but usually their focus is on camera and performance—not sound.

It is good practice for the director to occasionally check with the sound mixer and make sure everything sounds up to par, or ask if there are problems. This does not mean that the director should hover and micromanage the sound mixer, but everyone appreciates face time and occasional attention from the director. When a department head does not get that face time, they might naturally work less hard, or start making their own decisions about carrying out their jobs that the director may not want. The more welcome that the director can make the sound mixer feel as part of the crew, the more motivated she or he will be to do a better job.

Preparing for post-production

During production, it is important to record as many relevant sounds as possible. The sounds of ocean waves. Birds singing. Children playing in a nearby playground. These types of sounds are available in post-production sound libraries, but often the authentic sounds of the specific spot where a scene was filmed will mix better in the finished audio track. This is especially the case when it comes to dialogue. Get every line of dialogue, and if some lines are going to be spoken off camera, it can be helpful to record alternate lines that had been considered in the script as well. While it is common to have to record some dialogue in post-production, many directors try to do this as little as possible. ADR—additional dialogue recording—happens in post-production. It can be expensive, and even when the budget allows for the actors to record the dialogue in a high-quality recording environment, it is difficult to perfectly match with the existing production sounds of the film. This topic will be explored further in Chapter 12, but generally directors who intentionally leave dialogue for ADR sessions are putting themselves in a potentially

vulnerable position of having to use dialogue that does not feel completely authentic.

Despite the ambient noises that might detract from getting clean audio recording (such as a nearby highway that the director does not want to hear in the movie), recording sound on set often allows for the most emotionally resonant material. The director and production sound mixer should discuss what types of unwanted noises can be cleaned from audio tracks, and what cannot be. For instance, echoes are difficult to fix in post-production, as are the hums of generators or refrigeration compressors. Improvements in the technology to clean up production sound are constantly improving, but these solutions—even when technologically possible—can be expensive and time-consuming. The director should be cognizant if the sound mixer has concerns about the production sound, taking the time to address those problems with the mixer.

Collaboration with the sound mixer also means figuring out which sounds, by necessity, do not need to be recorded on set, and can instead be added in post-production. For instance, if there is a party scene with music playing, the music will usually be added in post-production and not recorded on set—although some musicals, such as *Les Misérables* (2012), provide a notable exception to this rule by recording the music live on set. Music rights issues and continuity problems would make editing challenging if music played on set while the scene was shot. A sound mixer will have insights into this issue that a director may not immediately consider. The more the sound mixer knows about the director's vision for the film's sound, the better the sound mixer will be able to give the director the audio elements needed to execute that vision in post-production.

2. Director case study

Dialogue is more than just the words on the page. Beyond the information that dialogue provides, actors' voices can also work as a sonic element in and of itself. In some regards, dialogue is just one type of sound working in conjunction with the myriad of other sounds in a film (such as effects and music, which will be discussed in Chapter 12) that build a movie world. This section looks at director Robert Altman's approach to recording dialogue, and how his recording techniques helped to tell his stories in such an original fashion.

Altman began his career as a film director relatively late in life, after spending over a decade directing television. He was proven to be a prolific craftsman by his work in television. But it was his film work that would revolutionize American cinema from the 1970s to the end of his career in the early 2000s. Known for his ensemble casts, roving camerawork, tightly packed frames full of action and emotion, and innovative use of dialogue recording, Altman's cinema is instantly recognizable. His films are energetic in their feel and dense in their content—a lot is going on at once in his movies, and the audience needs to pay careful attention. His films also

famously defied genre and easy marketing categories, which limited, to a degree, the box office potential of his films. For instance, *California Split* (1974)—the film discussed in this section—is usually put in the comedy category, but it shares little in common with most lighter, highly accessible comedies of its era. His movies are too immersive and confounding to be considered as straight-up entertainment. In Altman's cinema, the audience is swarmed by passing people, catching bits of their conversations as they move around; it is hard to know what to pay attention to, what to look at, or where the center of the party is. But this impressiveness is not particularly frustrating or confusing, because what audiences realize when watching the films of Robert Altman is that no matter where they look, or to whom they pay attention, it is always going to be interesting.

In the opening credit sequence of *California Split*, career-gambler Charlie, played by Elliott Gould, enters the California Club, a gambling club where the numerous tables are filled with poker players. As he circles the room and surveys the players, Charlie, on a whim, pushes the button on a television screen to watch an informational video about poker. As Charlie finds a table and starts to play, the voice from the video explains the rules and protocols of poker. In a wide shot, Charlie takes a seat and begins chatting with another player. At the same time, a casino announcer, who is calling players to their tables, lists off a series of names and tables. All these layers of dialogue are happening at the same time, and while the volume of one conversation is occasionally boosted slightly over another, for the most part they are played at the same loudness levels in the mix. The audience is listening to three conversations at once and will inevitably miss some, if not most, of the dialogue. Not only is this not a concern for Altman—it is the point. The audience has been invited to a party; the party is crowded and loud, uncomfortable but exciting, and full of fascinating although unpredictable characters. Surrounded by so many simultaneous conversations, the audience is in a race to pick up as much of the local flavors as possible, to understand what is happening, and to do its best to enjoy the ride.

This makes for a thrilling cinema: a type of filmmaking that feels cutting-edge even decades after its release. This technique of overlapping dialogue can make editing challenging because with characters talking over one another, any cut is likely to not match the conversation with the following cut. This was the reason that producer Jack Warner fired Altman from his first feature film, *Countdown* (1968). When Warner saw the overlapping dialogue in the dailies, he assumed that Altman knew so little about filmmaking, or was so sloppy, that he did not know any better. But continuity was not an overriding concern for Altman, and he largely mitigated this problem by cutting less frequently than most directors. Altman preferred a roving camera that explored each scene in long takes.

Traditionally, the camera will be on the speaker in a film, or a two-shot can show two people talking to each other. But in *California Split*, there is a three-shot where the character in the center is not speaking, and the two

people next to him—at opposite edges of the frame—are chatting to other off-camera characters. Even more unusual, the camera is tracking in slowly on the man in the center of the frame—the only character not talking. A few shots later, the camera returns to a tracking movement toward this character, but just as he finally begins to talk, he is drowned out by a sea of other conversations that erupt off camera.

By the end of this opening sequence (which also serves as the opening title sequence of the film), the audience has met several central characters, gained an understanding of how to play poker, learned how Charlie defies the rules, and felt implacably present at the tables. The audience can almost smell the cigarette smoke and cologne in the room, touch the felt tabletops. The result is exhausting and enthralling, as the audience is embedded in this new and possibly unfamiliar world. In the cinema of Altman, there are no wrong choices for the audience to make when listening. If the worst type of dialogue is expositional dialogue—spoken merely to inform the audience about the plot—then Altman's use of dialogue recording is the opposite. There are many ways to get to know a character, and if the audience cannot always hear them, the audience will tend to watch them more closely. This effect is similar to when two people who do not speak a shared language try to communicate. There is more focus put on the eyes, gestures, and—in particular—the tone of the words. Even if the words themselves are beyond our comprehension, it is how they are spoken that reveals the meaning. This is especially a relevant technique given that the game of poker is, in part, about reading expressions and gestures, looking past the dialogue for the truth behind the eyes.

Ultimately, in an Altman film, the audience learns a great deal about its characters, but it is not always clear how these things came to be known; more often than not, it is because audiences tend to observe Altman characters more closely than characters from other films. The audience has been immersed so profoundly into the auditory and sensory experiences of their worlds. The audience gets to know the characters by feeling, in an intensely visceral and auditory way, the places where these characters choose to live, work, and play poker.

Altman's technique of recording multiple tracks of production works for other purposes as well. In his Korean War comedy *M*A*S*H* (1970), there are scenes in an operating room of surgeons repairing devastating and visually graphic wounds of soldiers who have been injured on the front lines. The film focuses on the lives of the surgeons: the drama and tragedy of their work, and the juvenile pranks and hijinks they engage in, as a way to avoid and mitigate the emotional pain and exhaustion of the war. Altman uses overlapping dialogue to portray the collision of these parts of the doctors' lives. In one surgery scene, two doctors operate on a single patient; one doctor talks out loud about how badly injured the patient is, describing his wound in graphic detail, while the other doctor chats amiably to a nurse and asks her to scratch an itch on his nose with a surgical

tool. The conversations happen at the same time, both bits of dialogue being recorded simultaneously, giving the audience a view into the skill, boredom, weariness, humor, and discipline of these surgeons. The overlapping tracks of dialogue make a point about the world of these surgeons, and how they behave when tragedy is a commonplace occurrence.

3. Interview with a production sound mixer

Patrick Southern has worked in the sound department for a range of narrative films, television shows, and documentaries. In this interview, he discusses his collaborations with directors as a production sound mixer on indie films such as *Her Smell* (2018, directed by Alex Ross Perry) and *Good Time* (2017, directed by the Safdie Brothers).

TAKOUDES: I'd like to start by talking about the job of the sound mixer as it relates to the director.

SOUTHERN: Well, on set, the production sound mixer is far away from the director, over at the sound cart recording the sound. It's the boom operator who's on set and relays all the information from the director to the mixer. On a smaller movie, it's scrappier and more personal, and the mixer might actually be on set more because there's just not that many people. In that case, the mixer can talk directly to the crew about a sound problem. But on bigger sets, that's difficult.

TAKOUDES: Why?

SOUTHERN: Because the mixer is only talking to the boom op, and the boom op is relaying information to the set. It's just not that personal. It becomes more about understanding what kinds of problems the director needs to hear about, and what kinds of problems the director doesn't need to hear. Because that varies widely from person to person, and project to project. Since the director has a better sense of the final product, the director is in a better position to know if a sound problem is something to stop for and deal with, or whether it's cool because they already know that they're going to replace all the audio. Being able to predict those responses from the director is the key to not wasting time. Which is the name of the game on set. The process of recording people talking is relatively easy—it's just the cameras and schedule that make it hard. You can put the microphone right in front of someone, but what if you can't get the microphone exactly where you want it. And you only get a certain amount of time to do it. So, recording sound is about doing something that's relatively straightforward, in a very complicated context.

TAKOUDES: Since there aren't many opportunities for the mixer to talk to the director, how do you go about understanding their needs and vision? How does that get communicated to you?

SOUTHERN: The first thing I try to do is watch what the director has done before, to get a sense of their aesthetics. Because it stands to reason that

there's probably going to be some kind of relationship between what their past movies sound like and what they want this one to sound like. And then I'll ask the director, "What is the kind of sound world you're looking for?" Is it going to be a noisy movie? Quiet? Those things don't necessarily matter in terms of how the movie is recorded directly, because you do the best practices all the time. You record the dialogue as best as possible. But it does matter in terms of the types of wild sounds that you might gather. Feeling that out with the director can be difficult, because—and I don't blame them—a lot of directors don't know about the process of recording sound. It's one of the more esoteric things that happens on set. And that fear might make them hesitant to talk about sound. I think that's one of the reasons that sound sometimes gets neglected on set, because people don't really know how to talk about it. Everyone knows a little bit about cameras. With sound, that's not really the case. Everyone on set is focused on the visuals, what's going on in the monitor, so it's a little jarring to pull the director out of that and push them into a different world. And I'm sensitive about that. You don't want to frustrate the director. But sometimes you need to get their attention, because they'll thank me later.

TAKOUDES: What do you do if you hear a problem with the sound, but you know it's the type of noise that can be corrected in post-production?

SOUTHERN: That's a big thing, and it's hard to talk about it unless people know about it. In the last 10 years or so, there's software that can remove problems. If you play with it for a little while, you can figure out what sounds it can remove better than others. So, hearing everyone on set, if you hear an offending sound, the sound person needs to be able to speak with some authority on whether that kind of sound is something the software can deal with. In some movies, we're moving fast and a certain moment is maybe really going to happen only one time—especially a lot of indie directors are trying to capture lightning in a bottle—and the sound person doesn't want to impede on that. But sometimes there's a problem and you know that the noise reduction software is not going to be able to fix it. And later the director is going to be upset if we don't do it again. So, it's about finding that way to communicate that to the director.

TAKOUDES: When you first get the script, how do you start preparing for the job?

SOUTHERN: The big thing I look at is how dangerous these locations are going to be for sound. How many people are talking and how many people need to be wired? It can be hard to predict because you don't know what the shots are going to be. But I look at that because I need to know what kind of sound kit I'm going to have. And do I need two boom ops? So, there's that technical analysis. I'll talk to the director about the sound they want. I know that my job is to give them the sound materials that allow them to ultimately make the decisions that need to be made in post-production. A diverse group of sounds, which really means full, open boom sounds. And controlled lavalier sounds.

TAKOUDES: So that they have the most latitude possible to make those decisions.

SOUTHERN: Yeah, so they can go in any direction.

TAKOUDES: When you talk to the director about the script, what kind of information do you like to hear?

SOUTHERN: Things like, "Is there going to be dialogue that's off screen? Are we going to see every line?" "How do you feel about ADR? Are you totally allergic to it and against it, or do you think it's kind of cool and want to play with it?" That has huge implications for me.

TAKOUDES: Because then you don't have to wire certain actors for sound?

SOUTHERN: Right. If the director doesn't think we got a certain line, and I don't think so either, we may be okay anyway because it's going to be ADR. It helps for me to know what they want. Like Alex Ross Perry [*The Color Wheel*]—he told me he's never used ADR for any of his movies.

TAKOUDES: He wants all the dialogue recorded on set. He doesn't want to redo the dialogue in post-production.

SOUTHERN: Yeah. And that's important for me to know.

TAKOUDES: Because you're going to be more sensitive to the production sound.

SOUTHERN: It helps me set my threshold for how particular I'm going to be. And it's easy as the sound mixer to get lost in any imperfection. You get so attuned to any little thing that's a little off. You want to jump in and fix it. I think that's one thing that gives sound a bad rap. Because we're only bringing bad news. It was supposed to be the perfect take, and now here comes the sound mixer to bring news about something that's hard to even describe, that has ruined the take. You have to find where that threshold is as the sound mixer, and that's dependent on the director and project.

TAKOUDES: So, an early conversation with the director is important to establish that understanding.

SOUTHERN: Otherwise, I'm out to sea. And I can do that. Sometimes the director isn't sure what they're going to do with the sound, or they don't know about sound, or they just don't want to be interrupted. I totally respect that. And then I can have a standard operating procedure of what my threshold is of intervening. And I'm okay with that, too, but the more I know, the better. Also, to have the post-production supervisor lined up, and me in communication with them, is the best possible thing. Because they can also tell me, "Hey, make sure you get this, this, and this wild. Get these different sounds."

TAKOUDES: What are you looking for in the tech scout? What do you want to know from the director?

SOUTHERN: The main thing I'm looking for is problematic sounds. And if there are, I want to get that conversation going now rather than on the day of shooting. For the most part, I think that's what directors expect me to be doing. I also like to know more about what the scene is supposed to feel like, and what the director cares most about. Because it ends up informing

what I do in weird little ways that I can't even necessarily describe. I want to hear the conversation with the director and DP about how the scene is going to play on a non-technical level. Like what the tempo is going to be. How it's supposed to feel.

TAKOUDES: That information informs how you do your job, but also people just work better when they feel involved.

SOUTHERN: One hundred percent. It also makes it easier to anticipate conversations, so that some conversations don't even have to happen. Then you feel more connected to the project. One of the reasons that Benny Safdie was on sound for *Good Time*, in addition to acting and directing, is that he'd done sound on all their other movies. He was not ready to leave that kind of relationship he has with the actors, where he's there listening to their dialogue through the boom. It's really intimate. That's a part of his directing process—they call "cut" and he's right there and they're immediately talking. Anyone in the room, literally, is in the room emotionally. There are sacred things happening in there. And you sometimes see people on set who don't really care. They're just there to do their technical thing. And it degrades the quality of specialness of what can happen in the room. It works well when the people in the room are just the actors and the people who really get what's happening. That's it.

TAKOUDES: Part of your job is hiring the boom op. What do you look for in running your own department?

SOUTHERN: I find boom ops who are the most agreeable people I can find. Someone who people are comfortable baring their soul in front of. Because that's what the actors have to do.

TAKOUDES: I've heard this idea as it relates to camera operators, or cinematographers, who might also find themselves physically very close to the actors. There needs to be a level of comfort.

SOUTHERN: You can imagine if it's a hostile relationship, how that could ruin everything. You can sometimes tell it's going to be a great movie, just because on set there's a cohesion of what everyone's doing. And the boom op's vibe in the room is so important. I've had to replace a boom op during the shoot, and the replacement boom op will come in and be in the exact same place, but the actor will say to them, "Can you move back a little bit?"

TAKOUDES: The energy just feels different.

SOUTHERN: Yeah, but nothing has changed. The only thing that's changed is the person at the other end of that pole.

TAKOUDES: Do you like to see the blocking of a scene?

SOUTHERN: Ideally, that happens at the beginning of the day of the shoot. The blocking tells me who has to get wired. The blocking tells me everything.

TAKOUDES: Is it helpful for the director to check in with you during the shoot and listen to playback?

SOUTHERN: I don't know if I've ever really seen that. But it's helpful to have the director check in, sort of, as people. When a scene is done, I like to be part of the moment of everyone saying we got it. But I'm also happy to be ignored if that's what needs to happen. I think a lot of directors appreciate that. As a director, people are trying to pull you in a million different directions. And I don't want to be one of those people who's pulling unless I have to. There's something really vital about hearing the dialogue, and you're so close to it, closer than you're ever going to be again in that raw dialogue. And there's a hypnotic effect to hearing the dialogue over and over again.

TAKOUDES: It sounds mystical.

SOUTHERN: The whole film process is mystical. It's a memory machine, the movie-making thing. All those mistakes get to be forever.

TAKOUDES: It's interesting hearing about how autonomous the sound mixer can be, but still there are a few key points of collaboration.

SOUTHERN: I think the director should feel free to talk about the sound issues, and not be intimidated by the esoterism of the process. It's okay for the director to not know what they're talking about technically, but talk about what they want. I'd way rather have a totally superfluous conversation with a director about what they want than not have any conversations. I want to hear whatever weird things they want to capture, and they don't need to be specific about it, or articulate about it. My job is to figure out how to translate what they want into the boring stuff. But at the same time, they shouldn't feel that they have to babysit the sound person at all. Some directors are dramaturges. They don't care about the technical process at all; it's all about the actors. For others, it's the other way around. There's no one way to direct; it's so varied. But I think a lot of directors find a sound person they trust, and that's it—they make a bunch of movies together, and I think that makes sense.

4. Tasks for the director

The production sound mixer is one of the more autonomous department heads on a film crew, and collaboration with her or him will operate differently than with most department heads. Nevertheless, it is vital that the director not fall into the trap of neglecting the sound department.

Here is a list of tasks to help ensure that the director is maintaining clear lines of communication with the sound mixer. The next chapter in the book looks at the styling departments of wardrobe, hair, and makeup.

1. The director should give the script to the sound mixer as early in preproduction as possible. Then, together, they should discuss the overall sound strategy of the film. The director should also let the sound mixer know if certain actors tend to speak more quietly, and if there are particular sound elements that the director wants to have. The director

should also be sure to ask the mixer to have headphones for the director, assistant director, and other relevant parties to listen to the recorded sound on set.

2. The director should schedule a meeting between the production sound mixer and post-production sound supervisor, to establish their workflow.

3. After the locations have been chosen, the director should invite the sound mixer to tech-scout to the locations. It is important to discuss the general blocking of each scene so the sound mixer can get a sense of what types of recording equipment to bring, and how the recording devices will be set up.

4. During production, after arriving at each new location to shoot, the director should do a walk-through of the blocking with the talent and relevant department heads. The sound mixer should be part of this walk-through, to determine where to put recording devices, and where to station the sound mixer.

5. At each new location, it is important for the director to briefly check in with the sound mixer about any sound problems.

10 The director and wardrobe, hair, and makeup departments

1. Wardrobe, hair, and makeup departments overview

An actor's transformation into character requires work that is both internal and external. The internal work, as mentioned in Chapter 5, is personalized for each actor, and based on the script and discussions with the director. The external work is handled by three separate departments that, depending on budget, are sometimes collapsed into a single department. They are wardrobe, hair, and makeup. Sometimes the actors and director will decide the wardrobe on their own. Actors might do their own makeup, which may even be as basic as the actors applying powder so their faces do not shine under the lights. It is also not uncommon, on low-budget films, for the wardrobe search to begin in the actor's own closet. However, when this happens, the director and actor should understand the limitations and risks of this approach. For instance, on set, sometimes clothing can be lost or damaged. It is also likely that an actor would only have a single set of a particular clothing item; therefore, if the item gets wet, stained, or becomes damaged, shooting additional takes would be delayed until the item is repaired or cleaned.

For higher-budgeted movies, and depending on the type of film, these departments could be significantly larger. The wardrobe department may be responsible for designing and manufacturing clothes; the makeup department might include artists applying scars, wounds, blood, or aging effects. The application of temporary tattoos (or covering up of an actor's existing tattoos), as well as prosthetics, is time-consuming and only used as much as the budget allows. Makeup effects need to be applied with care to match the tone of the movie; for instance, too much blood coming from a character's wound might make a drama feel like a horror film. It is best for the director to set aside time in pre-production to do tests with the makeup department, to try out different levels of an effect before deciding on the right look.

To embrace the collaborative experience with these departments, it is useful for directors to organize their conversations around two topics: expressing who the character is, and contributing to the overall color palette.

Expressing character

Just as in real life, a character can tell the world who they are by how they present themselves physically. Their personality, career, eccentricities, wealth, or poverty—and range of other details of their life—can come across by the clothes they wear, and the style (or lack thereof) of their makeup or hair. Sometimes these choices are intentional. For instance, a character can dress up to impress others, or dress down to show a relaxed attitude; they are choosing how the world sees them. But sometimes these choices are unintentional. Essentially, how accurately do they pull off this presentation? This is when wardrobe, hair, and makeup can be particularly revealing of who a character is. For instance, if a character who wants to be taken seriously over-dresses for an occasion, but the suit is ill-fitting, this may suggest that the character is naive about the social circle they are trying to enter, or they do not have the means to buy a better-fitting suit.

The director should give the script to these department heads, and spend time discussing who the characters are, to find solutions in these nuances of a character's styling. The time period in which a story takes place, or the setting of the film, will dictate the range of what a character would wear. However, the director should be aware of the smaller choices that can be made: applying a character's makeup just a bit too heavily might suggest a desire to be noticed, or by having a character wear their clothing in a certain way might provide another "tell" about who they are, or how they want to be seen.

More often than not, especially on smaller-budgeted movies, wardrobe, hair, and makeup departments are overlooked by the director for their creative potential, and seen more as technical departments, to simply get the character appearing "right" for the role. But to sit down with each of these department heads and talk through the internal worlds of the characters can help create ideas to do something more, to develop the character's personality or suggest backstory that may not even be in the script.

The palette of the film

Another way for a filmmaker to think about wardrobe, hair, and makeup is to envision the overall palette of the film, and how the styling of a character will work within that palette. When it comes to colors of the wardrobe, these conversations should include the cinematographer and production designer, as those department heads will have the most responsibility for creating the color palette.

Will the characters stand out or blend in—or some combination therein—with other colors in the frame? If so, what is the director hoping to achieve by creating such a color scheme? There are many strategies and reasons that the director will want to integrate the wardrobe colors into the overall look of the film (the following section about the films of Kelly Reichardt

explores several of these reasons). But the styling of a character becomes a way for the director to help create a frame that is distinctive and visually dynamic. On smaller budgets, it can be hard to control the colors of buildings or cars or walls, or whatever is in the background of a film. Wardrobe, though, can be controlled and utilized by the director fairly inexpensively (with budget shopping, and depending on the style of clothes required) to help create a certain look, feel, lightness, darkness, or whatever tone the director wants to achieve in the frame.

Sometimes wardrobe can also be used as a solution for other departments. For instance, in the film *Donnie Darko* (2001), director Richard Kelly staged a scene where two high school students rush out of a classroom and kiss at the base of the school steps. The scene was shot under the glare of the sun, and because their faces were turned in a direction that cast them in shadow, their faces risked being underexposed. Also, because the entire scene was done in one shot, there was no close-up to reframe (and relight) to shine more light on their faces. Kelly and his team used wardrobe to solve the problem by dressing them in a school uniform of bright, white shirts. When the characters came together to kiss, their shirts acted as bounce boards and reflected light onto each other's faces, giving their skin the correct exposure.

Not all styling decisions on set will be as experimental as this one, but it is an instructive anecdote to get the director thinking about how wardrobe, hair, and makeup are integrated into the entire frame of the film, and how by controlling those colors and textures, certain aesthetic tones and feelings can be attained.

2. Director case study

Kelly Reichardt, a great talent of American independent cinema, is known for her intelligent and understated character-driven films. The stylization of her actors is remarkable, in part because she manages to adhere to a naturalism that rarely calls attention to itself, but nevertheless adds to an overall palette and look of her movies. In some films, particularly fantasy or period films, wardrobe may call attention to itself in bold ways, but Reichardt shows that subtle stylization choices can also be used to significant effect. Let us look at two of her films, *Wendy and Lucy* (2008) and *Meek's Cutoff* (2010), to see how she works with these departments, and, particularly in the case of *Wendy and Lucy*, how she makes strong choices on a small budget.

Wendy and Lucy is a low-key drama that features Michelle Williams as Wendy, a young woman who is on a road trip to Alaska with her dog. Wendy seems to have no family other than a sister with whom she is not close, and is living a hand-to-mouth existence as she heads toward Alaska in the hopes of finding well-paying work at a fishery. But when she stops in a small town in Oregon, and loses her dog Lucy, Wendy must set about finding her companion with little means or help. Wendy's journey results in a quiet, beautiful, and heart-wrenching film.

Reichardt, in her typical restraint, gives the audience little background information about Wendy, and allows almost everything that the audience knows about her to be inferred by observations of her character. For instance, when Wendy is introduced in the film, she is wearing brown cut-off shorts, a lightly colored plaid shirt, a basic blue zip-up sweatshirt, and old sneakers. Her hair is cut short and she wears no obvious makeup. These choices make sense for a character: without money or a home, Wendy lives a bare-bones life focused on survival. But there are nuanced decisions about her stylization that tell the audience even more about her: except for her shoes, her clothes are all clean and well-kept. Another director, seeking to stylize a character who is living on the road and likely wearing the same clothes every day, or most days, might choose to make her clothes stained, ragged, or torn. These choices would not necessarily be bad ones, and they might be made for the sake of realism of Wendy's circumstances, but they would not describe Wendy. Wendy is, even in her humbled circumstances, a precise, confident, and in-control young woman. Her meticulous care for her clothes, which is never mentioned in the movie but apparent for the audience to see, speaks to her character—without her, or any other characters, having to mention this. The audience may not know the facts of her backstory, but this does not mean that she is a stranger. Her unfussy, practical style speaks toward a capable woman whose crises and obstacles may grow with every story beat, but she remains unflappably tough. Wendy is a deeply sympathetic character, and part of the audience's admiration and respect for her comes from these directorial choices.

At the same time, realism is key to Reichardt's cinema, and hence her shoes. They are more ragged than the rest of her clothing. This makes sense because shoes are simply harder to keep clean given her life on the road. Wendy also has a bandage around her right ankle and a watch on her left wrist. The bandage is never explained and suggests an injury, speaking to the fact that once again, even though the audience knows almost nothing about her life before the first frame of the film, she has endured difficulties and risks on the road. The watch could not be simpler or more functional, speaking to Wendy's practicality.

At the same time, Reichardt is working with the styling departments to coordinate Wendy's colors with the rest of the mise en scène. As previously discussed, a distinctive visual frame can be difficult to achieve when the budget is low, and when time and crew resources are limited. But Reichardt uses wardrobe to help hold her frames together. For instance, in one scene, Wendy removes a large bag of dog food from her car trunk and pours the pellets into a bowl for Lucy to eat. Wendy wears the blue sweatshirt and is framed against the backdrop of a house painted two shades of blue. Moments later, when she approaches a car repair shop, the door, garage gate, and lettering above the door are all blue. These are subtle details but important ones; they show a director who is actively making decisions that even while filming in an ordinary town, and without a budget to paint houses and

buildings, or to build sets, the wardrobe can be used to match the existing colors in the frame. The audience does not become bored by the monotony and randomness of a palette that would ensue by simply picking up the camera and shooting whatever is easiest, or closest. To dress Michelle Williams in a blue sweatshirt, and then seek out a blue house to use as a background to her shots, requires little in terms of expense, but does indicate a director who is fully aware that given the few cinematic tools available to her on the limited budget, she plans to get the most out of the decisions she made.

Later in the film, Wendy goes to a grocery store to find food for herself and her dog. The grocery store has a different tone than the world near her car. The grocery store represents her struggle, a place full of food that she cannot afford; it is the place where she will be arrested and lose her dog. The grocery store is painted yellow, and Reichardt dresses the checkout clerks in shades of yellow or pale yellow. Once again, the financial investment of a couple of shirts is minimal, but the result is—as the clerks are framed against the existing yellow walls—to show the next phase of the visual arc. The palette has moved from blues to yellows as Wendy enters a place of danger. When Lucy goes missing and Wendy asks a clerk for information about the dog, the unhelpful and dismissive clerk has golden/blonde hair, further emphasizing the yellow color palette. In contrast, Wendy stands out in her blue sweatshirt. She is an obvious outsider, easily seen. This perhaps suggests why her theft was so quickly caught.

In a scene where Wendy is detained at a police station (for stealing dog food), the walls of the station are gray and off-white—and Reichardt responds by giving a new color choice to Wendy's wardrobe. Wendy has removed her blue sweatshirt and she now blends in with these pale, cold-hued walls in a gray/light brown plaid shirt. In these off-white shots, she sits cross-legged on a bench and the white bandage on her ankle becomes even more prominent, suggesting that this place represents her vulnerability—her ability to be wounded.

All three of these color schemes stay within a naturalistic dimension—none of it feels symbolic or overwrought. But these simple, clear-eyed wardrobe decisions go a long way to exploring this character's personality and past, creating a dynamic visual arc across the narrative, and suggesting symbols of her relative strengths and weaknesses.

Finally, the blue/yellow palette continues deeper into the story: it is notable that her dog is a yellow retriever, and although Wendy and the dog are close companions, there is a separation in the color palette that foreshadows the inevitability of the film's bittersweet ending.

Reichardt's subsequent feature film, *Meek's Cutoff*, a western told from the perspective of three wives traveling in a group of settlers in Oregon, once again features her subtle use of wardrobe, hair, and makeup in a naturalistic—yet creatively significant—manner. The landscape of *Meek's Cutoff* is comprised of the browns from the ground and the grays of scrubby brush—with

the occasional swatch of dull blue when water or sky are shown. This relative drabness of the palette is important because much of the tension from the film arises over the fact that the settlers are lost: the sameness of the landscape around them adds to the feeling of being trapped, of not making progress despite endless days of travel. The psychological impact of this barren landscape works well for communicating the frustration and growing panic of these characters.

Additionally, these settlers have few objects with them. Other than some animals and wagons that carry their belongings, there is little opportunity for Reichardt to populate her frame to make the film visually interesting. Her hair and makeup choices adhere to what is practical and realistic for the situation: that is, no noticeable makeup, and hats and bonnets meant to block the sun usually cover their hair. However, it is Reichardt's use of wardrobe that helps to tell her story. Like *Wendy and Lucy*, her decisions are straightforward but have a significant impact.

In this caravan of settlers are three husbands, three wives, some children, and their guide Stephen Meek. Meek is the antagonist of the film, a bullying and vain man whose arrogance threatens to get the settlers killed. He is supposed to bring the settlers safely through Oregon, but he only gets them more lost. In terms of the importance of the characters to the narrative, the three husbands are the least important. Reichardt dresses them in tans, browns, and grays—a choice that has them blending together into the landscape. They need to be in the film, but Reichardt is careful to paint them to the edges of the narrative so the audience is not distracted by them. One of the jobs of a director is to tell the audience where to look—to suggest which pieces of information are more important than other pieces—and wardrobe helps her to achieve this task.

When the audience first meets Meek, a central character in the film, he is wearing a bright red shirt. However, Reichardt is mindful not to have Meek overwhelm the frame and hijack the audience's attention—especially since Emily, Millie, and Glory (played by Michelle Williams, Zoe Kazan, and Shirley Henderson, respectively) are the leads of the movie. So, after the opening scene, Meek starts wearing a tan jacket that mostly covers his red shirt, and he never—for the rest of the film—removes it.

Interestingly, the only other use of red in the film occurs later when Meek and the husbands capture a Native American man. Emily believes that this man can serve as a much better guide to the settlers than Meek, even though they share no common language. To win the Native American man's loyalty, she gives him a red blanket. After this moment, Meek's authority becomes greatly diminished, as if the red blanket represents that transfer of power.

The three protagonists wear dresses in the film, and the only consistent use of color throughout *Meek's Cutoff* is reserved for them. Each dress is a different color: yellow, green, and rose. The colors themselves tend toward pale-hued, pastel shades, and they look natural and realistic. But the colors have just enough saturation to let the three women stand out against the landscape.

There are many ways in which the women drive the story, but Reichardt ensures that their wardrobe also shows them standing out from the ensemble of characters and reminds the audience whose story this is.

Interestingly, the film is shot in a 1.33:1 aspect ratio, which is a boxier (and less rectangular) frame than most films—and especially most western films. The western genre was one of the reasons for the popularity of the very widescreen look of CinemaScope in the 1950s and 1960s. The endlessly lateral landscape of the American West naturally suited the wide frames, to capture the majesty and grandeur of the deserts and mountains around the characters. Reichardt's decision to create a more box-shaped frame is significant, and by Reichardt's own words partly motivated by the bonnets that the three women wear. The bonnets act like blinders, limiting what the women could see of the world, and Reichardt uses this aspect ratio to show the audience the world as the women see it. Wardrobe tells the audience who is important in this story, but more than that wardrobe also affects how the audience sees the story.

3. Interview with a wardrobe designer

Miyako Bellizzi is a stylist whose works spans films such as *Good Time* (2017), directed by the Safdie Brothers and starring Robert Pattinson, and *Patti Cake$* (2017), directed by Geremy Jasper. She has also done wardrobe on music videos such as Jay-Z's *Smile* (2017). In this interview, she talks about wardrobe design as it relates to collaboration on a film set.

TAKOUDES: I'd like to talk about your process of reading a script. What do you look for in terms of wardrobe, color palette, or narrative?

BELLIZZI: It's kind of logistical at first. I read it through once and then I see what's going on regarding the outfits, and then I figure out: What time period is it? Where is the script taking place? I will break down the script by character and see what's exciting about their personalities.

TAKOUDES: At what point are you talking with the director?

BELLIZZI: Early on. I like to be close to the production designer and art people. I like to make friends with them so we can talk and share ideas. We have lots of meetings going through the script.

TAKOUDES: Meetings that happen in pre-production?

BELLIZZI: Yes. There's usually a big meeting at the end of pre-production with all the department heads where we all go through the script together, and everyone chimes in about what they're going to do for each scene. But it's important to do multiple meetings like that. You can't just have that meeting two days before you start shooting. That conversation needs to start at the very beginning of pre-production. Months before shooting. So that we have time to change things and to see what other people's ideas are. It's all about working closely together. I usually talk to production design very early on because we need to figure out things like the colors.

TAKOUDES: So that everyone is working within the same color palettes.

BELLIZZI: Yeah. I also get photographs of all the locations because I'm all about figuring out the overall frame. Knowing exactly what we're going to see. As soon as they have locations, I'm chiming in. Wardrobe depends on where the scenes are going to be. If you put someone in all white, and then you realize that you're shooting them in an all-white hallway, it's not going to work. And if you find out that information the day that you're shooting, it really sucks. For me, it's important to know everything, to talk to the cinematographer about the colors of the lights. We usually have a color scheme that we all talk about. It's like how the colors are very coordinated in *The Handmaid's Tale* [TV series]. I love that. I love the idea of colors affecting emotion. And of course, I'm talking to the director about the major characters, and the wardrobes that I see for them. We'll talk about who these characters are, and who the director and I think they are. And we'll look at the differences in what we thought about these characters. The director might have a different idea about who the characters are. We have to figure that out.

TAKOUDES: What are some of the discussions you've had about a character that relates to their wardrobe?

BELLIZZI: For instance, in *Good Time*, Rob's [Pattinson] character never once wears his own clothes. The whole film, he's wearing other people's clothes. He's wearing uniforms, or clothes that we don't always know where he found them. In that regard, we don't really know who he is. A character's personality is in his clothes, but what his character is wearing is not his personality. He's only wearing disguises throughout. And Josh [Safdie, the co-director] and I had to talk about how this would pan out, logistically—how he's going to change from one wardrobe to the next.

TAKOUDES: And where did the ideas for the character's clothes come from?

BELLIZZI: In general, the director and I start sharing photo references of what we're thinking about the character. That's for any movie, any collaboration. But for *Good Time*, the photos were all about New York; we wanted to be genuine about how people look. A lot of the characters, we'd imagine them on the subway with us. We prepped by taking photos of people on the street. We wanted the character to be someone you wouldn't look twice at, someone authentic. And it worked, because no one ever recognized Rob while we were shooting. Not one person. We were in the streets and no one ever recognized him. And we'd do test shoots early in the process. It gave us a sense of whether the wardrobe was working in certain situations. We'd look at the footage and see how it works, and we'd assess what needed to change.

TAKOUDES: So, your collaboration was fairly constant throughout the process?

BELLIZZI: Yeah, because the Safdies are very detail-oriented. That's what makes them incredible. I see how much of a difference it makes that they're involved in every detail, every aspect of their films. They develop their film for years and think about every single thing. And they give me so much feedback. I don't think other directors tend to care as much. It's not

an ongoing conversation—they just wait and see what the stylist comes up with. But it's not really a dialogue that continuously goes. Other directors usually don't think about wardrobe as deeply, but Josh and Benny know how important wardrobe is in a film. They'll continue figuring it out with me during the entire process. It's a true collaboration.

TAKOUDES: What type of feedback do you like to have from a director? How specific do you like their ideas to be?

BELLIZZI: If the director has a very particular vision, I'd like to hear it. And then we can talk it out. The director will have an idea, and then I'll have another idea, and we can work it out. Sometimes their ideas won't be realistic, but I really like for the director to be specific. Josh and I would text every day, all day. I think he's the most communicative director I've ever worked with. But it's also probably because we're friends. He'll send me eBay listings of things, saying, "Oh cool, look what I found!" We send each other stuff like that, all excited. We also do a lot of fittings. Way before shooting, we've already done so much work. We start early.

TAKOUDES: It's a fascinating way to work, because other department heads sometimes like to work more independently. They'll have an initial meeting with the director, then go off and work for days or weeks before checking in.

BELLIZZI: For me, it would be worse if you have a meeting with the director, and you work for three weeks on your own, getting all these clothes made, and then you come back and the director doesn't like it. That's worse because then you only have a short time to change everything around. I like to be with the director through the entire process.

TAKOUDES: What is the actor's role in this collaborative process?

BELLIZZI: A big part of my job is to make sure the actor feels like they're in character. That they feel good in what they're wearing. Or, that it helps them get into character. For the actor, it's very important. For Rob ... I'd call him and say, "We just got a bunch of new stuff in yesterday." And he'll come in and hang out, we're trying on everything and talking about all of it.

TAKOUDES: Talking about what?

BELLIZZI: That something is true to character. Or how he feels in certain clothing. When we first started working, we were thinking about completely different outfits. Some actors don't like certain fabrics, and we'll have to figure out another way to do these things. But at the same time, I am the stylist, and the most exciting part is how the clothing changes them. Changes their persona so that they feel different. They start to look like the character. It's so fun how one article of clothing can change everything. Shoes are a big factor. Shoes tell me a lot about a person.

TAKOUDES: I think wardrobe is as mysterious as music, in terms of affecting how you feel.

BELLIZZI: Yeah, you can see the transformation in people.

TAKOUDES: And when you work with the actor, are you also thinking about the director's notes?

BELLIZZI: I keep those in mind, for sure. But I'm also there to listen to what the actor has to say. To talk to them and figure out the collaboration. I think it's interesting. Because then everyone can feel good, and the actor can feel good in what they're wearing. If they feel good, then there's trust. They trust that you're not going to put them in anything stupid. That's a big thing for a lot of actors. They don't want to look stupid. But the conversations with the director are part of this process. The directors who collaborate the most are usually the best experiences. It's harder when there's not as much collaboration.

TAKOUDES: What happens?

BELLIZZI: I feel like if there isn't enough critiquing of your work, then there's no room to grow. Your work isn't going to be as good unless there is a director questioning why you're doing things. Even if it's an amazing outfit.

TAKOUDES: The feedback from the director brings up your level of work.

BELLIZZI: Yeah. Otherwise, it's too easy.

TAKOUDES: I also think that some directors have a blind spot when it comes to wardrobe.

BELLIZZI: For sure. I think the departments that the directors don't know as well, they can be intimidated by them. Which they shouldn't be. It's so important to be involved, as a director, in every department.

TAKOUDES: Do you and the director talk about movies and photos for points of reference?

BELLIZZI: Lots of photo and film references. Looking at characters in film, but also just people in general. Going out on the street and taking photos of real people. I like to go to people's homes and take photos of them, see what's in their wardrobe, look through their clothes. That's how you really get to know someone. People have the most interesting things in their closets. Taking photos of their closets can give references to the director as well.

TAKOUDES: It's an intense, rich way to work. And the director sets the tone on set for whether there's going to be this type of collaboration.

BELLIZZI: On some sets, someone will make a suggestion but the director maybe won't care. They won't think it's important.

TAKOUDES: But when they pay attention to every department, it's special. It stands out.

BELLIZZI: And everyone on the film gets really excited. There's a sense of, "Let's all do this together."

4. Tasks for the director

Depending on the budget and type of film, the stylization of characters may range from subtle and naturalistic, to aggressively flashy and over the top. It is paramount that the director works with the wardrobe, hair, and makeup departments to ensure that whatever the choices, they work with

the story and setting, and that the actors—since they are the ones wearing these styles—are comfortable with these choices. The following list of tasks will help keep the director's collaborations running smoothly.

The next chapter in the book will move into the post-production phase of filmmaking by examining the director's work with the editorial department.

1. The director should share the script with the wardrobe, hair, and makeup department heads, then meet with them individually to discuss the personalities and backstories of the characters, and how their stylizations should reflect these attributes. As part of these discussions, it is important to also talk about the general feeling or mood, and color palette, of the film.

2. After the respective department heads have had time to research their stylings, the director should sit down with them and look at photos, drawings, or other materials. The images should represent possible directions for styling. The director will then give feedback on these ideas and further narrow in on the right looks. Only after this process should clothing or materials be purchased.

3. On lower-budgeted films, if the actors will be supplying their own clothes, the director and actors (and wardrobe designer, if there is one) should look through the actors' closets and discuss fitting choices for the character.

4. If there are any special makeup effects, such as wounds or injuries, these should be discussed specifically, and examples made of the appearances of these effects.

5. On set, before shooting, the director will want to have a last look at the actors' styling—alongside the respective department heads—to ensure that everything looks correct.

11 The director and editorial department

1. Editorial department overview

There is a common saying that a movie gets made three times: when it is written, when it is filmed, and when it is edited. Each of those phases is overseen and managed by the director in collaboration with three key department heads: the writer, the cinematographer, and the editor. The editor—who runs the editorial department—is responsible for taking all of the footage shot during production and assembling it into a film. Editing is a job that is both technical and highly creative. It also represents the first major stage of post-production.

Let us look at the responsibilities and operations of this department, but begin the discussion by looking at differences in editorial work at a range of budgets.

Budgetary differences

For some departments, such as the camera department, smaller budgets mean less access to camera and grip equipment. For wardrobe, a smaller budget means fewer options for outfits. However, the editing software used to cut a film is largely the same from smaller to larger films. The budget can determine the type of computers, monitors, and hard drives used to run the software—and whether the film is cut in an editing suite or a home office—but some of these differences are matters of convenience and less consequential to how the final film turns out. An edit between two shots is what it is, and regardless of the computer system being used, successful editing comes down to making the right cuts at the right time. A good edit—given the minimum baseline of affordable and accessible equipment—is dependent on the creative choices of the editor, and the director's ability to be an effective collaborator during this process.

A more critical factor when it comes to budget is how much time the production can afford with the editor. A higher budget means that an editor can spend more time on a film, and unlike the software used for an edit, time can have a real consequence on the quality of an edit. This happens in a few

different ways. The more time the editor has to work on the edit—for instance, to solve problems in the narrative and hone in on the subtleties of pacing—the better. But if the production can afford to pay for an editor to start working in pre-production, and be on set, this is additionally advantageous for the director. In this case, the director and editor can discuss the editing strategy of the film. With the takes be long or short, and will the length of these shots change across the narrative? Will the cuts be smooth, continuous edits, or jump cuts? If an editor can be a part of the pre-production collaboration about shot lists and coverage, she or he can help to offer insight into what shots can help achieve that visual strategy.

Additionally, editors are often great script readers because their skill set naturally lends itself to understanding narrative flow and efficiency. Editors have a knack for spotting scenes—or parts of scenes—in scripts that will usually wind up on the cutting room floor, thereby saving time in production from having to shoot those story beats.

If the production can afford to hire an editor to be on set, editors can also play an important role in watching the monitor for coverage and performance. Editors can also assemble quick sequences on set, so that during production, or at the end of the day, the director can see if the visual strategy is cutting together as planned—or if adjustments need to be made.

The workflow of the editor

The editor represents one of the strongest creative influences on the film, and experienced editors will come to the job with many techniques to help solve the inevitable problems and shortcomings that may have happened on set. The editor works at the service of the director, but the director would be wise to hire an editor whose vision and ideas the director can trust. Frequently, the final edit of a film will look and feel different from the film that the director set out to make. This shift, or evolution, is natural to the filmmaking process, and while it can leave the director feeling unsteady about the film they shot, it is this collaboration with the editor that can ultimately turn the film into something new and wonderful.

This collaboration occurs across many stages, and often the first step, in post-production, is for the editor to create an assembly. The editor will review all the footage and talk with the director about how the movie should feel and move. Are there some performances that the director would like to highlight? What does the director see as the most critical moments in the movie? The editor will also have the script to use as a reference while cutting, as well as notes from the continuity person on set, who will have made notes on the director's favorite takes.

Assemblies are the film with all of the beats placed in order. The assembly is the screenplay (or what was shot of it) on screen, and one of the first lessons that a director will learn during the edit is that not every beat in the script was necessary. Sometimes scripts are overwritten, but knowing where

the overwritten parts are is not always discernible until after the shoot. For instance, if there was a scene written with the intention of making a certain character more sympathetic to the audience, it might be discovered in the assembly that the casting decision alone—perhaps the actor has naturally warm eyes and a gentle disposition—created that sympathy. The scene becomes moot and could potentially be cut.

The assembly is a slab against which all the footage is thrown, and certain moments simply do not survive. The director and editor will watch the assembly and discuss matters such as: What beats are extraneous? What moments no longer seem as interesting on screen, despite how vital they might have read on the page or felt during production? Such a realization can cause a director—who might have felt passionate about some of these moments— to feel despondent. This is where trusting the editor comes into play. Cutting precious, much-loved beats happens in almost every movie, and represents a healthy step in the editorial process. The overall movie becomes tighter and cleaner, and the story becomes more focused.

After the assembly, the editor will embark on a series of rough cuts. Rough cuts will aim to remove the extraneous moments and drill down to the essence of the film—to find the core of the story, the most efficient way through subplots. Pacing and story clarity are also important goals for rough cuts. There is no prescribed number of rough cuts that a movie must go through before the problems are solved and the cut begins working well. Indeed, the process can sometimes feel endless. Many directors like to be able to step away from the edit for a few days and then return to the rough cut with fresher eyes, make notes, and talk with the editor about what changes they should try for the next cut.

Collaboration with an editor is likely to inspire a series of wide-ranging discussions about the film, but knowing the specific language of the editorial process can help the director organize her or his thoughts and communicate with the editor. Let us look at some key topics likely to be discussed in the editing room.

Cutting for performance refers to making sure the best acting moments are included in the film. Out of the potentially many takes of a scene, the performances will come off slightly different each time. To cut for performance means to find the actor's most interesting, appropriate, truthful takes. Sometimes directors have a harder time making this call because of a phenomenon called cutting outside the frame. Directors can form emotional attachments on set, depending on how they felt about a day's shoot, or their personal relationships to the actors or crew members, that will inform how they view a take. Essentially, directors will look at a take and see everything else going on that day—they are watching outside the frame—and it may impact how they view the footage. An editor is usually more removed from everything that was happening on set, and can sometimes have more of a surgical removal from those emotions, and view what is inside the frame more objectively.

That being said, a director's instinct is a powerful tool, and the director should rely upon her or his storytelling instinct when making final decisions in the editing room, but it is also important to listen to other voices as well, especially from a trusted editor.

Additionally, there are other elements to discuss when choosing the right takes. Does the action match from one cut to the next, or are the continuity breaks not a problem? The editor will also work on cutting for pace. Is the movie dragging or moving too quickly? Should the shots be shorter and lines cut out to quickly move a scene along, or should the shots linger to give the audience a chance to absorb the visuals? Will the shots favor the characters when they are talking, as is the traditional way to edit a film, or favor the characters who are listening, which can provide a quieter and sometimes more nuanced feeling to a film?

As the rough cuts become increasingly polished, the editor will embark on the fine cuts, which means that the shape of the overall narrative is set, and the editor is making more refined cuts to adjust the rhythm or flow of the scene. Adding or subtracting a few frames from a shot can make a scene feel more complete; the fine cut helps to smooth out any last wrinkles. Once the fine cut is complete, and key department heads such as the editor and the producers agree on the cut, then it becomes picture locked, which means that no more work will be done on cutting the images of the film.

Types of edits

Editing is a mysterious craft and can feel almost magical in the many ways it can transform a film. Movies can feel slower and more ruminative, or quicker and story-driven, depending on the edit. Given the footage that was shot, a certain approach may not feel right, and it is up to the editor and director to discover the best editing approach to fit the film. Within these broader discussions, there are individual cuts that comprise the edit. Let us look at some of the language used to describe those cuts.

A single cut can transport the audience thousands of miles or thousands of years. Most cuts are more modest in their ambition and designed to lead the audience's attention through a scene. These are called matches on action. This type of edit is what most television shows and movies use the vast majority of the time. For instance, a character might be framed in a medium shot as he picks up a can of soda; as he lifts the can to his mouth, the sequence cuts to a close-up of him starting to drink. This cut matches the action from one shot to the next to create a continuous event; the cut itself is unobtrusive and sometimes even invisible to the audience. Proper coverage and the actors' abilities to repeat their actions in the same way across all takes are required for this type of edit to work.

If a director wants to create a sense of edginess in a scene, jump cuts can also be quite powerful. A jump cut is an edit where the two camera positions being cut together are less than a 30-degree angle from each other. The cuts

can feel choppy, disorienting, and—in the right context of story and tone—can work well to infuse the scene with a charged momentum.

Editors are well versed in techniques to make cuts feel continuous, and most movies exist entirely on this type of edit. However, it is useful for a director to be aware of a few other types of edits. These edits usually need to be planned ahead in pre-production to work correctly, but they can have a stirring effect when employed. Graphic matches happen when a specific item, or color, is kept in a particular part of the frame across two shots. Yasujiro Ozu, an early and mid-twentieth-century Japanese filmmaker who was known for his precise camera framings and poetic cuts, employed graphic matches to create uniformity from one frame to the next. In his 1962 master-piece *An Autumn Afternoon*, about an aging father and the unhappiness of his three grown children, two men sit at a dinner table (covered with dishes) as they drink. In one shot, a man pours sake into a cup. At the right edge of the frame is a large red bowl; at the left edge is a green saucer. In the next shot, another man is also pouring sake. The white sake bottle is in the same position—relative to the frame—as the bottle in the previous shot. Additionally, at the right edge of the new frame is another large red bowl, and occupying the spot where the green saucer had been is now a green cup. Ozu carefully matched the placement of these key objects and created a sequence of quiet visual elegance and continuity.

Sometimes filmmakers will use metaphorical cuts, where the edit is meant to convey a larger meaning about the theme or mysteries of the film. In Stanley Kubrick's science fiction epic *2001: A Space Odyssey* (1968), there is a sequence that takes place in prehistoric times, when a group of ape-like hominids attacks a rival clan. The fight ends when a victorious hominid throws a bone into the air, and the bone gets a match cut to a spaceship—of a similar shape to the bone—zooming through outer space thousands of years later. The match cut helps unify the vast leap in time and space, making it feel coherent. But this edit also adds a thematic association between the bone and spaceship: on the ship is a computer named HAL 9000, which will become a new weapon in the evolution of humanity.

Another famed metaphorical cut occurs in David Lean's *Lawrence of Arabia* (1962), when the adventurous T.S. Lawrence prepares to join a battlefront on the Arabian Peninsula during World War I. While meeting with a military officer who warns Lawrence about his mission, Lawrence lights a match. The film cuts from the tiny matchstick flame to a shot of the rising sun over the desert. It is a cut that transports the audience, with remarkable efficiency, out to the desert where Lawrence's adventures will begin, while also commenting on how a single man would be able to ignite such war and drama as he would soon encounter. It is the edit that director Steven Spielberg once said made him realize the limitless possibilities of cinema.

Collaboration on the edit requires that the director understand some of these concepts of editing, but more than that, the collaboration requires a constant discussion. The relationship between the editor and director is one

of the most intimate during the filmmaking process, and it is paramount that the director hires an editor who is right for the material, and with whom the director feels an ability to communicate comfortably.

2. Director case study

Director Martin Scorsese has enjoyed one of the most famed and successful collaborations with an editorial department in cinema history. Of the many reasons for this success, two are at the heart of this book's thesis.

First, Scorsese has been working with his editor, Thelma Schoonmaker, for the majority of their careers. Collaborations that work well require both trust and a shared language between the director and her or his department head. For a director to have a working history and close friendship with a department head, films tend to go smoother and challenges are met more easily. Filmmaking is, at its core, a people business, and working on the same creative wavelength with others supplies confidence to the process. Cinema has been shaped, in part, on the strength of some of these notable collaborations: director Terrence Malick with production designer Jack Fisk, director Yasujiro Ozu with screenwriter Kogo Noda, director Kelly Reichardt with producer Anish Savjani, and director Barry Jenkins with cinematographer James Laxton. Earlier in the book, the legendary collaboration between director Ron Howard and producer Brian Grazer was discussed.

Second, Scorsese's success is rooted in his knowledge that editing is more than merely piecing shots together. For him, with Schoonmaker, the edit itself is a tool for storytelling. Scorsese's films are potently subjective: they bring the audience into the hearts and heads of his characters. Understanding the emotions, thinking, and belief systems of a character is one of the significant challenges for an external medium such as filmmaking. One of the central goals of filmmaking is to go beyond merely watching what characters do, and giving the audience access to feel their emotions. How does a filmmaker set about expressing the internal through the use of pictures and sound, and create a subjective experience for the audience? Let us look at two examples of how Scorsese and Schoonmaker achieve this.

Raging Bull (1980) is Scorsese's masterpiece about Jake LaMotta, a boxer whose violence in the ring is matched, and perhaps surpassed, by his violence outside the ring. In the film, physical violence is plentiful but not gratuitous—so there is a purpose to the violence shown to the audience. In charting LaMotta's rise and fall, it is violence that gets him to the peak of his career, and it is the restraint of violence that gives his personal life some leeway to grow and develop. But when he loses control and the violence spills across every aspect of LaMotta's life, Scorsese wants the audience to transcend violence as mere cinematic spectacle and get the audience to understand the damage. More than that, he wants the audience to feel it. In a notable fight scene between LaMotta and Sugar Ray Robinson, a variety of editing techniques are used as LaMotta endures a beating by Robinson, and loses the match, but takes as a point of pride that at least

Robinson never knocked him down. The shot strategy is designed to show the audience the variety of punches that Robinson gets in on LaMotta, but it is the edit that carries a great deal of the emotion. When LaMotta is pushed against the ropes by an assault from Robinson, the pacing of the edits shifts away from the rapid-fire cuts, and now the length of each shot dramatically increases. Time seems to slow. As Robinson reels back for his punch, and LaMotta helplessly awaits the blow, there is an illusion of time nearly stopping. The anticipation of the hit leaves one feeling queasy and unnerved.

After the blow lands, suddenly the cuts quicken. As Robinson lands punch after punch, the edits happen so fast that it is hard to keep track of the angles. Time seems to be speeding up, creating confusion, disorientation, and a loss of control. LaMotta is rendered helpless; everything is happening too fast. When a shocking moment occurs in real life, time can seem to slow down, or it can seem to move incredibly fast. The editing strategy of showing both of these phenomena brings the audience firmly into LaMotta's shoes.

Editing, properly applied, can create the illusion of time being stretched or compressed. Each cut deepens the audience's understanding of LaMotta's experiences: the dreamlike dread of anticipating the hit, the out-of-body experience of the deluge of punches. The pattern of edits, and the shift in that pattern, is what makes the scene subjective: it puts the audience squarely in LaMotta's mind. The editing gives directorial perspective to the action. LaMotta is a difficult protagonist; he is violent and paranoid. If the audience is on board with him as a character, then the more the movie lets the audience experience his life subjectively, the more it might be able to identify with him—to experience the complexities, fears, and feelings of this complicated character.

As was explored earlier in the chapter, editors usually seek to balance shots with continuity of action. Each shot with an actor performing has a certain visceral energy. The editor's job is to maintain the integrity of that energy by allowing the shot to play out at a proper length, while also making sure the subsequent and preceding shots fit together temporally and spatially. Scorsese and Schoonmaker's collaboration pushes this balance to the edge. In the stock-trading drama *The Wolf of Wall Street* (2013), about an aspiring stock trader named Jordan Belfort (Leonardo DiCaprio), who gains wealth and power through corrupt trading practices, there is a scene where Jordan has lunch with a mentor named Mark Hanna (Matthew McConaughey). The scene takes place in a white tablecloth restaurant on the top floor of a Manhattan skyscraper. As Mark orders food and openly snorts cocaine at the table, he taunts, teaches, and cajoles Jordan into believing that stock trading is not about practicing good business—it is only about amassing personal wealth. McConaughey's performance is wildly energetic; he is constantly in motion, making unusual sounds while speaking incredibly fast. Scorsese made room for the actors to improvise in this scene, and he wound up with magnetic performances. Improvisation can sometimes wreak havoc on continuity issues, because if every take is different, then the shots will not fit together.

In fact, in this lunch scene, there are several continuity errors: a napkin jumps around erratically, body positions suddenly move, and people in the background suddenly disappear or reappear.

However, this is not the sign of sloppy editing. Scorsese and Schoonmaker understand that in this case, emotion is more potent than continuity. If the point of the scene is to show Jordan being swept away by this strange mentor's rhetoric, then the audience must be inside Jordan's head and feel his same mixture of awe and surprise. The editing creates a subjective experience for Jordan: everything is moving jarringly fast. Schoonmaker is picking and choosing McConaughey's best performance moments and focusing on the pacing of the scene rather than continuity, dazzling and destabilizing both Jordan and the audience.

Each cut offers a choice for the editor: what is more important, performance or continuity? Depending on the footage, a single edit may meet both requirements—the actor gave her or his best performance, and also managed to match the action from the previous shots. However, especially when improvisation is at play, the editor may have to prioritize one requirement over the other. Choosing to edit for performance is part of what makes McConaughey and DiCaprio's lunch scene work the way it does; it is perhaps technically flawed, but also a brilliant piece of cinema. If the scene had been edited for technical continuity, instead of performance, then it may look smoother but lack the energy and momentum that McConaughey creates through his most exciting performance moments.

Additionally, the jumpiness also puts the audience into the head of Mark, who is high on drugs. The edit shows the audience the inner worlds of both of these characters, combining Scorsese's directorial vision for loose, magnetic performances with the boldness of Schoonmaker's cutting room choices.

3. Interview with an editor

Andrew Hafitz is a film editor with two decades of experience. His early work includes Whit Stillman's *The Last Days of Disco* (1998) and Lodge Kerrigan's *Keane* (2004), and more recently he has worked with directors Mary Harron on *Charlie Says* (2018) and Michael Almereyda on the upcoming *Tonight at Noon*.

TAKOUDES: Given the range of directors you've worked with—and at varying budgets—what do you feel are some of the keys to a successful collaboration with a director?

HAFITZ: Every situation is a little different. Or rather, a lot different. There are directors who need to be in the editing room all the time, and there are directors who don't. I'm pretty experienced by this point in my career, and there are some directors who might say, "I'm not going to be there for every cut," versus another director who might be a control freak. I've worked with directors who are also editors, and in that case the director

might cut some scenes and we'll pass edits back and forth. So the director and editor definitely collaborate, and different people will collaborate differently, but generally you'll develop a language together. There's a trust level. That's important because it's a very intimate relationship. The editor is like a spouse to the director, but also like a midwife for the film. There's a lot of emotion and tension, and the director is inevitably going to feel at times that the movie isn't what they thought it was going to be. Because it never is. Unless you're Hitchcock.

TAKOUDES: Why not?

HAFITZ: It's like they say, there are three versions of a movie: the script, the production, and the edit. In the edit, you have to change scenes and cut things out, so you wind up with a movie that's not exactly what the director originally thought.

TAKOUDES: That could be a difficult position for the editor. The director might have the original movie stuck in their head and not be able to accept the changes that have to happen. Do you ever have to convince a director to see the edit anew?

HAFITZ: Usually, a consensus develops about what's working and what's not working. Casting and performance are such important factors in terms of what footage you get. In the edit, it's like, "Oh, this character isn't as forceful as we wanted it to be." Or they're too pretty, or not pretty enough. They don't hold the screen well. Whatever problems you're going to deal with in the editing room, you just don't know when you write it. Films transform in the edit all the time. Rarely is the edit just a tweak here or there. Why is a Scorsese film one or two years in the edit? It's because they figure out what works and what it needs. It takes time and there's no formula.

TAKOUDES: You're not just cutting based on the script. You're creating something new.

HAFITZ: The edit will start from the script. But then it develops. I edited a film called *Naz & Maalik* [directed by Jay Dockendorf], and in the script there was a long, important scene. But when I was cutting it, the scene wasn't really coming together. Then Jay suggested, "What if we take out that scene?" And it's like an old story, but the movie immediately became much better. But those are the changes that happen in the edit to make the movie better.

TAKOUDES: How do you communicate cutting something out that the director might really want to keep?

HAFITZ: It depends on who you're working with. The director is the boss. I do serve the director, but I try to help the director get their vision out as best as possible, even if it isn't my vision. The important thing is that if I can understand what the director's vision is, then I can help get them there.

TAKOUDES: Which is the starting point of a collaboration. Sharing the vision.

HAFITZ: Experienced directors are usually more willing to lose material than inexperienced directors. A good director is very trusting; trust is really the key. The beauty of the collaboration is when the editor or director want to

try an idea and maybe it doesn't work—but that leads to a new idea. And from there, you can get somewhere that works. That type of collaboration is what I love the most.

TAKOUDES: I've noticed that sometimes an editor can have clarity on the footage that the director might lack, simply because the director has been exposed to the material so much more. The editor can have a bit more surgical detachment. But on the other hand, that extended exposure can also help a director see more deeply.

HAFITZ: Yes, I think that directors can see deeply, and that's part of the skill set of a director. The editor tends to be less emotional about cutting an actor's performance, or reducing an actor's performance, because they don't have the same amount of contact as a director.

TAKOUDES: I'm curious about whether collaboration is happening on set, too. I imagine you're paying attention to the coverage that the director is getting.

HAFITZ: Coverage is part of it. I have to solve problems in the cutting room that people on set don't understand.

TAKOUDES: Like what?

HAFITZ: Timing problems. Continuity problems that are almost impossible to see. The best script supervisors might not know the exact place where you want to make the edit, where you're planning to make the cut. On set, I can see if the timing of some actions is going to be tricky. Most cinematographers know how to get good coverage, but I don't always follow the traditional rules of cutting. I just have a sense. I put the shots together and those cuts are ultimately going to work or not. You just keep trying new ideas.

TAKOUDES: Do you prefer directors get B-roll to help give you more options in the editing room?

HAFITZ: The demands of production generally supersede anything that I can request.

TAKOUDES: You get what you get.

HAFITZ: You get what you get as an editor, and you make the best of it. I do think it's smart to have an editor on set to be able to say, "The close-ups are out of focus," or "We never got a certain line," or "Are you okay with that line being off camera?" That's what coverage is, getting all the dialogue lines on camera.

TAKOUDES: So, you get what you get, and hopefully it's all there, but once you sit down and start editing, how do you balance cutting for story, versus performance, versus other demands of the edit?

HAFITZ: Essentially, I'm looking for performance. That's something that [director] Larry Clark taught me. I was relatively inexperienced when I worked with him, and I asked, "Do you want me to cut for script?" Because he's a photographer, I thought he might say visuals. But he said the first thing to look for is always performance. And that's what I do every time now. Because I think that's what touches audiences the most. It's not about the beautiful shot, it's all about the actor. That's what's interesting. You can tell there are shots that the crew spent a lot of time setting up and preparing, but really I don't care. It's

about performance. That said, for the first cut, I'll also include those big camera shots. Is it ultimately going to make it in the final cut? Well, maybe we'll find another way to do it.

TAKOUDES: How do you keep a fresh perspective on the cuts? When you watch your edits over and over, you're naturally going to see it differently than a first-time viewer.

HAFITZ: That's the greatest challenge. Other than being a psychologist to your director, and being an editor is like being a psychologist, the greatest challenge is having fresh eyes. The best way to do that is to screen it for people—and screen it another place, not where you've already seen it over and over again. Because then you start to see the movie through an audience's eyes. Even without them saying anything. Even if you just sit with the audience.

TAKOUDES: You can feel their energy.

HAFITZ: Yes. Your head goes to what they may be seeing, as opposed to what you're seeing. It's incredibly valuable.

TAKOUDES: I'm curious what you mean when you say that an editor is a psychologist for the director.

HAFITZ: The film is something that the director has been working on for a number of years, and it's becoming a reality. But maybe in the edit, the film doesn't work how they expected. That's why I'm there: to make the film work. It's emotionally difficult for the director. There's a lot of ego involved. Having something that's not good, or not perfect, and getting it to work in a different way is not easy. Editing is not easy. And it can be emotionally stressful for the director.

TAKOUDES: I have heard that Orson Welles was reluctant to watch the finished print of *Citizen Kane*, because when he saw it all he wanted to do was recut it.

HAFITZ: Directors have a hard job. They sometimes want to keep the process going. It's much easier to say, "I'm working on my movie" than "My movie is done"—because once it's done, you can't do anything about it.

TAKOUDES: Let's circle back to the discussion on collaboration. What are some ways that you've found that make the collaboration work well, despite stresses and changes in the film?

HAFITZ: I like the director to be around some, but not a lot of the time. Almost every day, I want them to see some of what I've done, but I don't want them watching me work.

TAKOUDES: So, daily communication works for you. But why not watch you work?

HAFITZ: Because if they see the nuts and bolts, or the stitching that goes inside of an edit, then they see that stitching as opposed to the movie. If they don't see how I did something, then maybe with a fresher eye they'll know better about whether it works. That's one reason. The other reason is that I feel a lot freer to play around when I'm not making the director wait. I might not try things when someone is looking over my shoulder. It can get in the way of my flow and my process. I worked with one director who

was easy to be in the room with. I barely knew he was there, so it was fine. He had a bit of a quiet presence, which is unusual in a director. But he was very patient and that was great. Other directors are looking at every moment, and they'll comment on everything I do. They'll say, "Oh, that's out of sync!" But I know it is.

TAKOUDES: You just haven't gotten to it yet.

HAFITZ: Right. I like to have myself satisfied with the work before showing it to the director. I like to have the freedom to go out for a walk if I need to, and to look for old footage if I need to—without anybody watching me or watching my mental process. I know how I can be most efficient. But the director may not. This is part of the trust discussion—when the editor and director trust each other, it makes everything easier.

TAKOUDES: What about music? Do you like to cut to the film's music, or temp music, or nothing?

HAFITZ: There are a lot of theories on this. Some directors like to see everything put together whenever they see the cut: all the music and sound elements. But that's a time-consuming process.

TAKOUDES: And expensive.

HAFITZ: Yes. But my training is that you make the cut work without the music. I want to make it good without the music first.

TAKOUDES: It'll only become better with music.

HAFITZ: If the music is right. For me, if you're using temp score from movies that are similar to the movie that you're working on, I think that's a reason why so many soundtracks sound the same. I think it hurts the music.

TAKOUDES: Also, the director will sometimes become married to the temp music, because they hear it so much while watching the cuts. But when they hear the actual score, it can sound off-putting.

HAFITZ: I agree.

TAKOUDES: Something else that's interesting about the collaboration is that one of the skills of an editor is to get inside someone else's head. Whether it's the director's head, to understand their vision, or the audience's head in terms of reading how they see the movie. Editors almost need to have a kind of heightened perception or sensitivity.

HAFITZ: You put it well. I want the director to express to me what they're thinking, so that I can think like them. To help fulfill their vision. And it may take a while, but then I can try to cut what the director wants without being told. It becomes a shared understanding of what the movie is. And because I'm the editor, I know the ways to get there.

4. Tasks for the director

The editorial process is in some ways the opposite process of production. The time crunches and urgency that define production, as well as the cacophony of conversations with many department heads, shifts into a more

intimate, even quiet process where the editor sits alone (or with a team of assistant editors) to make sense of the footage that was shot.

Collaboration between the editor and director means that the director will be less hands-on with the material while the editor works, and the director's vision usually combines with the editor's ideas, along with the possibilities (and limitations) of the footage.

The following list of tasks will help keep the editorial process focused, and put the director in a strong position for the final collaborative stage in the process, working with the post-production sound department.

1. The director should hire the editor early in pre-production. It is important for the editor to understand the director's original vision and intentions for the film, as this will help guide the edit. Editors usually have strong skills for understanding narrative pacing and structure, and can therefore give informed reads on a script before it is ready to shoot.
2. The editor and DP should meet to discuss the technical elements of file formats and footage workflow. Both heads should be comfortable with matters such as the aspect ratio, frame rates, file sizes and types, and how the footage will be delivered to the editor.
3. After the DP and director have settled on a shot list, it should be shared with the editor. It is useful for the editor to get a sense of the type of coverage that they will have in the editing room, and spot any coverage missing from the shot list.
4. If budget allows, the director should be sure to have the editor on set during production. Editors can quickly assemble sequences on set to make sure the shots are cutting together properly, and it is useful to have the editors watching the monitor to ensure the actors' movements will cut together smoothly and continuously.
5. In post-production, the editor should receive a copy of the script supervisor's notes about which takes worked best for the director. The director and editor should discuss expectations for what the assembly should or should not include.
6. The director and editor will screen multiple cuts of the movie. After each cut, the director gives notes to the editor, who then goes back to work and addresses those notes. When the edit feels solid, screen the film in front of a few people for a fresh take on the material. Consider supplying a questionnaire to the viewers, asking about story clarity, pacing, and any other concerns that the director and editor might have.

12 The director and post-production sound department

1. Post-production sound department overview

The post-production sound department is responsible for taking the sound that was recorded on set, then mixing and cleaning the quality of that sound, and adding more elements—such as sound effects and music—to create the overall soundscape of the film.

Depending on the type of sound work being done, the director will collaborate with various people; some of them include the composer, actors who may record some additional dialogue, as well as the head of the post-production sound department, called the supervising sound editor. Sound is a vital layer of the storytelling process, and the communication between the director and post-production sound editor can sometimes get lost in the highly technical nature of the sound editor's job. The nature of collaboration means that the director does not need to understand the many technical details of what a sound editor does, but the director does need a vision for the sound design and be able to communicate this vision. That is, to speak the sound editor's language and understand the central issues of sound design.

Will the film be quiet or loud, or somewhere in between? Will there be lots of ambient sounds—such as the wind blowing through the branches of trees, or street traffic, or the hum of computers—or will the film be unnervingly quiet? There does not have to be only one answer to such questions. Indeed, directors should consider creating a sonic arc to their narrative. Do the quiet scenes and loud scenes alternate in a certain pattern to create a dynamic feeling to the film? Will the film begin with quiet sounds that grow increasingly harsh as the narrative develops? What is the director hoping to achieve in terms of creating emotion, or building intensity, by making these choices?

These are all points of discussion that the director can use in collaborating with the sound editor. The sound editor will have ideas of how to implement that vision—ways to manipulate the sounds of the film, and choosing certain types of sounds—but that vision begins with the director.

Let us look at a few key concepts in the area of sound design to put the director on a path toward communication and collaboration.

Density and clarity

The world can be a noisy place. City streets, music concerts, even the forest when the wildlife and weather are particularly active. In noisy venues, the many sounds combined create an atmosphere that feels authentic and carries a certain kind of energy. Dense soundscapes such as these can be rich and cinematic. Chapter 9 showed how director Robert Altman sometimes filmed his scenes with overlapping dialogue from multiple, simultaneous conversations, in order to create an intense feeling of realism.

However, overly dense soundscapes can also be confusing. For instance, if there are too many sound sources on screen—that is, diegetic sounds—the audience's attention can feel pulled in too many different directions. It can be hard to know what to look at or listen to. Sometimes this effect is intentional—drowning the frame in sounds can communicate a character's subjective feelings of claustrophobia or confusion. But too many sound elements pushed together can also be off-putting to the audience. When the soundscape becomes too dense, the sound editor will seek to balance the density with clarity. That is, to give a focus to the soundscape. While the audience may be hearing many different sounds, the most important sounds come to the forefront and are more clearly audible. The sound editor has various tools to create this clarity, but the director should be versed and aware of this issue to be able to talk about it.

The world can also be a quiet place. There is a great deal of dramatic potential that is possible in a scene when the soundscape steps back to allow strong visuals, or a powerful performance from an actor, take hold. However, too much quiet, or the lack of density, can make a scene feel unnaturally empty. Sometimes a filmmaker will completely remove all the sounds in a scene to create an effect that is disorienting. This can work, but it is important to understand that this is a choice. Room tone can help fill in the soundscape, to help make the world quiet but not silent.

Put another way, too much density can make a scene feel chaotic, but too much clarity can make a scene feel fake. When balanced correctly, a film can feel both rich in sonic texture and coherent and focused in its narrative aims.

Sounds can be layered into a scene in many different ways. Sound editors will often have access to robust libraries of sound effects, and depending on the background environment of the scene, can add noises from street traffic to specific birds or insects that might be around the area. The sound editor can also manipulate these sounds to give them a spatial orientation, making them sound more distant or close to the camera, as if they are on one side of the set or another.

For sounds where an effects library may not be sufficient, such as particularly unique types of sounds, or creating footsteps to match an actor's on screen, sounds may be recorded in a controlled environment, such as a studio booth, by a technique called foley. Most commonly, a foley artist will watch the film play on a screen and mimic the actions that she or he sees, making sounds that go with the visuals. This could be footsteps, or manipulating a

prop, or any other number of situations. The addition of these sounds can also add to the density of the film, and is going to be part of the collaboration between the sound editor and the director. Given the highly technical nature of these issues, the extent of the collaboration is likely going to be budget-dependent as well. Recording new dialogue, or foley sounds, can be time-consuming and expensive. They require more staff and equipment. Gaining access to larger sound effects libraries can also be expensive. For lower budgets, most editing software comes with limited sound effects libraries and sound editing tools.

Ultimately, whether the budget is high or low, it is up to the director to supply the vision for the density versus clarity balance, and then communicate that vision and work with the technical skills and creative experience of the sound editor, to create a compelling soundscape.

Music

Music in film usually originates from two sources: existing tracks that are licensed by the filmmakers, or original tracks explicitly commissioned specifically for the film. Music, or the absence of music, plays a profound role in the overall telling of a movie. Some films, such as Paul Thomas Anderson's *Magnolia* (1999), play music throughout nearly the entire film. There is so much music in *Magnolia* that in a few scenes, musical tracks are played on top of each other simultaneously. For instance, in a scene where a car unwittingly crashes into a storefront, the background, non-diegetic classical score plays alongside a diegetic pop tune on a car radio. The result is a shocking, and strangely funny, cacophony of sounds. However, other films such as Jean Renoir's *Pickpocket* (1959) have almost no music and save a sliver of a score for the most vital turning point of the film.

When the director thinks about music, one thing to keep in mind is that there is a wide variety of options for music. Conventional Hollywood scores can be extremely beautiful, but the director should never feel that a big-sounding score is the only option for music to play over important moments in a film. The collaboration that happens between the director and a composer (if there is original music being written for the film) or the music supervisor (if existing songs are being licensed) should involve the sound editor—so that she or he understands the broader vision of the film's soundscape, and can work within the vision of what the director is trying to implement. But music can be used for a variety of purposes. In a film such as Alfred Hitchcock's *Psycho* (1960), where the Bernard Herrmann score plays a series of fast, high-pitched, staccato strings during the famous stabbing sequence, the score plays directly alongside the action on screen. Each stabbing motion of the knife is akin to the violent bowings of the strings, making the bloody attack feel even more visceral.

However, music can also effectively play against a scene—or at least play against what the scene is superficially about—while galvanizing and bringing

into light some truth that may have otherwise remained hidden. For instance, in Barry Jenkins' *Moonlight* (2016), there is a brief but potent scene where the protagonist, Little—a young boy, in this early segment of the film—is confronted at home by his mother. In a previous scene, she had maligned her son about his sexual orientation. When she confronts him, she screams something hateful to him, and his response is quiet devastation. But we do not hear her curse because the soundtrack is playing a complex, classical-style piece of music. The music feels both unnerved and uneasy, but also deeply sensitive. It is an unexpected piece of music, beautiful in all the ways that the mother's denigration of her son is ugly. What comes out of her mouth is something only the boy can hear, while the audience hears just the music. The music plays against the scene—against type, as it were—delivering an edgy gorgeousness in the midst of so much hatred.

Music does not merely need to show what is already on screen. It can play a more sophisticated role in a film; it can, like all the other departments of a film crew, tell its own story about the film, show another angle on the characters or events, and add an unexpected layer to a film.

The relationship between image and music is complex and can yield unexpected results. Walter Murch, the renowned picture and sound editor, has discussed his sound work on Francis Ford Coppola's Vietnam War movie *Apocalypse Now* (1979), and how different versions of the music track "Ride of the Valkyries," which plays during a scene of helicopters attacking a seaside village, made the water around the village look more or less saturated. A version of the music that emphasized brass instruments created the illusion that the water was a deep blue, while a version that featured string instruments made the ocean's color appear less blue.

This curious phenomenon illustrates how experimentation with different types of music during the post-production process can yield unexpected results. Applying music can happen in different ways during post-production, but regardless of the method, the director should remain open-minded throughout the process. Sometimes the editor will cut the movie to temporary (or temp) music; these are existing tracks of music that are put into the edit as placeholders for the finished music, which may still be in the process of being composed. Temp tracks are meant to deliver the feeling and pace of the final music pieces, and can be an effective way to get a sense for how the music will make the edited scenes feel.

However, one of the drawbacks to this approach is that often the director and others in post-production will like the temp tracks—or get used to hearing them in the edit—so the subsequent, permanent music may seem disappointing. Also, using temp tracks can sometimes put composers and musicians in a difficult position, where they are not able to be as creative. If they are being asked to create tracks of music akin to the temp tracks, then they are potentially in the position of being asked to make a cheaper knock-off version of music that is too expensive. This is not the most inspiring task to assign a composer.

For some films, the music is written during the production, or even pre-production, of the movie. This can be a creative way to bring the composer into the filmmaking process, to her or him to see the footage as it is being shot and find inspiration in it. If music is being written in pre-production, this might also inspire the director about how to shoot certain scenes, and the director and composer can have a long and evolving dialogue about developing the music and visuals together. However, this also requires more time spent creating music, which can be expensive.

Regardless of when and how the music is brought into the process, there are advantages and risks to any approach—it is up to the director to decide the vision and pathway for this workflow. To make an intentional decision and not simply let conventions decide how the music is incorporated into the process, or what type of music is used. As always with the collaborative process, being fully transparent with the relevant department heads about how the workflow will go is paramount.

2. Director case study

The director has many tools available for guiding the audience's attention. Camera framing and focal length can tell the audience where to look in the shot; character blocking can move the audience's eye toward the most important action. However, an often-underutilized tool also available to the director is sound. Sound design can indicate the central element of a busy frame, or provide another layer of information about who the characters are. Sound can give a scene rhythm, and dramatic or comedic flow.

Joel and Ethan Coen—the famed directing brother pair behind such films as *The Big Lebowski* (1998), *Miller's Crossing* (1990), and *No Country for Old Men* (2007)—are profound stylists of cinematic sound elements. Let us look at some examples of how they, along with their longtime supervising sound editor Skip Lievsay, use sound to help tell their stories.

The 1991 film *Barton Fink* tells the story of a New York dramatist who, coming off the success of a critically acclaimed Broadway play, is lured to Hollywood to write scripts for the silver screen. Barton—the title character and protagonist of the film—is put under contract by Jack Lipnick, a notorious producer of B-pictures who cares little for Barton's intellectual style of writing. The resulting conflict sends Barton down the rabbit hole into a 1940s Los Angeles that feels as much like a dream as reality. The tone of his journey develops from Barton's world feeling only slightly strange, to becoming an unruly nightmare of extraordinary proportions. Sound is one of the tools that the Coen Brothers use to create this tonal arc.

Within the first minutes of the film, Barton arrives in Los Angeles to a grand, but old and slightly decrepit, hotel. The lobby is empty; not even the desk clerk is present. Barton taps the service bell for the clerk, and this single strike rings inordinately, and then impossibly long. It is only when the clerk emerges through a door in the floor, and gently places a finger on the bell,

that the sound stops. Moments later, in Barton's room, the slightly strange sounds continue: a persistent mosquito, wallpaper sweating off the walls, and a suction sound whenever room or elevator doors open. This last sound resembles the hiss of an airlock, as if this floor of the hotel is perhaps high in the atmosphere. It has the connotation of feeling isolated, that Barton is living in a place where the conditions may not be entirely sustainable for human survival.

These sounds are all based in reality, but they are stretched and exaggerated. They create a world that is subtly off-kilter and vaguely threatening. The sounds help to suggest these feelings to the audience. This, in part, means that John Turturro, the actor playing Barton, does not have to "perform" fear. His response to this strangeness is fairly deadpan. Later in the movie, when he finally does express terror, the moment is much more impactful because the audience had not previously seen him like this. The sound design conveyed the threats of this world, while he was able to deliver a more deadpan, dour performance.

But there is another world presented in the film: the world of the movie studio. Lipnick is presented as an intimidating character, loud and bullying. When Lipnick walks around his desk, his shoes squeak. So do the shoes of his aide, Lou Breeze. In a later scene, when Lipnick has read Barton's film treatment and is extremely disappointed, and pounds his fist on the desk, Lipnick's chair squeaks. It is a silly sound that offsets Lipnick's threats. The sound design here is the reverse of how the hotel scenes are handled. In the hotel, the action is muted, but the sound design tells the audience to be wary. In the movie studio scenes, though, Lipnick's antics tells the audience to be wary, while the sound encourages the audience just to laugh it off.

Using the sound design to work against the images and performances is one method for making *Barton Fink* an unusually layered and complex film.

In other examples from Coen Brothers movies, sound can give rhythm to scenes and sequences that might otherwise feel empty or aimless. The film *Inside Llewyn Davis* (2013) follows several days in the life of an aspiring folk singer in 1961 New York City. The chronically broke Llewyn meets with his record label manager, Mel, to see if there have been enough record sales to garner a royalty check. The news is not good for Llewyn—his record is not selling. After they argue, Llewyn leaves for an apartment where Jean, his one-time girlfriend, lives. Jean, like most other people in this movie, is mad at Llewyn. Her reasons are many: he has left a cat at her apartment for her to take care of, he is asking a favor to sleep on her couch for the night, and he has gotten her pregnant. Jean knows that Llewyn has no means to support or help her, and lashes out at him as soon as he arrives at her doorstep.

These two argument scenes—the one with Mel and the one with Jean—are played comedically. But the scenes also come one right after the other, and at the risk of them feeling repetitive to the audience, the Coen Brothers are wise to break them up with an interstitial sequence of Llewyn arriving at Jean's building. But this presents a new problem: how to make this roughly

13 seconds of interstitial screen time not feel empty. After all, how exciting can it be to watch a person entering an apartment building and climbing stairs? The Coen Brothers solve this problem by using sound to create a shape for this sequence. Let us look at it closely.

The first part of the sequence shows Llewyn in a vestibule of the apartment building. The outside door is unlocked; he walks in and buzzes for the second, interior building door to be unlocked. We hear the low, droning sounds of the traffic outside against the abrasive and high-pitched sound of the buzzer. Then a mid-tone, second buzz of the interior door being unlocked. Very little action happens, but the three levels of sound give the moment a sense of fullness. The second beat of the sequence shows Llewyn climbing the stairs of the building. The heavy stomps of his boots echo through the stairwell. It is a lonely sound, speaking to his state of mind. The third and last beat shows Llewyn walking a long hall toward Jean's door. Here, we get the high-pitched hum of the overhead fluorescent lights and the muddy mix of voices from inside other apartments. None of these sounds are particularly attractive, but they are not supposed to be—the discomfort again plays toward Llewyn's state of mind, and against the soft, beautiful sounds of his singing and guitar playing. This scene ends with a crisp clunk of Jean opening the door and delivering her sharp line, "Explain the cat."

The sounds fit the setting and Llewyn's psychology, while also delivering across a spectrum of pitches and sonic textures to make this interstitial feel cinematically interesting. At least interesting enough to get the audience through 13 seconds of seemingly nothing happening in the story.

Sonic cues can also provide accents to a scene. In the Coen Brothers' 2009 film *A Serious Man*, a college professor named Larry Gopnik (played by Michael Stuhlbarg) is faced with a difficult moral decision. Larry has failed one of his physics students, and the student tries to bribe Larry to change the grade. When Larry threatens to report the bribe, the student's father threatens to sue Larry for defamation. Toward the end of the film, in one quiet and unnerving scene, Larry pulls out his grading book and considers changing the student's grade, both to make the lawsuit disappear and to gain some financial advantage by accepting the bribe. The soundtrack plays a soft, mysterious music cue as Larry erases the F grade and replaces it with a C. Then, to appease his moral guilt, Larry adds a minus to the C. At that moment, his phone rings—a brilliantly loud and piercing sound. Larry is startled, as is the audience. The changing of the grade is a crucial moment for Larry: it shows his moral failing, and the news that he will get on the call (an earlier medical test has come back with a worrisome result) is a karmic payoff for his failing. The Coen Brothers want to link these ideas: Larry lying and the medical diagnosis. The sound cue of the telephone is what bridges—and gives causality to—those events. Without the sound cue, the events might feel more sequential than cause and effect. The sound also gives shape to the quiet scene, providing a roller coaster ride of quiet sounds—the gentle eraser removing the failing grade, the light scratch of penciling in of a passing grade

—with a much harsher sound. The scene becomes more dynamic because of this sound cue, and works at the thematic level as well.

3. Interview with a supervising sound editor

Ryan Price is a supervising sound editor whose feature film credits include *Damsel* (2018, directed by David and Nathan Zellner) and the upcoming *The Kid* (directed by Vincent D'Onofrio). He has also worked in television and on documentaries, including PBS series *Independent Lens*.

TAKOUDES: I'd like to start at the beginning of your process. At what stage will you be brought onto the film?

PRICE: If I'm brought on early enough, I'll watch the dailies. Or I'll read the script first. But generally, I'll watch the film down and talk with the director about ideas I have, or issues with the film. We're trying to figure out what the big thing with that film is going to be. Watching it down with the director, we have what's called a spotting session. We talk about what the director is looking for in the scenes, what the focus of each scene is.

TAKOUDES: If you're brought in early during pre-production, and you get the script, what's the important information for you?

PRICE: I pay attention to anything that describes sound in the script. Alex Ross Perry, in his most recent film, wrote lots of notes about what was happening off screen. So, I'm aware of that. Sometimes there's stuff in the script that doesn't make it in the cut, some intention that isn't in the rough cut. So, we can use sound to fill that in. Some directors have really thought about sound, and others haven't until they're getting into it. Some directors just want technical cleanup; all they want is background, ambiance, clear dialogue, and for the music to play. So, sometimes I'm an operator, and sometimes I'm a collaborator. I think the process yields more for everyone if we're collaborating.

TAKOUDES: When you do collaborate, are they in the room with you while you work? How does that collaboration play out?

PRICE: I find what's best for me is taking a pass at the whole film, with their notes in mind, to do what I feel. I come up with ideas while I'm cutting and put those in, and it gives us a point to talk from. We'll play it down together and I'll say, "Here's a crazy idea, what do you think?" It gives us a point of knowing what's too far, or if something is great. It's a lot easier to be subtractive than additive with the process, and so I'll say, "Here's my idea," and if we mute it then we mute it. I try not to be precious about the stuff I try.

TAKOUDES: What types of solutions are you offering?

PRICE: Let's say two people are talking in a room, and that's the entire scene. But then maybe you also want to hear the kids across the street playing ball. You can expand what's possible with sound. If you see a kid rode by on his bicycle, you can hear him travel to a different place off camera.

How does a character get out of a space? Are they going through a door? Is the door open when we cut back to it? Where did they come from? What are they doing off camera?

TAKOUDES: You're creating a sense of space with sound.

PRICE: Yeah. An actor might look across screen a certain way, and it's like, "What triggered that?"

TAKOUDES: You'll put a sound right there, and that motivates the look.

PRICE: Right. Maybe a door closes. It totally depends on where they are. It's about being aware of what's on screen. Trying to communicate the most with the least amount. Sometimes when people who aren't from New York are mixing here, they'll say, "There's so much noise outside the window and I want all of that." But it's like, "No, you actually don't."

TAKOUDES: You want the feeling of it.

PRICE: Yeah, you want the feeling of it. But you don't need a siren in every scene. There's a siren in Manhattan all the time, sure. But you don't need to keep reminding the audience that we're in Manhattan.

TAKOUDES: You don't want chaos on the soundtrack.

PRICE: You try to work the sound design around the dialogue. You want to remind people of the space, but not detract from the conversation that's happening on screen. Or the action. And sometimes silence can be just as useful as sound. I worked on a film where two people are in a coffee shop. It's shot from outside, but the audience can hear the conversation. But I said to the director, "What if we don't hear what they're saying? What if we just play the city sounds on the exterior of the coffee shop?" The performances were so good you could see the conversation on their faces. So, what if we remove the dialogue? And the scene ended up being more impactful.

TAKOUDES: It's interesting to think about the interplay between sounds and images, and what can be revealed emotionally or narratively.

PRICE: Right, I always want to support what's on screen first. Because it's easy to get caught up in all that off-screen stuff. You can world-build, but you don't want to distract from the scene. There's always a conversation with the director, "Where are we going with this?" It's a movie, so you can do whatever you want, but where is that line of going too far? And to me, it always comes down to, "Does it work with the image?" A handheld film can have a different quality than a Steadicam, Hollywood-esque film, versus an indie film in terms of how clean or messy the sound can be. The camera affects the sound decisions. Like, *Good Time* has a certain visual and sound style. The western I just worked on was different, it was all these vistas. So the sound has to match the picture. It's a constant conversation with the director.

TAKOUDES: Do you like having the score early on?

PRICE: I like to have an idea of it as early as possible. For [director] Alex Ross Perry's films, they'll send the dailies to the composer. He'll write music cues and pieces that get the vibe of what they were shooting in the dailies, and then send the music to the editor. The director and editor start cutting

with these cues so the final score is very close to the temp. Some composers don't come on until later in the process. I will usually have a sense early on of what the tone of the music is. It's amazing how music can change the tone of a film, but it's always a juggling act. Are we favoring sound design here, or music, or dialogue? Do we really need the music here? Maybe I tried some sound element, but the score is already doing it, and I don't want to compete with it.

TAKOUDES: There are so many options, but it's a balance.

PRICE: You can take a piece of the score, or an actor's voice, and create a drone from it. So the sound element is still in the world. Because you want the sound to support the story that you just watched. I'm working on something now, and I don't know if it's going to work; there's a scene of two people in a room, and there's a lot of tension that builds and releases back and forth. And I thought, "What analogy works with that?" Let's say two people are talking in the room, and in terms of their relationship, the ship is going down. So, I have an idea of a ship sinking. Is that sound effect —not exactly that ship sinking sound, but that sound with some design on it—does that help with the feeling of what we're watching?

TAKOUDES: The sound can be metaphoric, but manipulated enough that it also fits organically in the world. It creates a feeling.

PRICE: Yeah, in this case of unease, I'm always trying to support the goal of the scene and the story being told.

TAKOUDES: So, sometimes the scene doesn't turn out right for the director. Maybe the feeling isn't there. But the sound can provide the solution to capture what was intended but didn't happen. Sound can give the scene another chance.

PRICE: In the [Silas Howard] movie *A Kid Like Jake*, there's a comic relief moment where there's someone doing scream therapy on the other side of the wall from the main scene. They recorded the screaming sound on set, but when we were in the mix, it was finding the line of getting just the right volume of the screaming to make it work. We went back and forth with that a few times before everyone felt it. There's so much you can do with sound.

TAKOUDES: But it's back to that balance question. How do you find the balance amid so many choices?

PRICE: That's why you need the director to be focused on what story they're trying to tell. The director has to know what they want. Or, at least, what they don't want.

TAKOUDES: Otherwise, everyone's just guessing.

PRICE: My rule is, "Do whatever sounds right." Which is a hard thing because I can't tell you what that means. And if I don't feel it's working, I'll communicate that to the director and we'll talk about it. But I have to make a case. I can't just say, "This doesn't feel right." And if the director is feeling that something isn't right, then we'll talk through the elements that are playing and suss it out.

TAKOUDES: It's good for the director to be able to make a case, too. To have more to say than "It just doesn't feel right."

PRICE: General feelings are hard. The conversation is usually more about what has impact. We need to make sure that a certain moment hits. It's great when a director says, "Do what you think is right and we'll go from there." Or, on the other hand, when the director says specifically, "I want *x, y,* and *z.*" Because I can get those sounds. But it's tough when the director is somewhere in between and they're being vague. And when it's like that, you just need to sit with the director and try things in front of them.

TAKOUDES: Are you in touch with the production sound mixer before shooting?

PRICE: I try to be. I worked on a movie recently where there's a kid in it, and I requested that they record as much of the kid as they could. Wild sound, even. It's useful because it's the right sound and can save me time from trying to recreate something that was just fine on set. Even if it's not recorded perfectly, it will give me a sense of what that thing sounded like. As long as there's a person with a microphone on set, then record as much as possible. It's nice to have a good rapport with the production mixer. They'll give me a heads-up if there is something they couldn't get or will record little extras that can be gems in the sound edit. Things like walla from extras, car doors, and room tone. It's great when they are thinking about what I might need beyond the shoot.

TAKOUDES: Any last thoughts on what makes a good collaboration between the sound editor and the director?

PRICE: I think that trusting the people you're working with is a big thing. Also, having conversations with the sound editor early in the process. Even just knowing the people you're working with. To create a rapport. And the biggest thing for indie film directors is listening to the production sound mixer. Well, hiring one to begin with is important. But then listening to them. The director should value the sound of your film as much as the picture while you're shooting it. Think about it early, don't let it be the thing that halfway through the mix you're like, "Oh, I've got an idea about the sound."

TAKOUDES: Directors can sometimes neglect their sound departments.

PRICE: Yeah, but you can save so much work later by having good production sound. If the production sound is good, then the dialogue edit won't take as long. You might not have to bring actors back for ADR. If we don't have to worry about issues with the production sound, then we can have fun with the creative stuff. We don't need to worry about the airplane that went by, or that the actor was off mic. Finally, I'd say it's important for the director to hire someone that they want to collaborate with creatively, not just because the budget or schedule fits. Otherwise, it has the potential to not be enjoyable. The director should feel like they're hiring the right person, that they want to work together, so that they can collaborate the right way.

4. Tasks for the director

Similar to the director's work with the editor, the collaboration between the supervising sound editor and the director entails communicating the vision and then allowing the department head to work, to some degree, unfettered for stretches of time. Because sound editors usually work on many more films than a director, and given the sound editor's technical expertise, the following list of tasks can help the director share her or his vision while remaining open to the sound editor's ideas.

1. In pre-production, the director should send the script to the supervising sound editor and discuss ideas for the film's soundscape. Music, the levels and types of sound ambiance, and the density versus clarity issue are important topics to cover. Often the production sound mixer is brought into these conversations so the mixer knows which sounds should be recorded on set, and which sounds will be added in post-production.
2. Once editing is complete and picture locked, the director should meet with the sound editor and screen the film together. This spotting session gives both of them opportunities to flag problem areas and suggest remedies, and allows the sound editor to commence work based on the director's vision.
3. When a version of the sound edit is complete, the sound editor and director should screen the film. Undoubtedly, there will be notes about what to change or improve, and the process will repeat itself with new versions of the sound edit, and then additional screenings. A key to refining and improving each pass of the sound edit is for the director and sound editor to sit down together, and experiment with different sound ideas. This is the most creative part of the process, and the director should be sensitive to listening to the sound editor's experience and ideas—while also making sure that the sound design does not detract from, or overwhelm, the visuals.
4. If additional sound elements are needed to complete the edit, the sound editor and director should discuss the various options, whether effects libraries or new recordings by actors or foley artists. Because there are budgetary implications for these choices, the producers should also be brought into the discussion.

13 Conclusion

A personal perspective

The essence of this book is to explore the principles and advantages of collaborative filmmaking. Every film has unique needs and opportunities for collaboration, and each filmmaker's application of these ideas will look differently from how other filmmakers do it. Collaboration works best as an individualized process, and the calculus for how that collaboration is implemented is based on the specific challenges of a given film, as well as the dynamics of the assembled cast and crew.

My own path toward collaborative filmmaking began during pre-production of my first directorial effort, a feature film called *Up With Me* (2008). I had previously worked in Los Angeles on the creative team for Imagine Entertainment, the film and television production company run by Ron Howard and Brian Grazer. There, I learned many of the classical Hollywood fundamentals of script structure and storytelling. But when I moved to New York City and set out to direct my own film, about a teenager from the East Harlem neighborhood of Manhattan who goes to boarding school in upstate New York, then winds up in disciplinary trouble, I found myself in unfamiliar creative territory. There was much about the characters and the setting of East Harlem that were unfamiliar to me. Early in the process, I realized that I had more questions than answers about the movie, and the only way to get those answers was by creating a collaborative experience with the cast and crew.

The first step in the collaboration was to find actors whom I could direct and steer toward a unified vision of what the film should be, but with whom I could also be, in some ways, creative equals. I spent several months looking for non-professional actors who displayed a motivation to delve into the nuts and bolts of the filmmaking process. For instance, when searching for locations, I prompted the actors for their ideas about where we should shoot. I wanted the locations to have personal significance for them, so that I could cater the filmmaking experience to their voices and experiences. It was my job to develop a unified vision of what this film was, while also imposing few constraints on their creativity, feelings, and histories. My greatest responsibility to the actors was to provide a narrative framework and production

mechanism that could directly channel their ideas. That meant directing by listening, and adjusting to their creative impulses. This extemporaneous feeling on set translated into footage that—if I was doing my job correctly—would feel organic and honest.

One of the key lessons that I learned during this process was that, even as the director, I did not need to have all the answers. I knew my strengths as a filmmaker, just as much as I was aware of the areas where I needed help to tell the story—namely, the worlds of these characters. Instead of my gaps in knowledge making me feel vulnerable, I discovered that it put me in a strong position as a filmmaker. As long as I could maintain a vision for how their voices fit together into a cohesive film, then I was working within a secure creative and collaborative realm.

The collaboration procured a number of surprises during production that improved the finished film—as well as the filmmaking experience. By choosing locations that were meaningful to the actors, we ended up filming several scenes in their apartments, and casting their family members as the characters' family members. As an act of generosity, one actor's mother cooked for our small cast and crew; I filmed much of this experience and included some of that footage in the film. I found myself welcomed into the actors' homes, which made the filming feel intimate and true. At times, I felt less like a director and more like a dinner guest, and this feeling deepened the footage that we captured.

On other days, shooting in the streets of East Harlem, we attracted attention from onlookers and the friends of the teenage actors. These friends followed us around while we shot, and eventually, after getting to know one another, I invited them to help crew the film. Later in the shoot, some of these people even became actors in the film. The collaboration that I had sought to foster in the shoot reached beyond my work with the cast, and grew into a collaboration with their families, and—to a degree—with the broader neighborhood community.

Collaboration came from other crew members as well. In a scene when the protagonist, played by Francisco Vicioso, gets in trouble at boarding school and is expelled, he returns to his dorm room to pack his bags. There, he must face his roommates, whose antics are what got him in trouble in the first place. The scene was originally written in a fairly aggressive tone, with one of the roommates taunting the protagonist as he packs. However, after shooting several takes, it was clear that the scene was not working. It felt false and overwrought. A host of dialogue changes and adjustments in blocking did little to improve the scene. The director of photography, Matt Timms, eventually raised the idea that we should drop all the dialogue in the scene—that we should shoot it all in silence, focusing only on the eyes of the roommates as well as the simple, sad act of packing. When we tried this, the scene came to life. The adornment of dialogue was not needed. The director and writer in me could not solve the problem; the actors could not improve what I was trying to give them. It was only the DP, observing the scene in a purely visual way, which one would expect from a DP,

who was able to have this idea. One never knows where a meaningful idea will come from, or which department will be able to frame the events of the shoot through their particular departmental lens, to shed clarity on how to proceed. The door to collaboration must remain open for all departments.

For my upcoming feature film, *The Jonestown Defense*, the collaboration began in a slightly different way. I had a group of three actors—Dennis Ostermaier, Robert Stevens, and Michael Michaelessi—with whom I wanted to work, but I did not have a story. So, the collaboration with them was more about developing the script and finding out—for myself—what about them as people and actors was compelling me to work with them. The actors and I had long discussions about their pasts and the turning points in their lives, and together we sought ways to turn these events into fictional scenarios. The result is a film that is fictional in plot but grounded in key emotional truths.

With both of these films, collaboration not only made the movies better, and saved the productions from daunting challenges by keeping the doors of communication with department heads open, but importantly it helped to teach me about my own movies. The act of directing is to essentialize and drill down on the central theme, or central drama, of a film. It is to take the endlessly complicated mechanisms of storytelling, of cast and crew dynamics, of budgetary constraints, of camera and sound recording and editing technologies, and to get at a single, core dramatic truth. The more minds working together to figure out this puzzle, to sift through the limitless combinations of how the movie might be put together, the better the chances of making a good film.

But collaboration also allowed me to understand my own craft better by seeing filmmaking through the eyes of my cast and crew. Roger Ebert famously called movies empathy-making machines, explaining that movies allow audiences to experience the world through the hearts and minds of fictional characters whose lives are different from ours. I agree. And I also believe that collaborative filmmaking creates empathy behind the camera just as readily as on camera.

As I head into pre-production on my next feature film, *The Limit of Wooded Country*, a dramatic adventure story about three brothers in Alaska, I am planning the ways in which I can employ collaboration. The experience will look differently on this film than my others. Collaboration does not happen accidentally, and it is more than just a frame of mind; often it is a strategy that takes planning and forethought. This is a powerful position for a director to begin making a film: being extremely well-prepared and specific in her or his vision, while also being open to the ideas of everyone who is part of the team. Those ideas create an instant response for the open-eared director, a chain of ideas guided by extemporaneous inspiration that will lead to still better ideas. The goal of the director should be to make a movie that surpasses their own abilities, and it is only through collaboration that this is possible.

Index